FASH

I ON

FASHION ICON : THE POWER AND INFLUENCE OF GRAPHIC DESIGN

GLOUCESTER MASSACHUSETTS

ROCKPORT PUBLISHERS

MIKE TOTH
and JENNIE D'AMATO

First published in the
United States of America by
Rockport Publishers, Inc.
33 Commercial Street
Gloucester, Massachusetts
01930-5089
Telephone: (978) 282-9590
Fax: (978) 283-2742
www.rockpub.com

**Library of Congress
Cataloging-in-Publication Data**

Toth, Mike, [date] and D'Amato, Jennie
 Fashion icon : the power and influence of graphic design / Mike
Toth and Jennie D'Amato.
 p. cm.
 ISBN 1-56496-949-5
 1. Advertising—Fashion. 2. Fashion merchandising. I. D'Amato,
Jennie. II. Title: Power of fashion in graphic design. III. Title.
 HF6161.C44 T68 2003
 659.1'9687—dc21

 2002153667

ISBN 1-56496-949-5

10 9 8 7 6 5 4 3 2 1

Cover Design: Kimberlee Danton

Printed in China

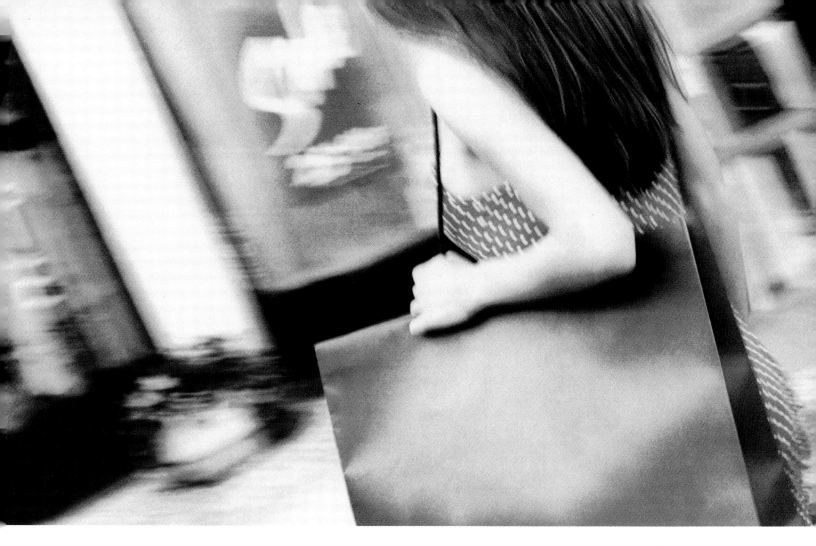

ACKNOWLEDGMENTS

Dreams are elusive; following the winding paper trails to finalizing contracts, approving images, attaining objects to be photographed, and photographing and filing them required long hours of arduous work by project manager Victoria Semarjian and art director Kimberlee Danton. Because of their fine endeavor, all the pieces of this book came together on deadline.

They, in turn, relied on many people to open doors all over the world. Those hard-working and courteous persons include Miki Higasa at Comme des Garçons; Nicole Ehrbar at LVMH; Katy Baggott at Virgin Records; Maurizio Marchiori and Bridget Russo at Diesel; Mimi Crume at Hermès; James B. Bradbeer Jr., and Kate Lester at Lilly Pulitzer; Julie Bench at Kate Spade; David Chu and Harvey Sanders at Nautica; Jennifer Koppen and Ivan Poljak at Laird+Partners; Anita Joos, Randy Kabat, and Rachel Low at Prada; Alfredo Alvarez at John Varvatos; Kana Dyck at Shiseido; Jean-Emmanuel Shein and Henry Hsu at 45rpm; Angela Niles at Cynthia Rowley; Avery Baker at Tommy Hilfiger; Alanna Hall and Patrick Deedes at Peter Lindbergh Studios; John Ward and Sarah Angell at Three Dots; Alanna Gedgaudas at Jenny Holzer studio; Francesca Perazza at Clemens Weisshaar studio; Reed Kram; Guillaume Salmon at Colette; Elizabeth Lydon at Coach; Stephen Walker at *Harper's Bazaar*; Ashley Liu, Andrew Wiles, and Siobhan Zetumer at Thomas Pink; Brian Phillips and Aoife Wasser at *Visionaire*; and Coline Choay and Michael Salamanca at Louis Vuitton, among many others.

To all who made it possible to realize this project, our extended thanks.

At Toth Brand Imaging, a group of dedicated staff turned its attention to this book, working together after hours, putting in their signature combination of concentration, talent, and camaraderie. At the helm was Mike Toth: approachable, inspiring, funny, insightful. Working with him were Thatcher Adams, Sebastian Bauer, Meaghan Brady, Ling Chin, Margaret Danenbarger, Kimberlee Danton, Valerie Donati, Jonathan Frederick, Julia Jordan, Jude Johnson, Brian Murphy, Michael O'Neal, Michael Orzech, Danny Pellegrini, Joanne Reeves, Jon Roberts, Victoria Semarjian, Maura Shephard, Kyoko Suzuki, and Lisanne Wheeler. They were joined by Salem-based photographer Bobbie Bush.

Ever gracious and encouraging, the editorial staff at Rockport Publishers, under the dedicated and thoughtful direction of Kristin Ellison, kept alive their idea for *Fashion ICON*. Without them, this book would never be. J.D'A.

FOREWORD

I was approached on Thanksgiving of 2001 by Rockport Publishers to work on a book that might help people understand the mystery that surrounds fashion, particularly, what makes accessible fashion brands work. Fashion is really difficult to grasp—it's always moving. There are a lot of very successful marketing firms that don't understand how to communicate in the world of fashion, and there are some brilliant fashion people who don't understand how to create brands. In between stand a few visionaries, creative giants with one foot on either bank, bridging the two. This book celebrates these people.

WHAT A WONDERFUL OPPORTUNITY FOR ME TO EXPLORE THOSE FASHION BRANDS THAT EXCEL! AND WHAT A CHANCE TO GIVE BACK A BIT OF WHAT I'VE LEARNED OVER 25 YEARS, WORKING WITH SUCH MASTERFUL CLIENTS AS J.CREW, RALPH LAUREN, REED KRAKOFF, AND THE PEOPLE AT COACH, AND MARY CARTER RANDOLPH AT POLO, AMONG MANY OTHERS. I'VE SEEN SUCCESSES AND MISTAKES MADE—I'VE CONTRIBUTED TO AS MANY MISTAKES AS SUCCESSES—BUT FROM BOTH, I'VE LEARNED A GREAT DEAL: RALPH LAUREN GAVE ME A CHANCE AT A YOUNG AGE TO BE A PART OF AND WITNESS TO GREAT BRANDING, WHILE TOMMY HILFIGER TRUSTED MY BRAND-BUILDING CAPACITIES FOR SEVEN YEARS, EVEN THOUGH THEY WERE UNPROVEN AT THE TIME. ONCE COMMITTED TO THE PROJECT, A DEDICATED TEAM THAT INCLUDES ART DIRECTOR KIMBERLEE DANTON, CREATIVE DIRECTOR JOANNE REEVES, PROJECT MANAGER VICTORIA SEMARJIAN, RESEARCHER LING CHIN, AND WRITER JENNIE D'AMATO, TOOK ON THE CHALLENGE OF REVEALING FASHION BRANDING THROUGH SHOWCASING THE VERY BEST PLAYERS. COMPILING THIS LIST WAS EASY: A HANDFUL OF PEOPLE HAVE ALWAYS DONE THIS THING EXTRAORDINARILY WELL; HERMÈS, FOR EXAMPLE, OR PRADA. IT WAS IMMEDIATELY CLEAR TO US WHO DOES A GREAT JOB; OUR GOAL WAS TO CONVINCE THEM TO BE A PART OF THIS ENDEAVOR. SO WHO ARE THEY, THESE MEN AND WOMEN OF ENORMOUS TALENT AND VISION? COMMUNICATORS, WHO KNOW WHAT THEY STAND FOR IN A WAY THAT SUSTAINS THEIR BRAND. DISCIPLINARIANS, WHO KNOW WHAT THE RULES ARE AND WHERE THE EDGES ARE, AND CAN COMMUNICATE IN CLEAR AND COMPELLING WAYS. DECISION MAKERS, ABLE TO BALANCE CONSISTENCY WITH SURPRISE, KEEPING IT RELEVANT, WITH TASTE AND STYLE. LEADERS, ABLE TO ATTRACT TALENTED PEOPLE OF LIKE MIND. BUILDING A LEGENDARY BRAND REQUIRES TRUST. I REMEMBER RALPH LAUREN AT AN ADOPTION MEETING SAYING "NO" TO SOMETHING THAT WAS BEAUTIFUL AND TASTEFUL—BUT WASN'T HIM. HE COULD HAVE SOLD A LOT OF PRODUCT WITH IT, BUT WHAT HE DID INSTEAD WAS STAY TRUE TO HIS BRAND. AND BECAUSE OF THAT DISCIPLINE, BECAUSE OF THE KNOWLEDGE OF WHAT MADE HIM WHO HE IS, HE PROTECTED THOSE PEOPLE WHO ENTRUSTED HIM TO KEEP THE BRAND PURE. SUPERLATIVE BRANDS RESONATE EMOTIONALLY WITH CONSUMERS, LETTING THEM KNOW THAT QUALITY AND RELEVANCE REMAIN INTACT. IT'S NOT ABOUT MAKING MONEY—FINANCIAL REWARD IS THE RESULT OF DOING THIS WELL, OVER TIME. UNFORTUNATELY, I'VE SEEN THE DANGER OF THAT, TIME AND AGAIN; SELF-INDULGENCE AFTER GREAT SUCCESS, WITH BRANDS LEFT A SHELL OF WHAT THEY WERE. WE APPROACHED THE CONCEPT OF THIS BOOK BY POSING A QUESTION: WHOM WOULD WE LIKE TO BE SEATED NEXT TO AT A DINNER? THE RESULTING GUEST LIST IS NOT VERY BIG, BUT IT'S LARGE ENOUGH TO CREATE AN INTERESTING EVENING. AS WE GOT TO KNOW OUR GUESTS BETTER, THEY BECAME EVEN MORE OF AN INSPIRATION TO US. SO WE'VE ENJOYED THEM AS GUESTS AT OUR PLACE FOR SOME TIME NOW. WITH THIS PUBLICATION, WE EXTEND THAT INVITATION TO YOU. FINALLY, I'D LIKE TO TAKE THIS OPPORTUNITY TO THANK MY GENEROUS AND LOVING FAMILY—MY WIFE, SUSAN, AND OUR CHILDREN, MAX, KEZIA, MIKA, AND ZACK—FOR THEIR PATIENCE AND SUPPORT, ALLOWING ME TO PURSUE BRANDING, MY PASSION. MIKE TOTH, AUGUST 2002

INTRODUCTION

STAND IN AN UPSCALE STORE AND PIVOT ON ONE HEEL. WHAT DO YOU SEE? ONE LARGE, WHITE ROOM CONTAINING EXQUISITE CLOTHES CLUSTERED UNDER SIGNBOARDS BEARING THE NAMES OF DIFFERENT DESIGNERS. WALK THROUGH THE RACKS OF CLOTHES, HOWEVER, AND THE SPACE STARTS TO FILL WITH APPARITIONS OF WOMEN: DONNA KARAN'S SENSUOUS, QUIET ONE, FULL OF LONGING; MICHAEL KORS' UPTOWN GIRL, COMFORTABLE IN HER FUR-WRAPPED SKIN; LILLY PULITZER'S GAL FRIDAY; CALVIN KLEIN'S FILLY, SWINGING HER LEGS AND ROLLING HER EYES. THIS IS THE MAGIC OF FASHION BRANDING AT WORK. IT STARTS WITH FABRIC, CUT AND SEWN INTO THE DREAM-WORLD SHAPES OF A DESIGNER'S IMAGINATION. THE FINISHED LINE IS GIVEN TO A CREATIVE TEAM WHERE THE ALCHEMY BEGINS: WHAT SORT OF AN EVE BEFITS THESE CLOTHES? CREATIVE DESIGNERS, ART DIRECTORS, STYLISTS, AND GRAPHIC ARTISTS START WITH A COLOR PALETTE, A BACKGROUND FOR THE CLOTHES AND ACCESSORIES THAT WILL ADORN THEM. COLOR IMPARTS MOOD; MOOD, THE OUTLINE OF A PERSONALITY. NEXT, THE ALL-POWERFUL PHOTOGRAPHIC IMAGE, THE FLESH AND BONES OF A BRAND, MODELED IN MAGAZINES AND ON THE STREET. STILL MORE EVIDENCE OF A FULL LIFE: LOGO, LABEL, HANGTAG, PACKAGING, AND CATALOG. THEN COLLATERAL AND THE PRESS OFFICE EXTRAS: GIFTS, INVITATIONS, SPIN-OFFS; FINALLY, THE SUGAR-SPUN CASTLE OF THE BRAND, THE STORE. PLACE THESE ELEMENTS IN THE HANDS OF MASTER SMITHIES AND WATCH THE SPARKS FLY, IGNITING MAGIC IN THE MARKETPLACE. FASHION HAS ITS AURA, LIFESTYLE, LONGED-FOR PLACE, FULFILLMENT OF FANTASY PURSUED—AND WE DO PURSUE IT, SEASON AFTER SEASON, YEAR AFTER YEAR, THIS BEAUTIFUL, EPHEMERAL THING, AT ONCE GAINED AND EASILY LOST. WHY DO WE DO IT? IN THE END, WE SEEK TO RENEW OURSELVES, REESTABLISH IDENTITY THE WAY WE WANT IT, TO WIELD POWER, AND DRAW COMPANIONS CLOSE; WE DO IT TO BE SEXUAL. FASHION PROVIDES THE RITUAL, WHICH GIVES US ALL THE FEATHERS, ALL THE DANCE, THAT SAYS, "LOOK AT ME. THIS IS WHO I AM." FASHION ICONS GIVE US WHAT WE WANT, EVEN BEFORE WE ARE AWARE OF WHAT IT IS WE WANT. SUCH IS THE IRONY OF BRANDING: THAT IT WORKS SILENTLY, NEARLY INVISIBLY, ALONGSIDE FASHION ITSELF, CASTING A SHADOW-SPELL LONG ENOUGH FOR US TO ENTER INTO. THIS BOOK IS ABOUT THAT WORLD.

advertising

Turn the page and there she is. The one you will remember.

Creative designers have less than a second to establish a relationship between a person and a brand. A glance up at a billboard, a flip through a magazine, one simple graphic, the right word to mark the moment of connection. Hey. You. I am the truth about you. Sirens call out your name with colors, movement, text, and perfect objects, beckoning across an ocean of multiple images: I'm the one for you. Such is the seduction of print.>

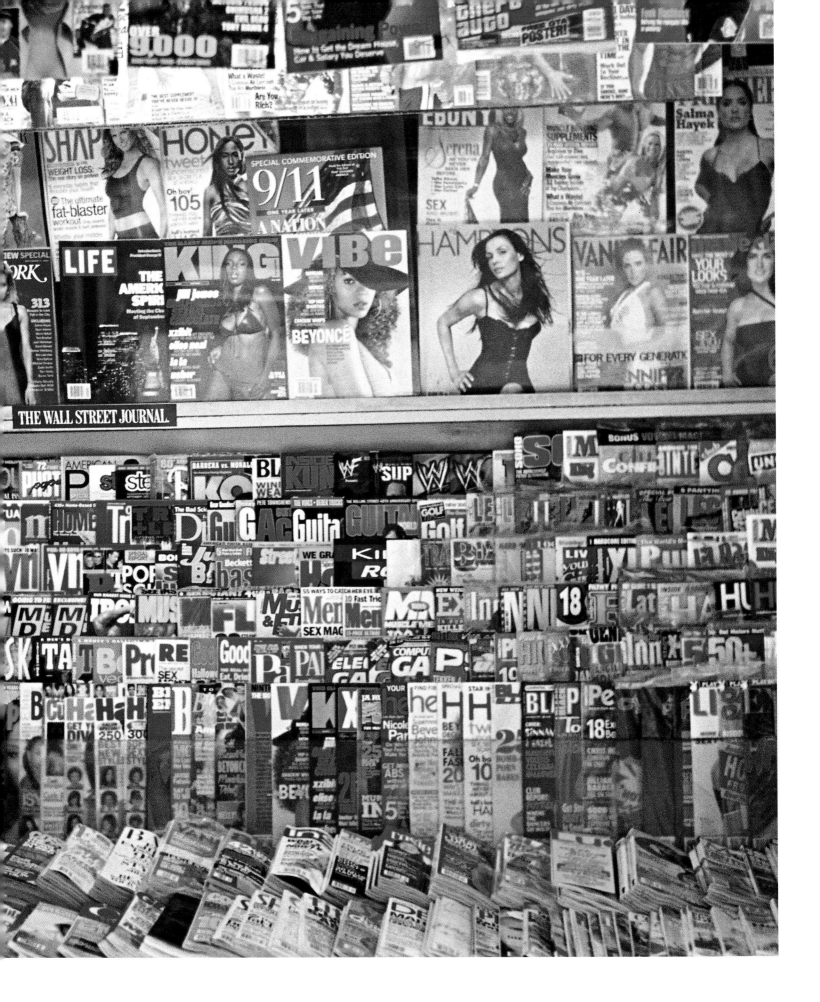

DISTILLED FROM MILLIONS OF ADVERTISING DOLLARS, ROLLS OF FILM, REAMS OF COPY, DEMARCATIONS OF FONT, COLOR AND SHADING, COMES ONE CRYSTALLIZED BEAD OF AN IDEA, CONSISTENT WITH EVERY ASPECT OF A BRAND'S PERSONALITY, INSTANTANEOUSLY COMMUNICATING IT. THE SLENDER LEGS OF A YOUNG MOTHER, HER ELONGATED SLING-BACKS WITH WHITE ROSETTES OFFSET BY THE BACKGROUND ANTICS OF A THREE-YEAR-OLD: KATE SPADE. THE SEVEN DWARFS—CHILDREN, REALLY—CARRY SNOW WHITE'S RED LUGGAGE THROUGH THE FOREST: LOUIS VUITTON. IT HAS TAKEN A HUGE INVESTMENT TO GET THERE: ACCOUNT PLANNING, MEDIA EXPERTS, CLIENTS, CREATIVES. MUCH IS AT STAKE; EVERYBODY KNOWS IT. BUT THE VERY BEST HAVE THE CONFIDENCE OF SURGEONS BEHIND THEIR LOUPES; THEY KNOW WHAT THEY ARE LOOKING FOR. AND FOR THEM, THE CREATIVE WELL IS BOTTOMLESS. THEY CAN PUMP UP CLEAR, CLEAN STORYLINES FOR EACH AD CYCLE AND EACH FASHION SEASON. FOUR TIMES A YEAR, ALWAYS IN HARMONY WITH THE BRAND BUT DIFFERENT TO THE CAMPAIGNS THAT WENT BEFORE.

DONNA KARAN ONCE PUT A MODEL IN A FORM-FITTING PINSTRIPE SUIT IN THE ROSE GARDEN, AND, IN A SERIES OF PRINT ADS, SWORE HER INTO OFFICE AS THE FIRST FEMALE PRESIDENT. IT WAS A RISK, TAKING SEX SERIOUSLY. BUT KARAN'S TEAM ANSWERED THE QUESTION CORPORATE WOMEN TOWARD THE END OF THE CENTURY WERE SILENTLY WONDERING ABOUT, AS THEY DIETED AND EXERCISED, HIDING THEIR CURVES BENEATH THEIR CLOTHES: CAN'T I HAVE MY BODY AND STILL RUN THE GREATEST SHOW ON EARTH? LIKE THE MODELS WHO TAKE ON THE CLOTHES AND BRING THE STORIES TO LIFE, SO CREATIVE TEAMS CONSTRUCT IMAGES SEEMINGLY WITHOUT EFFORT, OFFERING GLIMPSES OF A LIFESTYLE THROUGH GESTURE, GLANCES (OR THEIR ABSENCES), ABSURDITY, FANTASY, EVEN ANIMATION. BRANDING'S HOOK IS TO RECOGNIZE THE ULTIMATE MOMENT OF SELF-DEFINITION, AND ANSWER, "HERE I AM," SO THAT LONG AFTER THEIR FACES DISAPPEAR, THE MODELS' UNSMILING, LOCKED-IN EYES TUG AT THE MIND. YOU THINK ABOUT THEM, AND SO THEY RISE, MERLIN-LIKE, TO CAST THEIR SPELL.

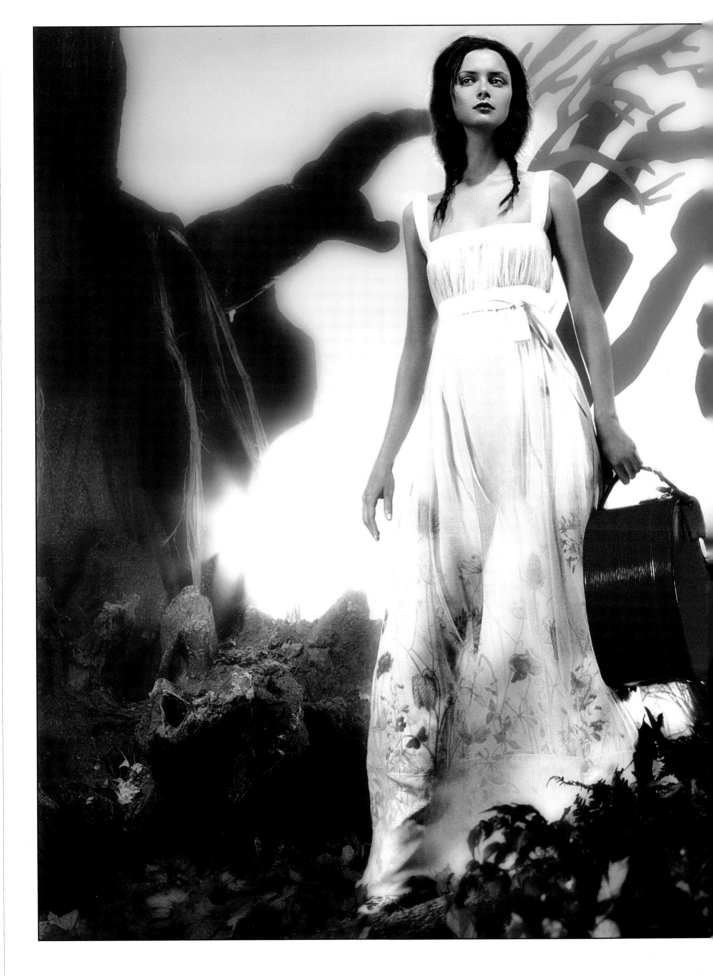

Prêt-à-porter, Souliers, Maroquinerie. Vendus exclusivement dans les magasins Louis Vuitton Tél. 0 810 810 010 www.vuitton.com

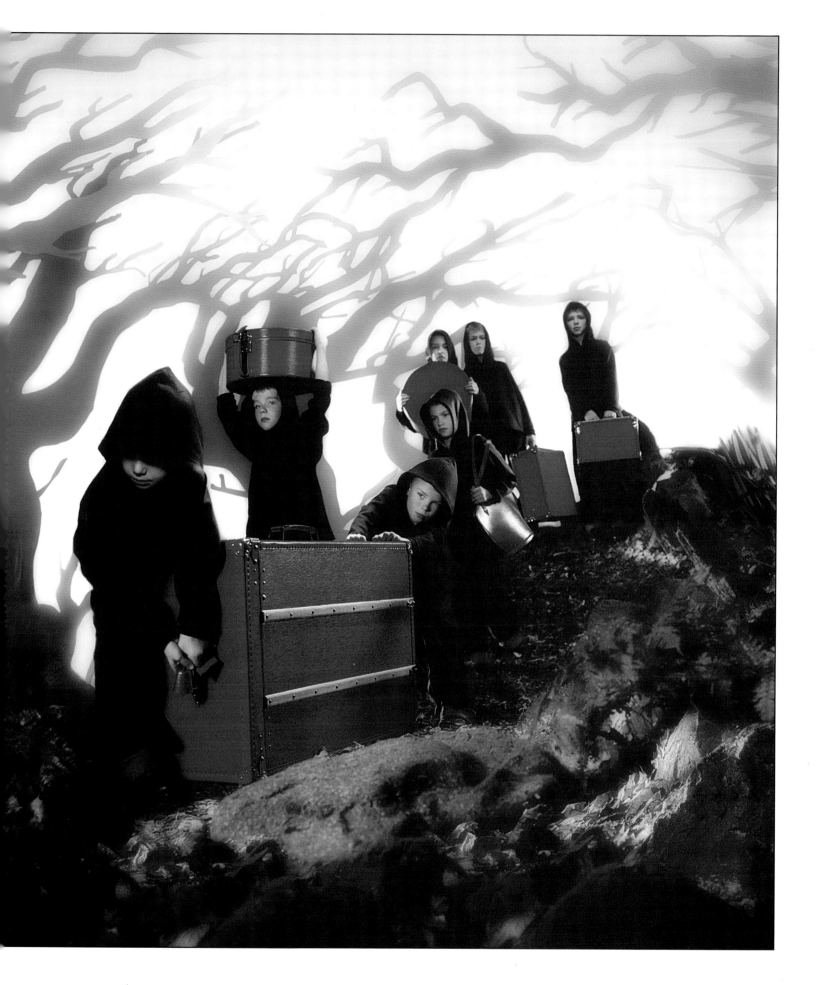

LOUIS VUITTON

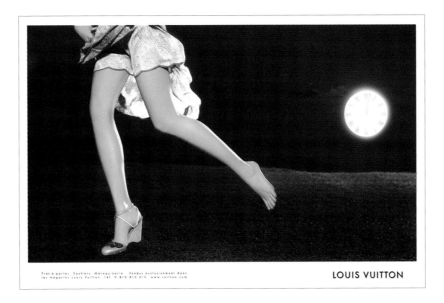

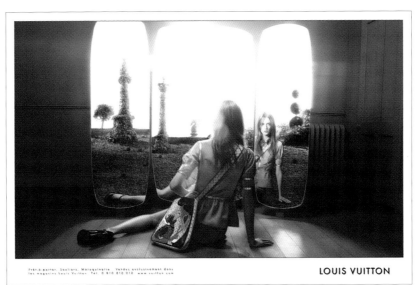

louis vuitton Louis Vuitton uncovers in memories of fairy tales echoes of our earliest enchantments. With a deftly turned couture twist, fabled heroines Snow White, Alice, and Cinderella wear Marc Jacobs' Louis Vuitton designs with the INSOUCIANCE OF YOUTH, assured in the knowledge that they, like Louis Vuitton itself, will never fall out of fashion. "Our desire [was] to express a need to get back to the simple values of life, a need to get to romance through this kind of childhood fantasy of...things you never forget from a personal life," says Claus-Dietrich Lahrs, president of Louis Vuitton in North America. Before the imaginative lens of Marcus Pigott and Mert Alas, and against a background of winter trees, elfin children manage to move along Snow White's large red trunk and several hat boxes—valises designed at the start of the last century and faithfully reconstructed for the current season. Meanwhile, Alice, her back to the camera, gazes through her triptych looking-glass, a richly textured patchwork bag slung over her shoulder—a limited-edition complex tote made up of fabrics collected by the House of Vuitton for over 150 years; and lastly, there is Cinderella, with her long and lovely legs, one foot bare, the other clad in a two-tone wedge beautiful enough to replace a glass slipper, as a white-faced clock points its two hands to the heavens, poised to strike the chimes at midnight.

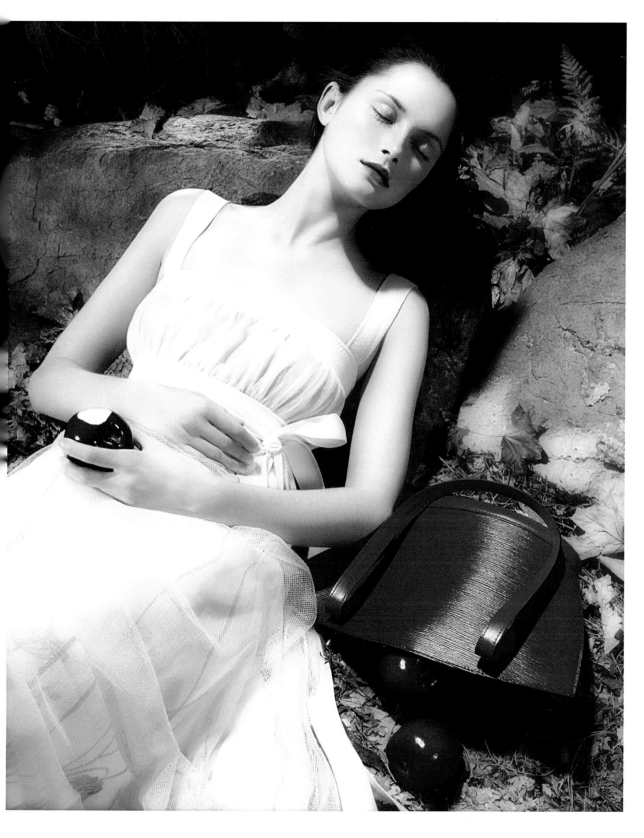

Prêt-à-porter, Souliers, Maroquinerie. Vendus exclusivement dans
les magasins Louis Vuitton Tél. 0 810 810 010 www.vuitton.com

LOUIS VUITTON

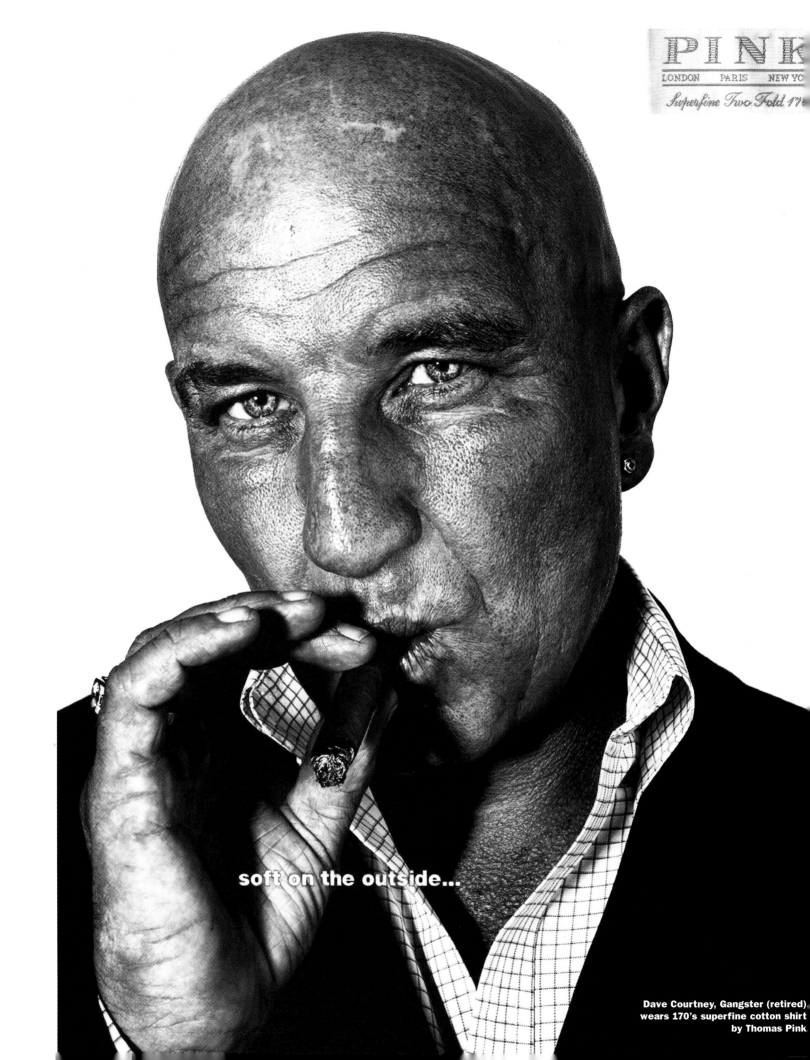

PINK
LONDON PARIS NEW YO
Superfine Two Fold 17

soft on the outside...

**Dave Courtney, Gangster (retired)
wears 170's superfine cotton shirt
by Thomas Pink**

What would Sir Thomas Pink, celebrated eighteenth century tailor to the carefree fox and hounds crowd, make of all this, then? When Thomas Pink shirt makers opened shop in London (1984) and New York (1997), they drew on TP's pedigree as a purveyor of custom-made tailoring, attracting a clientele of young businessmen wanting a leg up the ladder of sartorial splendor, and sporting the pocket change to climb it. For them, Pink introduced a ready-to-wear shirt of superfine two-fold 170s cotton—a thread so soft and dense it is usually reserved for custom-made. But if the quality spoke for itself, the ad campaign, created by photographer Richard Burbridge and M & C Saatchi's creative director Tiger Savage, did the rest. Blown in on the Guy Ritchie G A N G S T E R - C H I C wind of the times, the pair came up with nonactors tough enough to meet the expectation of the Sexy Beast–style copy Soft on the Outside: Dave Courtney, Gangster (retired); Baz Allen, Minder; Paul Ivens, Bare-Knuckle Fighter; Tony Ally, Diver; Freddie Foreman, Armed Robber (retired); Tony Lambrianou, Boxing Promoter. "The ads gave us an edge to get to a younger customer," says Andrew Wiles, Pink's marketing director. "We weren't specifically looking for gangsters when we were recruiting subjects. We were looking for interesting faces that were hard. It ended up that way, because they were great people, visually." A crowd that speaks only when bespoken to.

pink

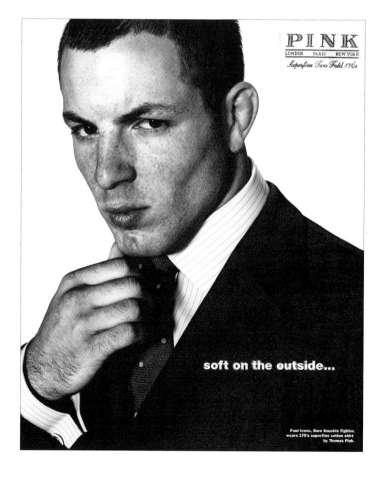

PINK
LONDON PARIS NEW YORK
Superfine Two-Fold 170's

soft on the outside...

Paul Ivens, Bare Knuckle Fighter,
wears 170's superfine cotton shirt
by Thomas Pink.

1

2

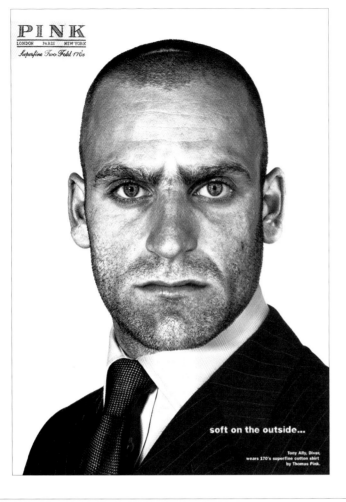

soft on the outside...

Tony Ally, Diver,
wears 170's superfine cotton shirt
by Thomas Pink.

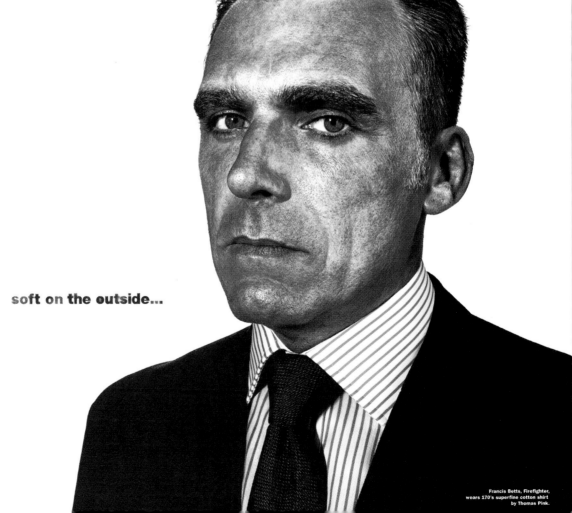

soft on the outside...

Francis Betts, Firefighter,
wears 170's superfine cotton shirt
by Thomas Pink.

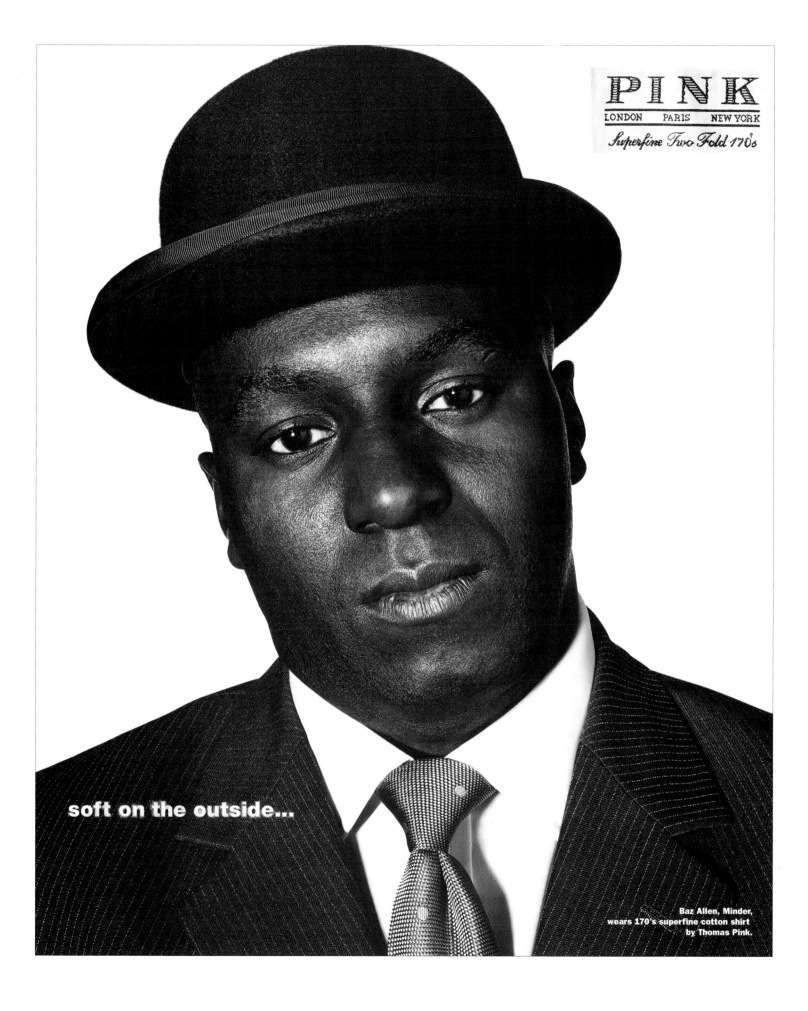

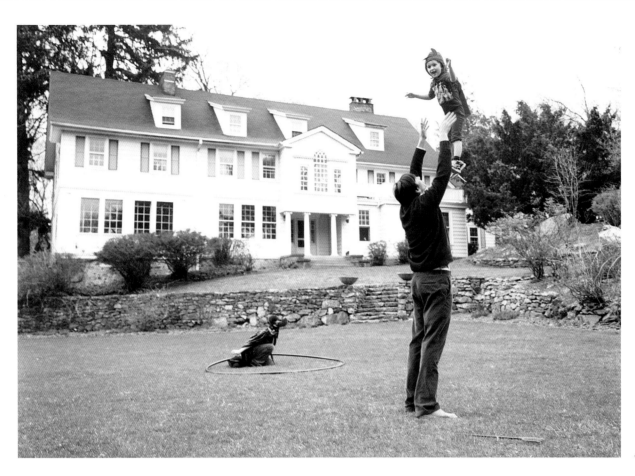

1 2

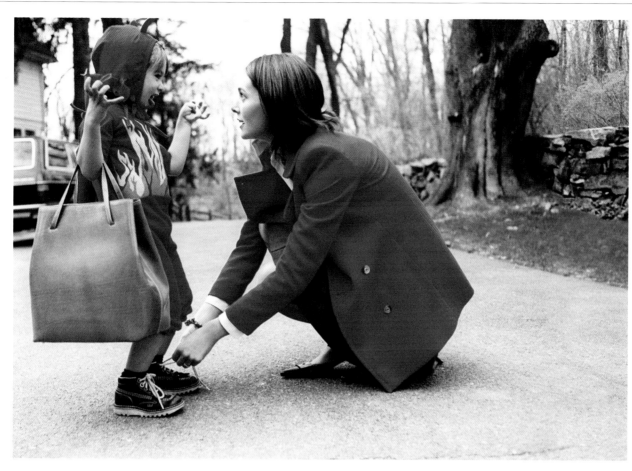

kate spade
NEW YORK
shoes handbags glasses

kate spade

The images: a girl in a tailored suit sleeps on a rumpled couch; a bag flies out of a window, à la Magritte; a young mother puts a car in reverse, her bag forgotten on the roof; a father playfully tosses his thrilled baby into the air; a mother, father, and their two sons settle into a hotel to visit Sis, who has moved away from home. The photographers: Tim Walker, Melodie McDaniels, Alexei Hay, Perry Ogden, Tierney Gearon, Larry Sultan. The set: Working with the photographer and stylist, WEAVING STORIES, finding locations, Andy and Kate Spade fashion a tapestry that becomes, season after season, the "kate spade" world, one in which action and emotion drive the scene, and product is reduced to prop. "We always try to find a natural place for the bag rather than try to sell it," says Andy. " We think about that going in. You can't just throw a bag in there. How do people live? Where do they put their bags? What do they do with their bags? You've got to think about life, rather than making an ad."

Visiting Tennessee

ADVERTISING

KAREN PATCH
closet building

IT IS ODD TO THINK OF CLOTHING AS A PROP. USUALLY THE MAIN FEATURE, CLOTHING IS ALMOST ALWAYS ITS OWN REWARD. BUT THINK OF IT AS DOES KAREN PATCH, AWARD-WINNING DESIGNER WHOSE STYLE DEFINES THE CHARACTERS IN *THE ROYAL TENENBAUMS*, AND A NEW APPROACH IS POSSIBLE: USE CLOTHING TO CREATE AN AMBIENCE FOR FEATURING SOMETHING OTHER THAN ITSELF. "CLOTHES TELL A STORY, MAYBE ABOUT WHAT YOU WANT TO HIDE OR REVEAL," SAYS PATCH. "EVERYTHING IN AN AD OR FILM HAS BEEN CHOSEN; THERE ARE NO ACCIDENTS." CLOTHES HELP CREATE CHARACTERS, AND THE WORLD IN WHICH THEY LIVE. "SOMETIMES CLOTHES TELL MORE ABOUT THE CULTURE,"

ADDS PATCH. "NO ONE MAKES FASHION CHOICES IN A VACUUM, YOU'RE EITHER REBELLING OR CONFORMING." SUCH VIEWS RESONATED IN THE EARS OF ACCESSORIES DESIGNERS KATE AND ANDY SPADE. THEY HIRED PATCH TO COSTUME DESIGN THEIR FIRST SERIES OF PRINT ADS TO RUN AS A NARRATIVE: THE LAWRENCES OF CHICAGO. THE SPADES' DUAL PHILOSOPHIES—TO FIND THEMSELVES IN EVERY DETAIL OF THEIR BRAND AND TO FEATURE THEIR PRODUCTS IN PROMOTIONAL IMAGERY AS CASUALLY AS IN LIFE—TOOK ROOT IN PATCH'S TERRITORY. PATCH ASKED TO APPROACH THE AD CAMPAIGN AS IF IT WERE A FILM; THE SPADES LIKED THE IDEA AND WROTE UP A TREATMENT AND PROFILES OF EACH CHARACTER, INCLUDING THEIR PERSONAL HISTORIES. THEN SHE "BUILT CLOSETS," ENTIRE WARDROBES BEYOND WHAT THE SHOOT REQUIRED, GIVING THE MODELS A CHARACTER RANGE OF WHO THEY COULD BE. PATCH HUNTED DOWN THE RIGHT COMBINATION OF BARBOUR WAXY JACKETS, VINTAGE COURRÈGES AND HERMÈS COATS, SWIX SKI HATS, INDIAN-BEAD JUNIOR BELTS, KENNETH LANE JEWELRY, 10-YEAR-OLD K-SWISS SNEAKERS AND MOTHER KAREN POWDER SKI JACKETS TO CLOTHE THIS CLAN OF MIDDLE-CLASS ECCENTRICS. SHE EMAILED IMAGES OF HER FINDS TO THE SPADES; THEY CALLED BACK WITH THEIR RESPONSES. BETWEEN THEM, THE CHARACTERS CAME TO LIFE: "THEIR STYLE, LIKES, DISLIKES, WHERE THEY WENT TO SCHOOL, AND HOW THEY ARRIVED AT WHERE THEY ARE NOW." PATCH'S PARTICULAR TALENT SURFACED IN THE *BIG PICTURE* AND *MY GIRL* AND REAPPEARED IN ALL WES ANDERSON'S FILMS. "THE TENENBAUMS DID IT FOR ME," SHE SAYS. "IT WAS A SUCH A GROUNDBREAKING WORK IN TERMS OF SETTING AN UNEXPECTED STYLE." THINK OF BEN STILLER, READY FOR TRAUMA, DRESSED IDENTICALLY TO HIS SONS IN RED ADIDAS TRACK SUITS, OR GWYNETH PALTROW, DROOPILY SMOKING IN A CUSTOM-DESIGNED LACOSTE DRESS AND VINTAGE FENDI FUR. (PALTROW SET A TREND IN ITALY, WITH FASHIONISTAS WEARING LIMITED EDITIONS OF PATCH'S CUSTOM DRESS.) THE LAWRENCE'S GESTALT WAS MINED FROM THE SAME VEIN. "I CAME IN THERE WITH THE THOUGHT, 'WHAT'S THE BEST WAY TO SHOW THIS [PRODUCT] OFF?'" SAYS PATCH, "BUT THE BAGS WERE PLACED AROUND THE IMAGERY, NOT THE IMAGERY AROUND THE BAGS." OUTSIDE THE CARLYLE HOTEL, THE LAWRENCES DOMINATE THE FOREGROUND; THE KATE SPADE LUGGAGE BARELY DISCERNABLE IN THE BACKGROUND. IN A RECORD STORE, PATCH, PHOTOGRAPHER LARRY SULTAN, THE MODELS AND THE SPADES SELECTED WITH GREAT CARE THE ALBUM COVERS THAT DECORATE THE SCENE. WHEN IT CAME TIME TO INSERT A BAG, PATCH SAYS "WE JUST PUT IT THERE. IT WAS INCIDENTAL." MONTHS LATER, THE LAWRENCES' STORY RETAINS ITS POWER. "I STILL IMAGINE IT AS A FILM," SAYS PATCH. "WHEN I EMAIL [ANDY], I SAY, 'SO WHERE IS THE LAWRENCE FAMILY GOING FROM HERE?'"

dear mom,
 it was so much fun seeing you, dad, toby, and jake. i loved having you here — it was wonderful to be a big sister and daughter again, showing you my favorite haunts. (thanks for picking up the tab!)
 i find that the older i get, the more i appreciate our crazy family. what used to embarrass me now makes me strangely proud. i'm really glad we had a chance to talk on saturday night... thanks for being so open with me. what's clear is that through it all, you and dad truly adore each other.
 anyway, i had a ball. big hugs to my goofy brothers. you and dad too. i'll call about thanksgiving —
 love you,
 tennessee

p.s. read "how to be good" by nick hornby. i think you'll enjoy it!

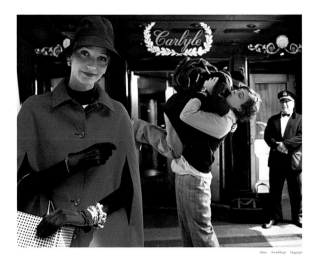

shoes: handbags: luggage

shoes: handbags: paper

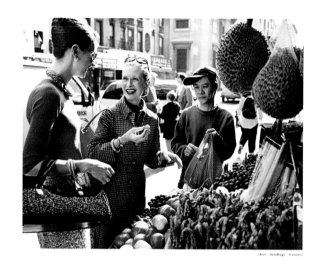

chies handbags reunions

the lawrence family autumn 2002

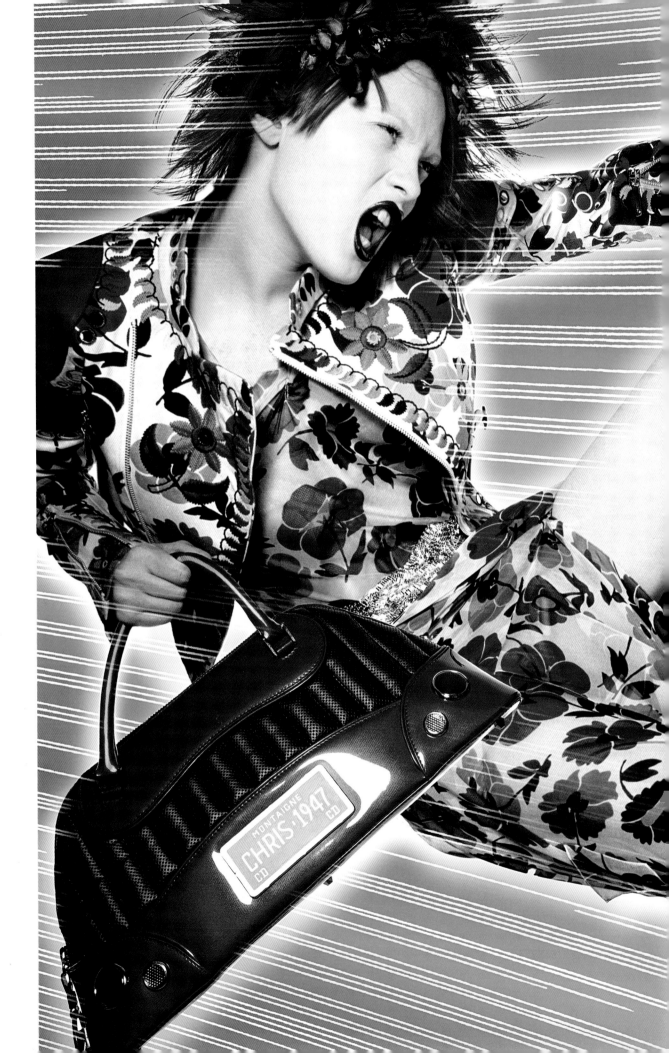

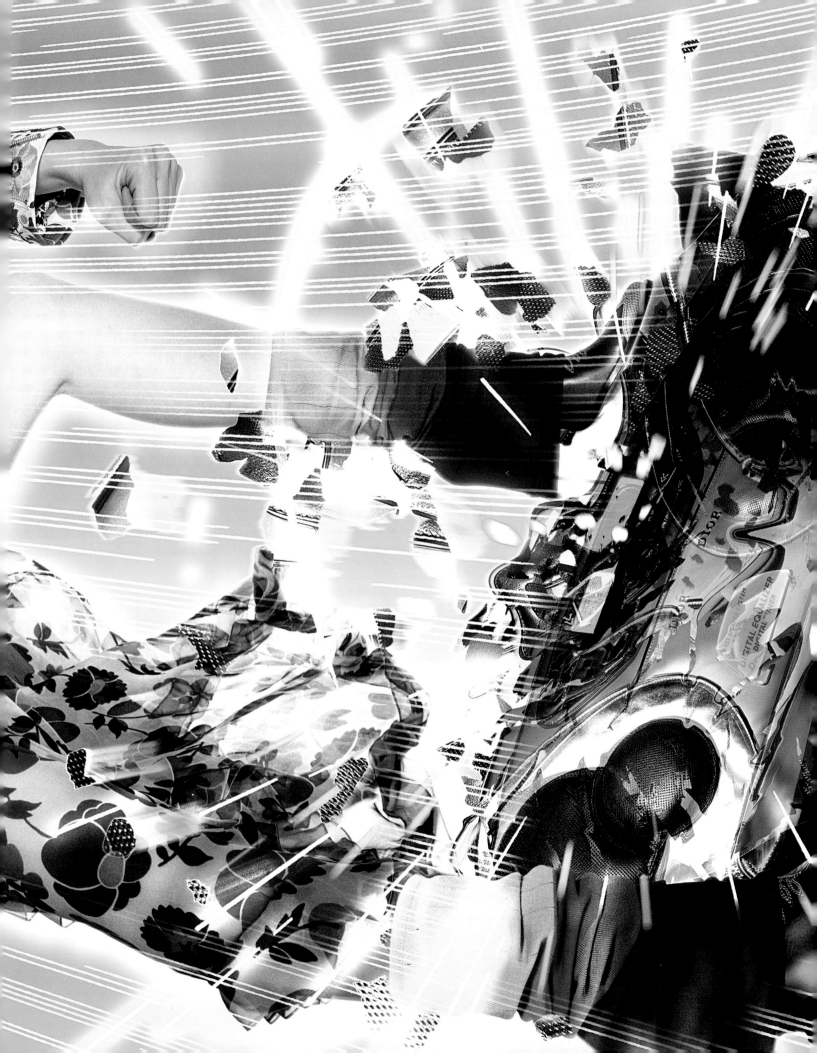

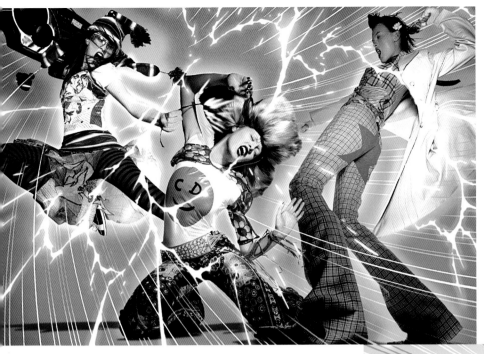

NICK KNIGHT
free to fly

"IMAGINE YOURSELF FALLING OFF A CLIFF IN A FREEFALL. DESPERATELY TRYING NOT TO FALL. YOU KIND OF CLAMP AND REACH OUT. YOU FIND THINGS WHEN YOU DO THAT. WHEN YOU PUSH AND PUSH AND PUSH AND PUSH, THERE IS AN OUT-OF-BODY EXPERIENCE YOU START TO FEEL, AND THAT'S THE DRUG IN IT ALL, THE ADDICTION IN IT ALL." PHOTOGRAPHER NICK KNIGHT IS TALKING ABOUT HIS WORK, AND USES METAPHORS OF FALLING AND FLYING TO DESCRIBE IT. "I LIKE THE ANALOGY OF FLYING," HE CONTINUES, "BECAUSE YOU DO FEEL LIBERATED FROM YOUR PHYSICALITY WHEN YOU'RE DOING IT, AND THERE IS A CERTAIN AMOUNT OF FEELING OF FALLING—WHICH IS HEALTHY." KNIGHT SHOOTS AND COLLABORATES ON ADS FOR CHRISTIAN DIOR WITH DESIGNER JOHN GALLIANO. MIXING TOGETHER A LARGE-FORMAT CAMERA, FISH-EYE LENS, PHOTOSHOP, AND LOVE OF FALLING, KNIGHT CREATES ONGOING CAMPAIGNS, INCLUDING A GALLIANO-INSPIRED HOMAGE TO JAPANESE MANGA CARTOONS. "[WE WANTED IMAGES] TOO LARGE FOR THE PAGE...IMAGES THAT THE MAGAZINES CAN'T QUITE CONTAIN, WITH

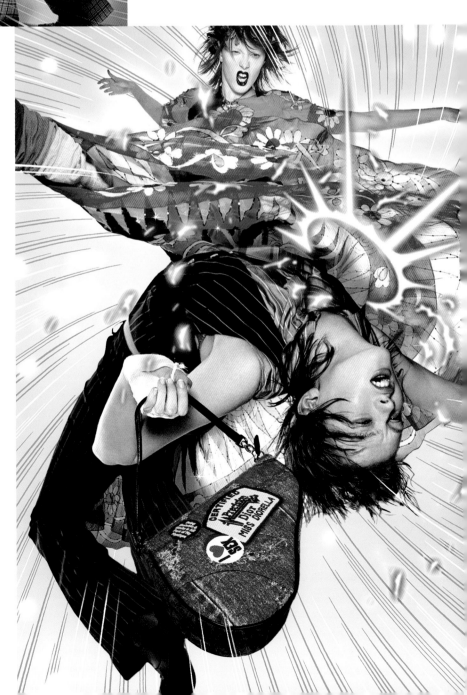

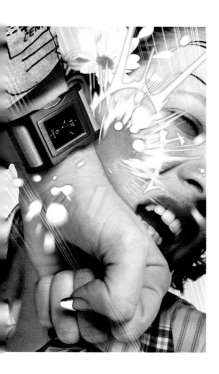

EXPLOSIVE ENERGY PUSHED IN THAT RE-EXPLODES OUT OF THE MAGAZINE AT YOU." GALLIANO DIDN'T WANT SEXY, WANTED SOMETHING "MAYBE EVEN VIOLENT," SO TOGETHER THEY DECIDED TO CREATE THREE "SUPERCHICK" CHARACTERS OUT OF FAVORED MODEL, KAREN ELSON. "KAREN'S ONE GIRL WHO WORKS REALLY, REALLY HARD UNDER TOUGH CONDITIONS OUTSIDE THE NORM OF MODELING, THAT OTHER GIRLS WOULD BE WEIRD ABOUT," SAYS KNIGHT. ELSON LEARNED FROM STUNTMEN HOW TO JUMP AND FLIP BACKWARD IN A BODY HARNESS—"PRETTY EXCRUCIATING WORK AND NOT COMFORTABLE EITHER." OF THE VIOLENCE: "WE WERE ORIGINALLY WORRIED ABOUT SHOWING A WOMAN BEING PUNCHED IN THE MOUTH," SAYS KNIGHT. "IT'S FINE FOR ME TO PLAY AT THIS FANTASY, BUT IT'S PROBABLY HAPPENING DOWN THE STREET." (GALLIANO SUGGESTED THE ADS BE SENT OUT TO FOCUS GROUPS AND, KNIGHT SAYS, PEOPLE LOVED THEM.) "MY HOPE IS ALWAYS TO TRY TO EMPOWER WOMEN—AND PUSH VISUAL LANGUAGE AS FAR AS I POSSIBLY CAN." TO RE-CREATE THE ELONGATED LIMBS AND HIGH-KICK CURVES OF MANGA, KNIGHT AFFIXED HIS 8 X 10 CAMERA WITH A 155 LENS, AND INSTEAD OF TRYING TO MAKE SENSE OF WHAT HE SAW THROUGH THE DISTORTED PINHOLE, HE TRUSTED THE SCENE BEFORE HIM, SHOOTING BLIND. "I HAD TO TEACH MYSELF TO STAND IN FRONT AND NOT LOOK THROUGH THE BACK." LATER, KNIGHT TOOK THE FRAMES OF DISTORTED IMAGES AND IMMERSED HIMSELF IN POST-PRODUCTION WITH RE-TOUCHER ALAN FINNAMORE. WORKING WITH FIVE OR SIX PHOTOGRAPHS AT A TIME, KNIGHT BUILT THEM UP "LIKE JIGSAWS" IN PHOTOSHOP, ERASING ELSON'S HARNESS, EXTENDING THE ANGLES AND LENGTHS OF HER LIMBS, REFINING AND SCULPTING. BACKGROUND IMAGERY, SPEED LINES, SKIN AND HAIR TONES WERE ADDED BY JAPANIMATION EXPERTS ADAM WARREN AND RYAN KINNAIRD, BOTH OF WHOM KNIGHT PURSUED FOR THE PROJECT AFTER SEEING THEIR WORK IN THE AMERICAN MANGA-STYLE MAGAZINE *THE DIRTY PAIR*. "THERE'S A CERTAIN FEELING WHEN YOU START TAKING PHOTOGRAPHS—YOU FEEL LIKE YOU CAN'T PHYSICALLY MOVE," SAYS KNIGHT. "AND I FIND, IF YOU CONTROL EVERYTHING. AND SAY IT'S GOING TO BE THIS LIGHTING AND IT'S GOING TO BE THIS WAY, IT'S NEVER GOING TO GET [PAST] THAT POINT. YOU'LL NEVER GET PAST THAT WALKING-THROUGH-TREACLE KIND OF FEELING." BE BRAVE ENOUGH TO LET GO, "AND THERE'S THIS WHOLE ENERGY THING THAT STARTS TO BUILD UP." SCRABBLING. FALLING, GRASPING—THEN FLYING. "AND YOU CAN ACTUALLY START TO THINK, SOMETHING IMPORTANT IS HAPPENING."

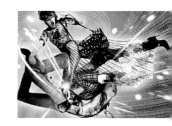

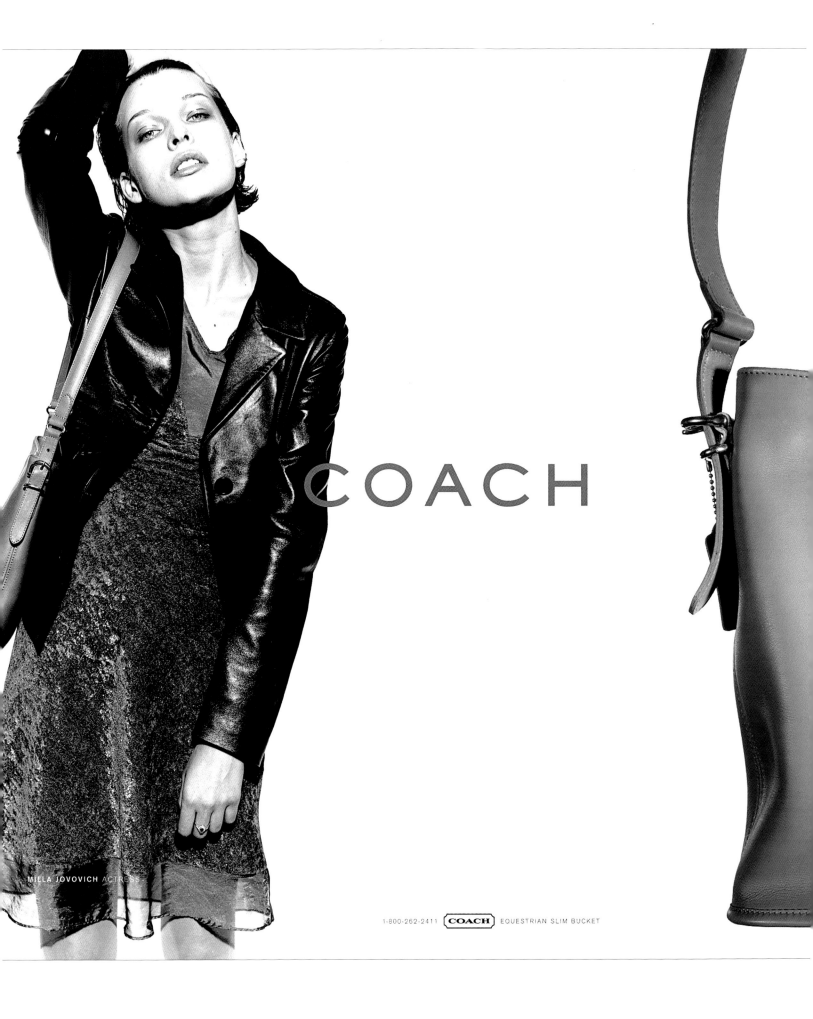

MILLA JOVOVICH ACTRESS

COACH

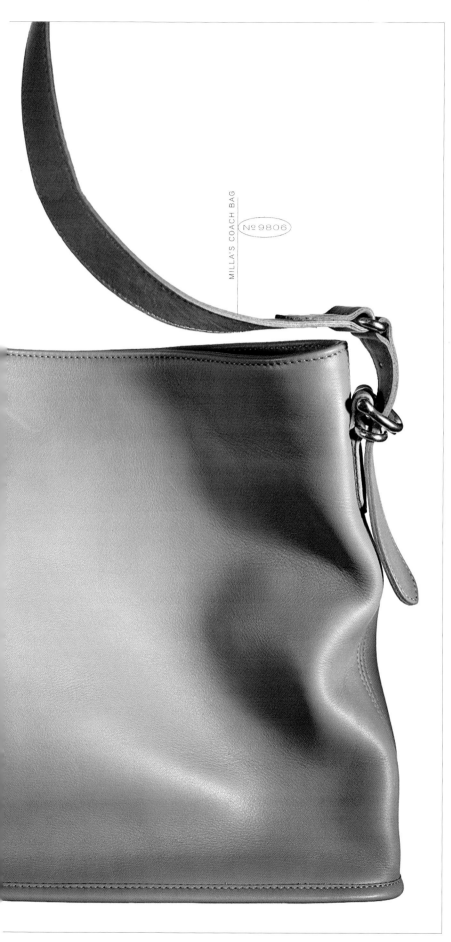

MILLA'S COACH BAG ⟨Nº 9806⟩

Photograph a woman in black and white to capture her spirit undisturbed by color. Show her next to a product cast in brighter hues, and a connection begins to snake through the image like a flashing needle. With this contrapuntal idea, Coach began its great turnaround from a 60-year-old American classic to the S L E E K E R product it would become. "We looked for women who embodied what we wanted to amplify—a great sense of personal style," says Coach's president and executive creative director, Reed Krakoff, who signed on such strong personalities as actresses Lara Flynn Boyle and Milla Jovovich, singer Cassandra Wilson, Soho arts pioneer Holly Solomon, and architect Felecia Davis, and hired cool-eyed Peter Lindbergh to photograph them. "Changing the image of your brand is a long process involving many steps," he adds. "It's easy to say you want to be updated and modern, but you have to have the imagery to back it up."

ADVERTISING

REED KRAKOFF

hands on entrepreneurship

TAKING THE HIGH GROUND, REED KRAKOFF CAN PAUSE TO SURVEY ALL COACH HAS BECOME SINCE HE CAME TO POWER. FURNITURE. CLOTHING. JEWELRY. HUNDREDS OF STORES IN 19 COUNTRIES, AND THE CREATION OF COACH JAPAN, A JOINT VENTURE WITH SUMITOMO, IN A LAND WHERE LABELS ARE AS VALUABLE AS GOLD. A CONCRETE THINKER WITH FLAIR AND A GIFT FOR THE LONG VIEW. KRAKOFF STARTED AS SENIOR VICE PRESIDENT AND CREATIVE DIRECTOR IN 1996. INHERITING AN ESTABLISHED DYNASTY, AND SHAPED IT TO HIS VISION—PROTECTING ALL THAT HAD BEEN MEMORABLY ACCOMPLISHED WHILE URGING IT TO YIELD TO THE TASTES AND PREFERENCES OF A NEW AGE: AN EDGY STYLE. UPDATED LOOK, AND A POSTMODERN. RETRO LOGO. BUT A NEW AMERICAN STYLE HAD TO BE REALIZED CAREFULLY AND FINESSED RESPECTFULLY BEFORE COACH'S TOWERING CORPORATE STRUCTURE. (THE SARA LEE CORPORATION OWNED COACH FOR YEARS.) TO EFFECT CHANGE, KRAKOFF HAD TO CONVINCE STOCK ANALYSTS, NAVIGATE POLITICAL WEBS AND RESEARCH-AND-DEVELOPMENT MAZES, MAINTAIN DAILY NUMBERS COMING OUT OF HIS STORES, AND KEEP HIS SOLDIERS IN LINE—WHILE NEVER LOSING SIGHT OF THE FINAL CREATIVE VISION. THE SEED OF THE BRAND WAS PLANTED 60 YEARS AGO, WITH SIX LEATHER ARTISANS WORKING IN A MANHATTAN LOFT,

MAKING DURABLE BAGS OF FINE QUALITY, USING SKILLS HANDED DOWN THROUGH GENERATIONS. WHEN KRAKOFF ARRIVED, FRESH OFF THE DESIGN LADDER BY WAY OF ANN KLEIN, RALPH LAUREN, AND TOMMY HILFIGER. HE HIT THE ROAD WITH PRESENTATION AFTER PRESENTATION. WOOING SPONSORS AND TRYING TO GET BUSINESS PEOPLE TO SEE THE WORTH OF COACH. KRAKOFF WAS ABLE TO EMBRACE EVERY CORNER OF THE LARGE. JUMBLED CONGLOMERATE AND UNIFY IT WITH A SERIES OF SMOOTH SWEEPS. TAKING WHITE-WALLED CORNERS OF DEPARTMENT STORES AND MAKING THEM DISTINCTIVELY COACH'S WITH DISPLAY DESIGN AND IMAGERY, SENDING OUT THICK BOOKLETS AND CATALOGS OF THE NEW COACH STYLE, OPENING

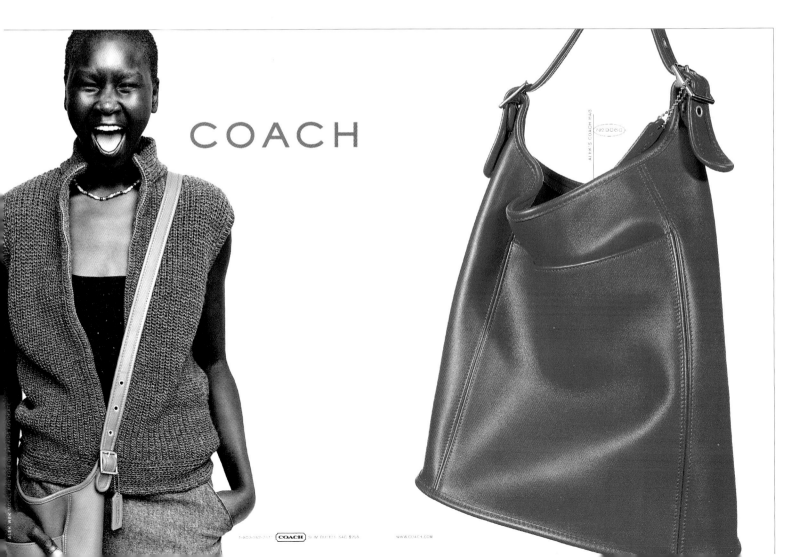

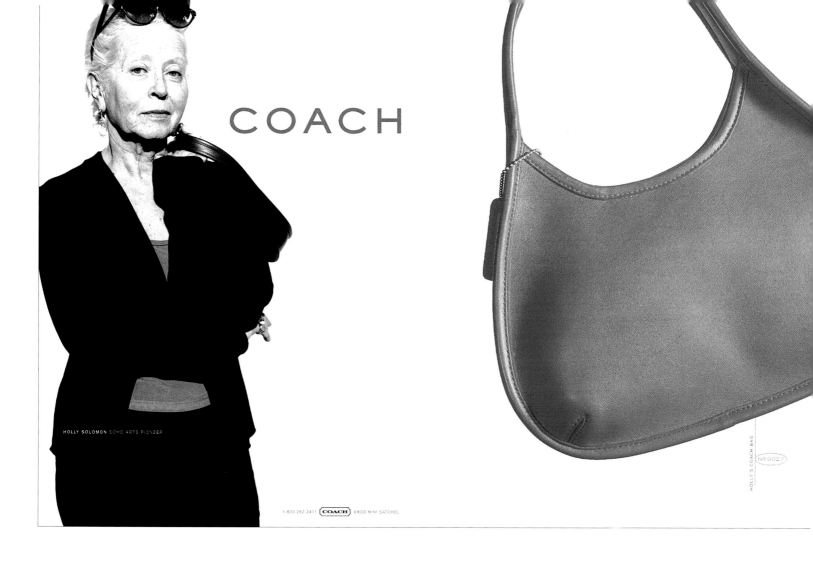

COACH

HOLLY SOLOMON SOHO ARTS PIONEER

1-800-262-2411 (COACH) ERGO MINI SATCHEL

HOLLY'S COACH BAG № 9027

COACH.COM, AND ORGANIZING A BLITZ OF PRINT ADS ON BUS STOPS, PHONE BOOTHS, BILLBOARDS, AND IN MAGAZINES, KRAKOFF RECOGNIZED, WITH THE APPEARANCE OF IMITATION COACH ON SOHO STREET CORNERS, THAT HIS BRAND HAD ARRIVED. "REED FIGHTS THE GOOD FIGHT EVERY DAY," SAYS JOANNE REEVES, CREATIVE DIRECTOR AT TOTH BRAND IMAGING WHO WORKED WITH KRAKOFF AND MIKE TOTH TO REPOSITION COACH IN 1996. "WITH OTHER BRANDS, [A DESIGN TEAM] CAN GO IN, AND LEAVE, AND THE COMPANY OFTEN REVERTS. HE TOOK WHAT WE STARTED, AND HE MADE SURE WHAT WE HAD CREATED CONTINUED TO GROW." KRAKOFF, NOW COACH'S PRESIDENT AND EXECUTIVE CREATIVE DIRECTOR, RECEIVED THE ACCESSORIES DESIGNER OF

THE YEAR AWARD IN 2000 FROM THE COUNCIL OF FASHION DESIGNERS OF AMERICA. OVERSEEING THE GRAPHIC DESIGN OF EVERY NEW HANDBAG, PIECE OF LUGGAGE, WALLET, PILLOW, AND GLOVE TAKES ITS CREATIVE TOLL. "I LOOK AT [A POTENTIALLY NEW PRODUCT] THIS WAY: IT HAS TO BE SOMETHING NO ONE ELSE IS DOING," SAYS KRAKOFF. "I DO IT ONLY IF THE PRODUCT OFFERS A NEW POINT OF VIEW." "FOR A TRADITIONAL HANDBAG MAKER, IT'S A TOUGH LEAP INTO SOMETHING ELSE, I.E., JEWELRY, EYEWEAR, OR FRAGRANCE. AT WHAT POINT IN OUR DEVELOPMENT DO WE DO THAT? WHERE ARE WE, AT WHAT TRAJECTORY, AT WHAT POINT IN TIME IN THE LIFE OF THE BRAND?" SAYS KRAKOFF. "YOU JUST DON'T DO ANYTHING FOR THE SHORT TERM."

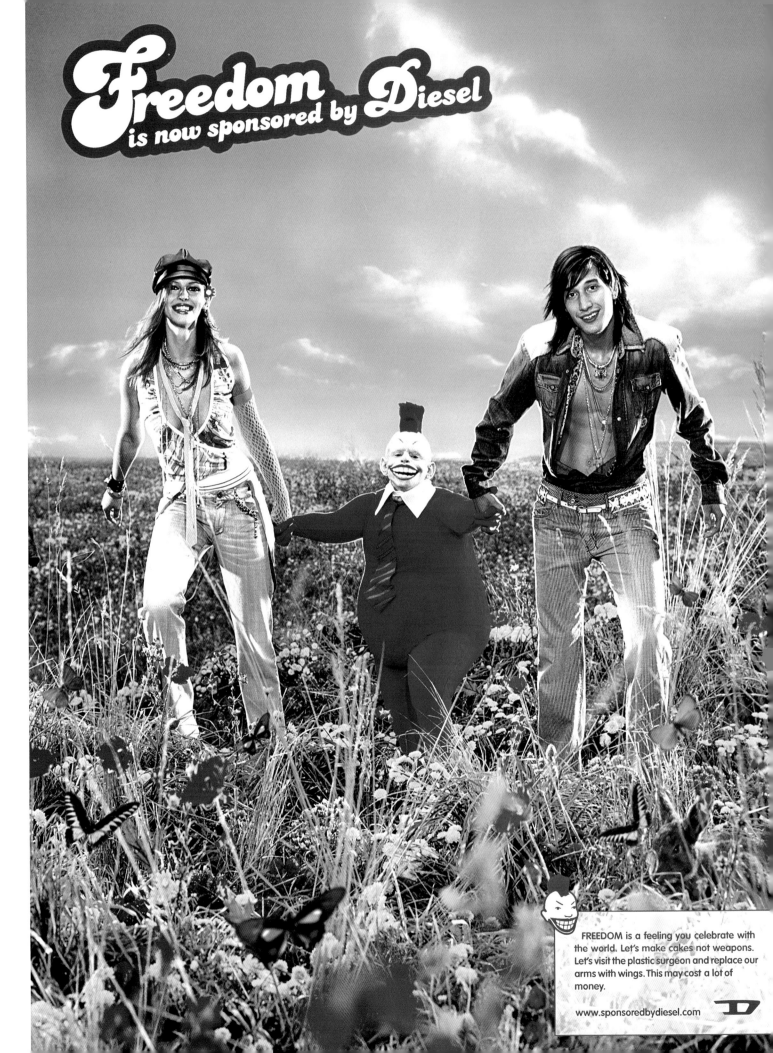

diesel

Advertising campaigns at Diesel last about as long as a tank of gas, but each leaves a memory as strongly evocative as the smell of jet fuel that hits the moment you step out of a cab at JFK. Winter 2002 spawned Donald the Clown and his postmodern Happy Valley, offering every manipulative emotion, urging the reader to choose one, or be chosen for. "The strategy stimulates people into thinking about what are real values until they realize, 'no one can sell me values, I can decide for myself' says Diesel's Director of Marketing Maurizio Marchiori,'" Ever VIGILANT FOR HYPOCRISY or over-30-type behavior, Diesel removed all its own logos for the campaign. Shot in Prague by Carl-Johan Paulin, the color-saturated Candyland was sugar-spun by Diesel's creative team in Modena, Italy, and Amsterdam-based advertising boutique Kesselkramer. "Diesel is not my company, it's my life," founder Renzo Rosso is fond of saying. "In the end," adds Marchiori sincerely, "you can also wear good clothing."

ADVERTISING

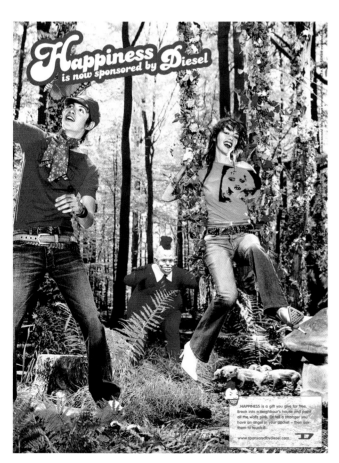

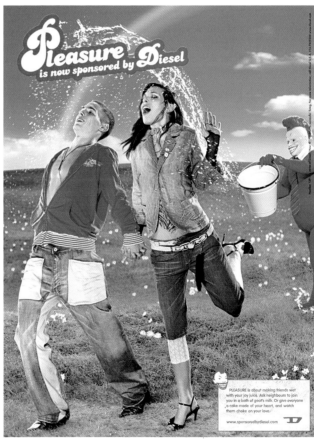

donald the clown Donald, you old scamp. With your bright red Mohawk and Imitation of Ronald costume, you lead innocents through the gardens of Happy Valley, knowing full well you intend to rip them off and slide that old plastic through the machine first chance you get. SELLING HAPPINESS ARE YOU? What else do you have in that brightly lit glen? Excitement, joy, passion, pleasure, fun, romance, desire, and more, you say. All there for the picking. Nicely commandeered off the Pied Piper of corporate America.

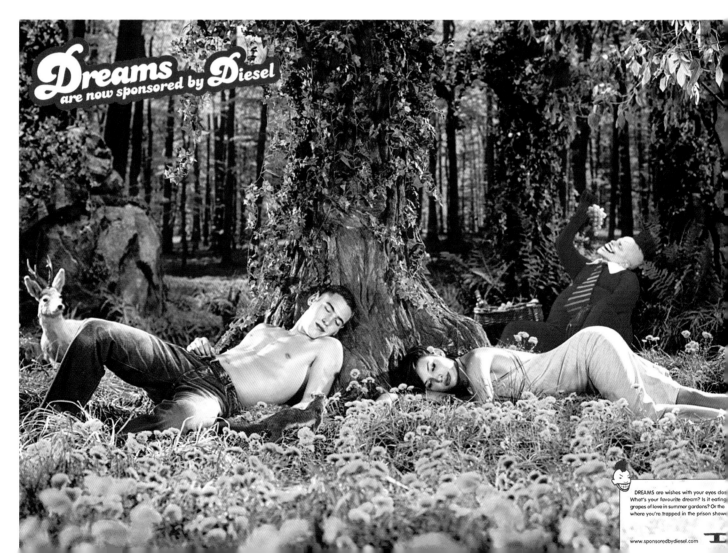

DREAMS are wishes with your eyes clos
What's your favourite dream? Is it eating
grapes of love in summer gardens? Or the
where you're trapped in the prison showe

www.sponsoredbydiesel.com

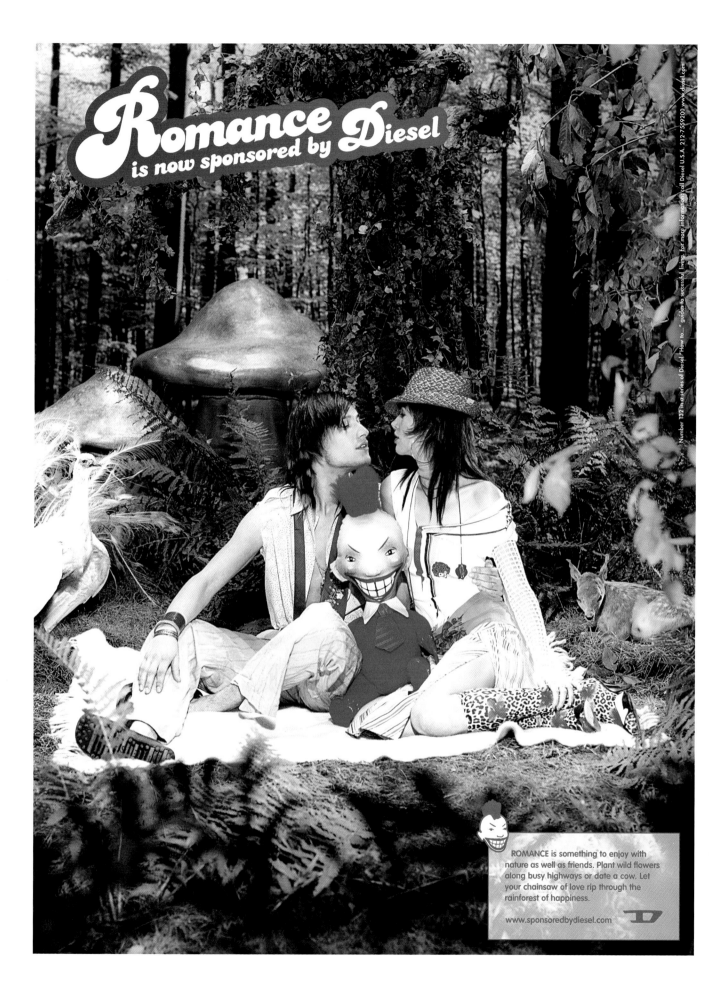

collateral

The seductive souvenirs that lie side by side with a body of a brand—the label, the model, the store—subordinate but essential, each one adding a dimension and richness in tone. Jack Spade's documentary on paperboys. John Varvatos' limited edition, hand-sewn brochures. Cynthia Rowley and Ilene Rosenzweig's *Swell* little book about the good life.>

page 046-047

THE POWER OF COLLATERAL TELLS THE BRAND'S TALE LIKE A FLICKERING SUPER-8 MOVIE, OFFERING UP HOMESPUN DETAILS THAT FLESH OUT A STORY FOR A SUSTAINED TIME—10 MINUTES, INSTEAD OF THE FLEETING SECONDS OF PRINT. THE MAGAZINE'S $150,000 DOUBLE-PAGE SPREAD NEEDS TO PACK AN EMOTIONAL PUNCH, BUT THE GIFT AT THE CASH REGISTER CATCHES A QUIETER ATTENTION, ACCENTS THE SHOPPING DAY WITH A GOING-AWAY PRESENT, A REMEMBRANCE THAT THE MEETING WAS SPECIAL. BROCHURES TUCKED INTO SHOPPING BAGS TO BE READ ON THE WAY HOME. AND MAILING LISTS LEAD TO WEB SITES AND THE BRAND IN ITS UNINTERRUPTED UNIVERSE. MAGALOGS ARRIVE IN THE MAIL, AWAITING AN EXTENDED PRIVATE CONVERSATION. ESPECIALLY IMPORTANT FOR COMPANIES THAT HAVE NO RETAIL SPACE, COLLATERAL BECOMES THE ONLY PLACE TO GROW, AND SO THEY EVOLVE THROUGH CATALOGS. AS PART OF THE CULTURE, RAISING ABOVE THE FRAY ONE SET OF VALUES THROUGH A STORY LINE.

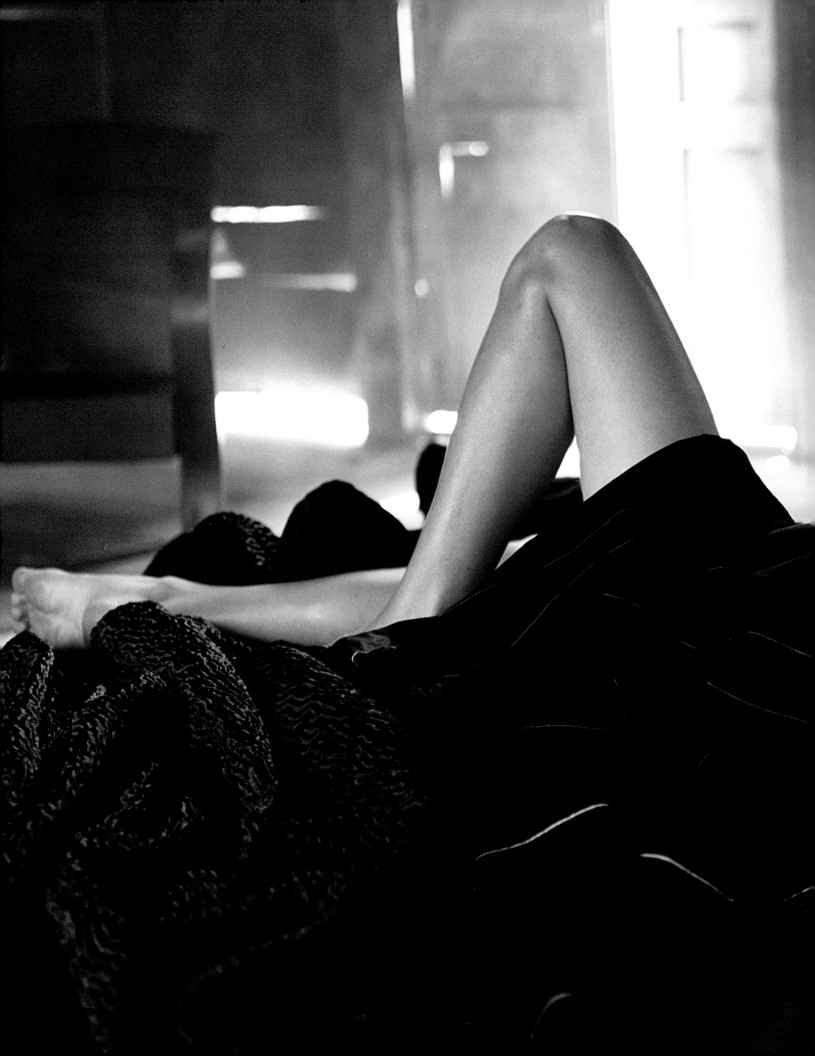

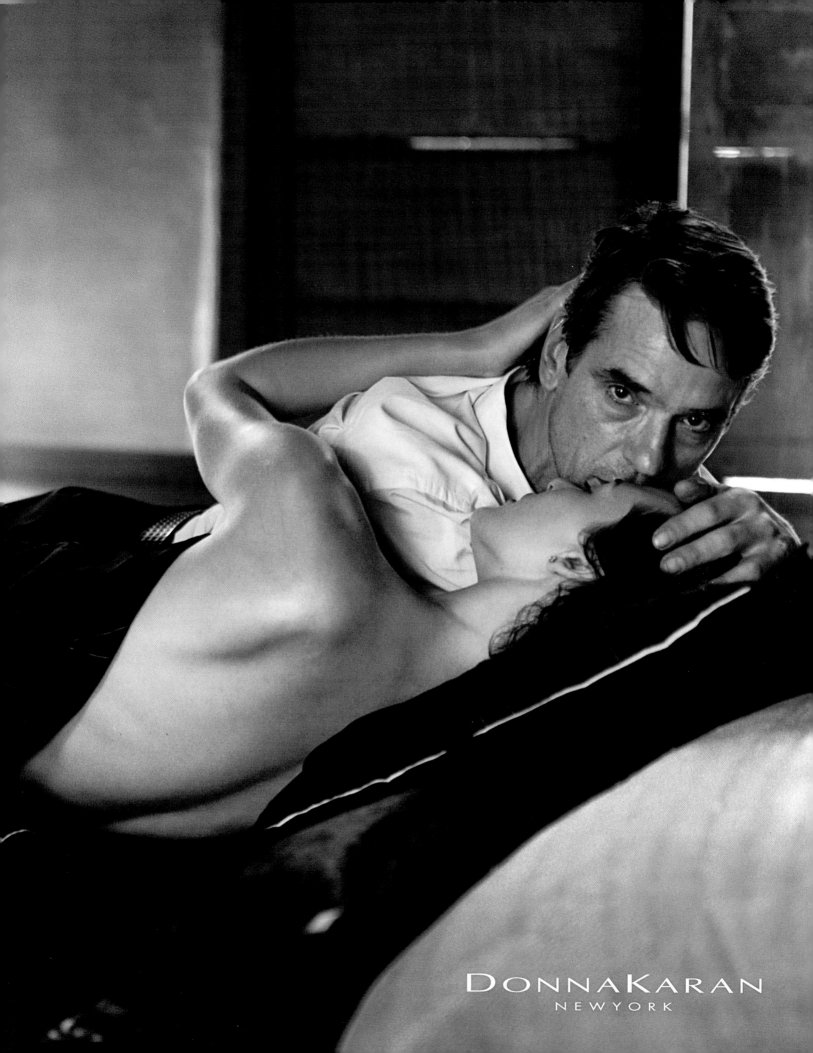

DONNAKARAN
NEW YORK

Like a silent movie, magalogs tell their flipbook stories of beauty and desire in a smooth continuous flow, bringing action as a complement to the billboard's stationary grace.

WOMANto WOMAN.

	2
	3
1	4

page 050-051

1	4	7	10
2	5	8	11
3	6	9	12

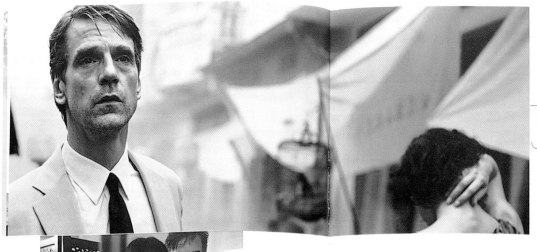

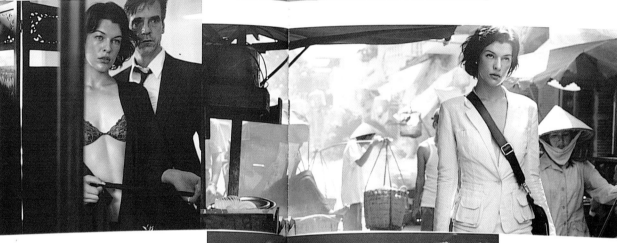

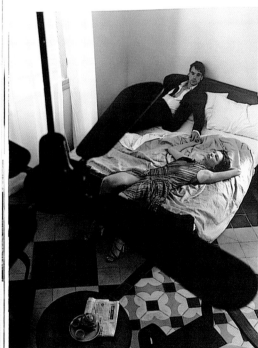

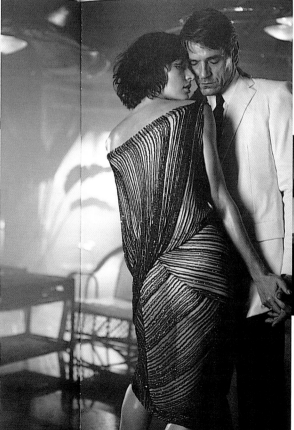

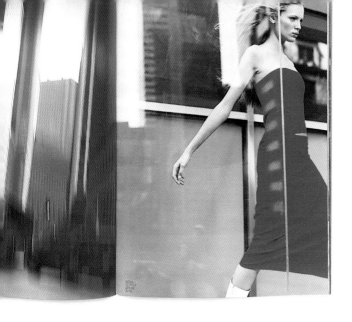

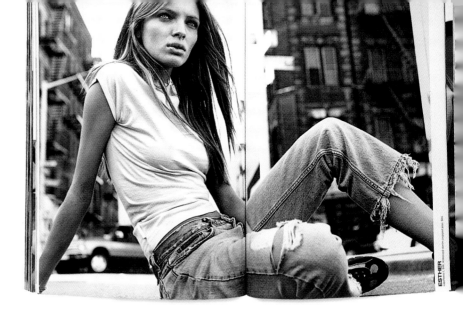

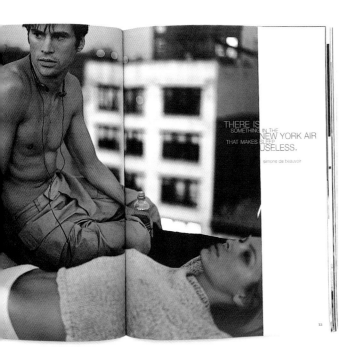

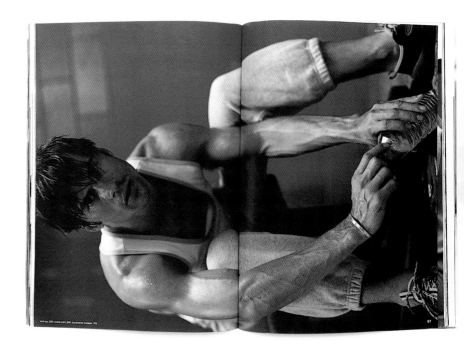

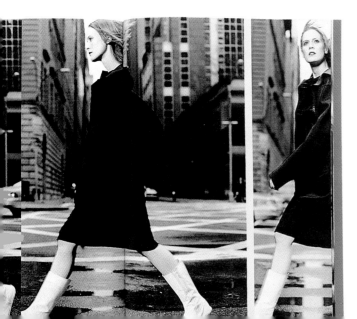

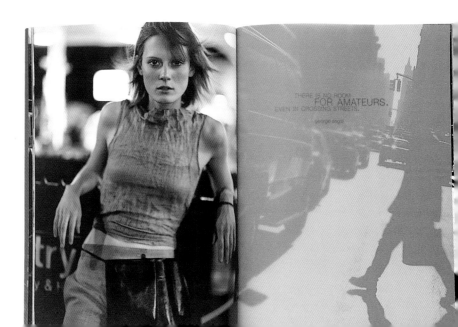

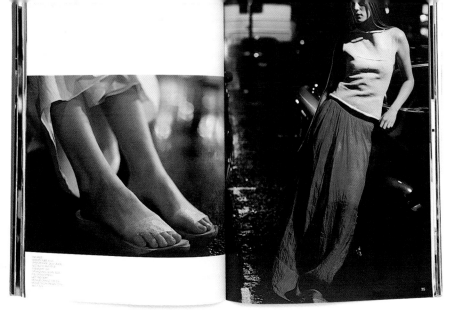

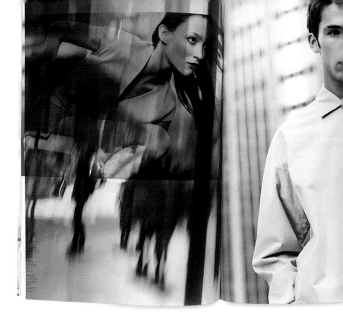

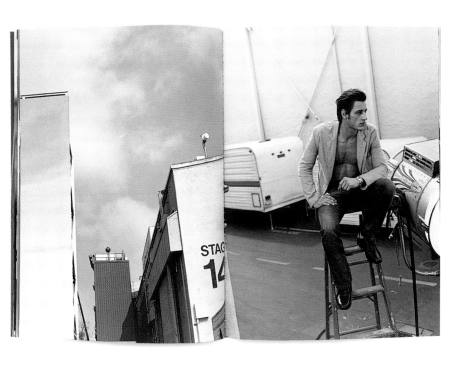

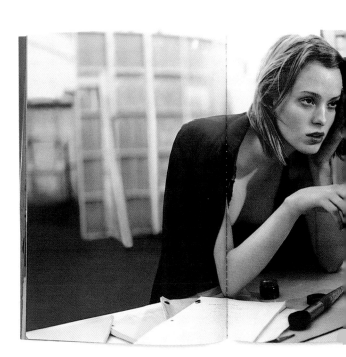

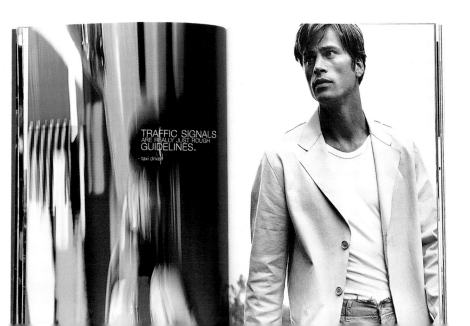

TRAFFIC SIGNALS
ARE REALLY JUST ROUGH
GUIDELINES.
- taxi driver

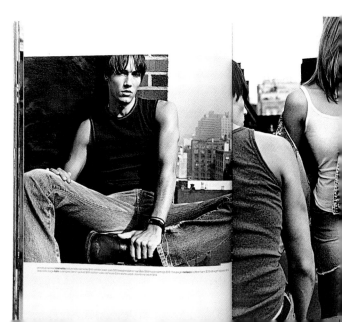

TREY LAIRD
creating relevance

"I CAN SEE THINGS CLEARLY, FROM ONE STEP TO ANOTHER, AND I CAN PUT THEM TOGETHER. I CAN LOOK AT A PRODUCT AND THINK, 'WHAT'S THE STRENGTH? WHAT'S THE STORY? WHAT'S THE MESSAGE?'"

COLLATERAL

HIS GREATEST SKILL IS PIERCING THE FOG. TREY LAIRD, CREATIVE DIRECTOR PAR EXCELLENCE, ORCHESTRATES FASHION PRODUCTION FROM THE DESIGNER'S DREAM, WAITING PASSIVELY ON A ROW OF HANGERS, TO A FULLY FLESHED ADVERTISING PERSONA. IT IS AN EVOLUTION THROUGH SEASONAL CAMPAIGN VISIONS COMPLETE WITH STYLISTS, MODELS, AND LOCATIONS AND PRODUCED THROUGH MANY PUBLIC OUTLETS—BILLBOARDS, PRINT ADVERTISEMENTS, STORE LAYOUTS, TELEVISION COMMERCIALS. FOR THIS MULTITASKING, TWO-HEADED WORK—WHICH RELIES ON BUSINESS ACUMEN AS HEAVILY AS IT DOES ON CREATIVE ENERGY—LAIRD CONTINUOUSLY FALLS BACK ON HIS GIFT OF DISCERNMENT. "YOU NEED TO TRUST YOUR EYE AND USE IT," HE SAYS. "WHATEVER IS PUT IN FRONT OF YOU: YES. NO. LOVE IT. HATE IT. THAT'S WHAT I DO, ALL DAY LONG. AND IT HAS SERVED ME WELL." WELL ENOUGH FOR LAIRD TO LIVE THE ALL-AMERICAN DREAM: AFTER 10 YEARS AS CREATIVE DIRECTOR FOR DONNA KARAN, HE IS IN BUSINESS FOR HIMSELF. AS PRESIDENT AND EXECUTIVE CREATIVE DIRECTOR OF LAIRD + PARTNERS, AN ADVERTISING, CREATIVE BRANDING, AND MARKETING COMPANY INCORPORATED IN FEBRUARY 2002, LAIRD CONTINUES TO REPRESENT THE DONNA KARAN COLLECTION AND DKNY AS WELL AS THAT OTHER ALL-AMERICAN APPAREL HOUSE, THE GAP. DREAMLIKE, INDEED. "BRANDS HAVE AN ESSENCE, A POINT OF VIEW, FEELINGS, STYLE, AND SENSIBILITY—LIKE A PERSON," SAYS LAIRD IN A VOICE THAT HINTS OF A SMALL-TOWN TEXAS CHILDHOOD. "YOU'VE GOT TO KNOW THAT PERSON. AND YOU PLAY IT OUT. THE BEST BRANDS CONSTANTLY MOVE FORWARD, ALWAYS WITHIN THEIR PERSONALITY. THEY ARE CLEAR AND CONSISTENT, WITHOUT BEING REPETITIVE OR BORING." IN THE SPECTACULAR CIRCUS OF SELLING FASHION, THE CREATIVE DIRECTOR—GOAL ORIENTED, BUDGET SENSITIVE—DRIVES THE IMAGERY FORWARD THROUGH A SERIES OF DETAILED DECISIONS, WITH ONE EYE FOREVER FIXED ON THE OUTSIDE WORLD. FOR IF THE BRAND'S PERSONA DOES NOT STAY RELEVANT TO THE REAL WORLD, IT DIES. BALANCING ART AND LIFE IN HIS HANDS, LAIRD WALKS THE TIGHTROPE OF ABSOLUTE DEADLINES. CASE IN HAND: HE DREAMED TO PUT ACTORS JEREMY IRONS AND MILLA JOVOVICH IN VIETNAM TO VIVIFY DONNA KARAN'S SULTRY SPRING 2001 COLLECTION. NEAR IMPOSSIBLE TO ORCHESTRATE, LAIRD SUCCEEDED IN SETTING AND STYLING THE COMPLEX PRODUCTION IN HO CHI MINH CITY. "YOU HAVE TO STEP OUT OF YOUR OWN HEAD AND DREAM," HE SAYS.

"BUT YOU ARE ALSO THE ONE RESPONSIBLE FOR MAKING SURE IT HAPPENS, WITH EACH NEW SEASON, FOUR TIMES A YEAR."

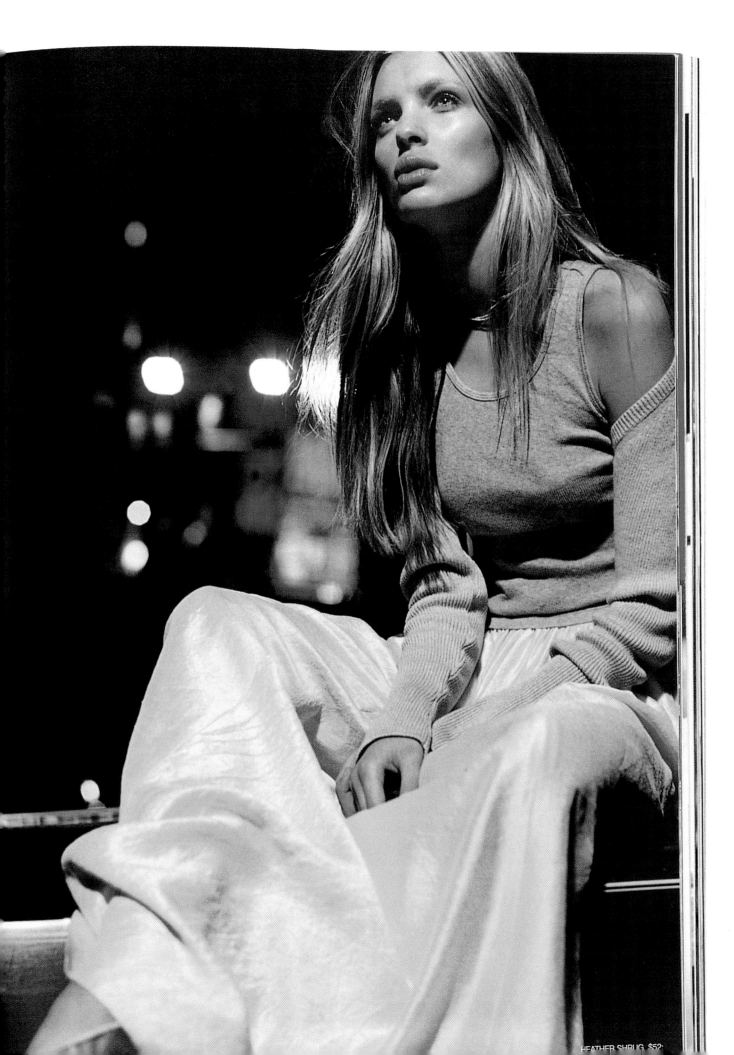

HEATHER SHRUG, $52

john varvatos "We wanted something…ALMOST IMPERFECT, done by hand, with an old-world, hand-crafted spirit." Photographed in deep sepia tints on heavy vellum paper with an uncoated matte finish, and hand-bound in wax thread, John Varvatos' 12-page limited-edition catalogs are an artisan's work of art, reflecting a master's style. The photography and quality of the brochure capture what Varvatos cares most about in his American menswear line: "the hand worked, hand finished quality of the clothes." Varvatos uses materials faithful to the brand—the same dense thread that binds the booklet can be found on Varvatos' belts and satchels—and pays undivided attention to surface details to create a luxury mailing for an exclusive brand, delivered to Barneys' customers all over the country.

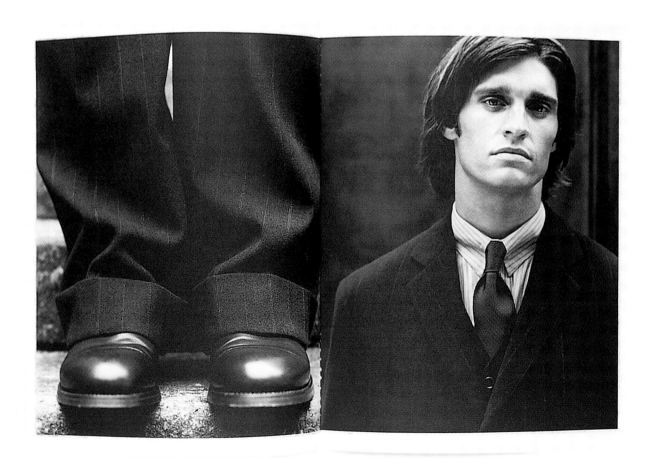

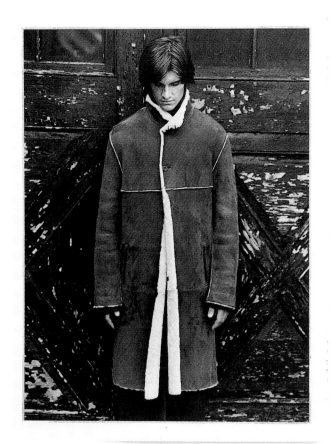

Style

Not just another pretty dress

abulousness, darling! It's all about peplums and shoulder pads. Chartreuse is the new black this season. A bateau neck with a three-quarter sleeve on a five-eighths coat with a full-circle skirt? Forbidden! Leopard is my passion this spring. Fashion tortures us, yet it makes us weep. . . .

YIKES! Scary fashion divas dictating musts and nevers are enough to make you want to pull a muumuu over your head and whimper, *Why bother?*

Because you feel like a million bucks when you look like it. The dictionary defines the original swell as a "person of distinction or ability, first-class person, member of good society, person of dashing or fashionable appearance." They're the people Cole Porter wrote songs about and Fred Astaire dressed and danced in the image of. Subsequent swells kept the tradition alive by paying fastidious attention to the cut of a jacket, a cuff link's polish. Porter wore eighteen-karat-gold collar stays. Cary Grant would measure the lapels of his suits with a ruler and send them back to the tailor if they were even an eighth of an inch off. "It takes five hundred small details to make one favorable impression," he said. Frank Sinatra's advice? Avoid sitting down and you won't wrinkle your pants. This wasn't just to impress dames. They did it for themselves, taking deep pleasure in superficial wardrobe details. Ladies, take note.

Being well turned out means luxuriating in your clothes, dressing up any room you walk into. Some say you have to be born with style. *Pshaw.* Think of your closet the way a designer puts together a show: storming through outra-

Swell—some word: a door opener to Asta, *My Man Godfrey*, dark purple nails, and crimped hair. It's a swell night and you threw a swell party. Your fellow's swell, and so are you! *Swell, A Girl's Guide to the Good Life* was born one night at the after-party of a Cynthia Rowley fashion show, the fantasy world of Rowley and long-time friend and style writer Ilene Rosenzweig. They are *Swell*, books of real-life anecdotes and handy how-tos, written in the rapid-fire, arched-eyebrow style of a Thin Man-Woman shot through with preppy zeal. *Swell*, the magical combination of two girlhoods: Rowley's in Barrington, Illinois, where mud sledding through potato fields was, well, a swell idea, and Rosenzweig's more confined Manhattan roots—SHOOTING ROUNDS OF SHIRLEY TEMPLES at the Russian Tea Room. The *Swell* girl is always game for the next adventure—learning a new language or getting off the highway at an unknown exit. She leaves life a little richer, a little prettier, a little more fun, and a little more action-packed than she found it. And sometimes, a swell new lipstick is all ya need. How *Swell* has grown—calendars, day planners, TV shows, home accessories, party goods, and a tip-of-the-month column in Glamour. And *Swell*? Thou swell too!

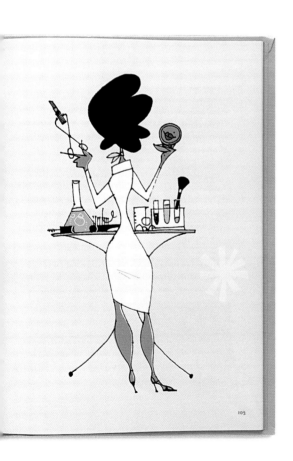

103

92

Prisoner of Seventh Avenue

Ilene: Friendship has its privileges. Many a time Cynthia has prepped me for the b
interview, big date. I'll arrive at her showroom on Seventh Avenue, look around thi
nothing that seems right for the occasion, then she blitzkriegs through the sample ra
together the just-right outfit I never would have seen. Of course, the downside of her
is that I can't get away with any of my miscreant fashion behavior. Just try showing
HQ in a pair of last season's glassphalt gray pants, now baggy in the butt. Her eyes
you get rid of those!" But I've learned a thing or two from my fashion parole office

Lose the jewelry

I used to get dressed, comb my hair, then put on my jewelry—all of it. Graduatio
chain from Mom, the zirconium studs Aunt Sheila gave me. When Cynthia would
up, I'd ask, "How do I look?"

"Great," she'd say, "but maybe leave out the necklace, and how would it loo
bangle bracelets?" For years, she wouldn't let me wear jewelry at all. (Meanwhil
show there were beaded hoops that reached down to the shoulder and that was OK.
a point: Wearing your whole jewelry box can make you look like a Christmas tree.

Wear sexy shoes

Countless times I would try on a dress and hear Cynthia say, "Cuuuute—with a pair
shoes." Not sure what that meant, I'd go out and buy yet another pair with chubby he
soles. Ugly shoes were my compulsion. Finally, Cynthia dragged me by my ear to
explained the facts of shoes: sexy ones have slender heels, pointy toes, and are "strap
Sure, there's a place for chunky platforms, and the Japanese clogs she's been wear
sexy in an offbeat way. But with sex and shoes sometimes you have to be direct, ask

Mess things up, roll things up

Cynthia always has a way of looking kind of neat yet casual at the same time. Thi
ed, is because she rolls things up—tube socks, the bottom of a T-shirt. And to keep
too prissy, she'll mess something up—push up the sleeves of a sweater with an eve
roll down the elastic smocking of a big red sun dress, and wear it like a skirt with
only to reappear later with it rolled back into a dress.

Break up the set

Trying to look put together, the temptation is to try to wear things that go together. In
when Cynthia and I are getting ready to go out, she'll hold up, say, a fleur-de-lys halter
"How 'bout this?" Instinctively, I grab for the matching jacket nearby, but she's not in
trying too hard. Just because it goes, doesn't mean it goes. "Because then it's an
ensemble," she explains, as if those were dirty words. So sometimes if it goes . . . it

marc jacobs Juergen Teller, Sofia Coppola, and Marc Jacobs sell perfume by taking a quasi-serious, quasi-erotic road trip; one, it seems, everyone wants to ride. Tight frames and washed-out, back-lit color diffuse the imagery of a pale young woman, her white legs scissoring the swimming pool's shadowy water; her lucent, sun-warmed feet resting on the dash of a car. Always alone, rarely smiling, quietly happy. The sun causes her to squint as it warms her fragile back. Occasionally, gardenias scatter the pool. More frequently, a bottle of PERFUME APPEARS IN THE SCENE, LIKE A LOVER: in her unmade bed, in her arms, in the pool. World-class German photographer Juergen Teller first evidenced his knack for capturing a woman's thoughts and feelings through her un-made-up eyes and unrehearsed body in *Go-Sees*, his book of 400 frames of would-be models who came knocking at his door, hoping for photogenic fame (many succeeded, most did not). Juergen took the designer's muse Sofia (director, designer, daughter) on a journey along the California coastline, from Big Sur to Napa, promising pictures of an ad campaign on his return. No stylists, no art directors, just the synergy of four elements: Marc's trust, Sofia's character, Juergen's eye, and the perfume, a scent of freshly cut gardenias floating on water. The only time Sofia smiles is when Juergen's feet are also floating in the water, caught in a voyeuristic glimpse by the camera's eye. Suddenly, the realization sets in that this is a perfume advertisement, not a remake of *Two for the Road*. She breaks character and laughs, inviting us to laugh with her. I mean, it's just perfume. Isn't it?

MARC JACOBS
PERFUME

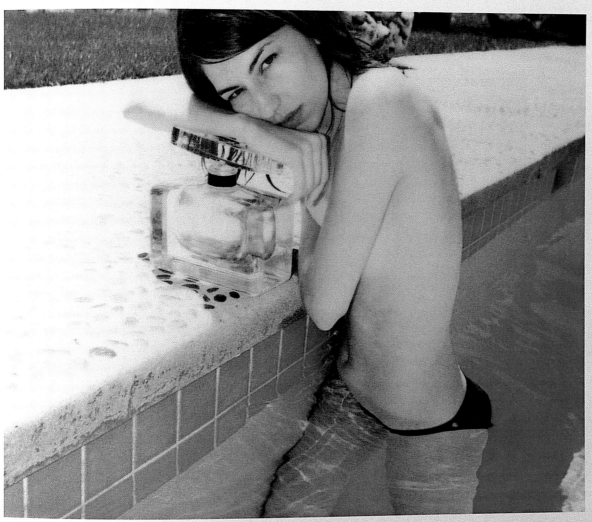

SOFIA COPPOLA PHOTOGRAPHED BY JUERGEN TELLER
DESIGN BY MILES MURRAY SORRELL FUEL

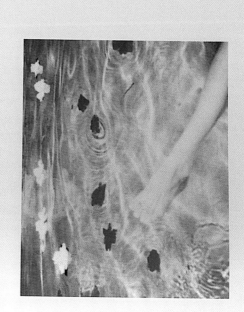

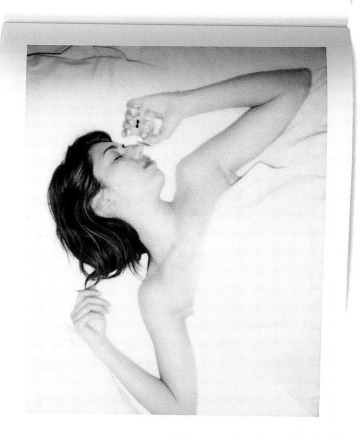

JACK SPADE PRESS ■

0001

We began JACK SPADE PRESS at a restaurant in lower
Manhattan. Sitting around the table, the conversation moved
from indoor plants and Marfa Texas, the Booker Prize and
Heavy Metal Parking Lot, to barbershops and newspapers.
We spoke a lot about our favorite newspaper columns—how
we read them first no matter how obscure they were to
find, how much we'd anticipate the next week's feature, and
our reactions to a disappointing offering. The columns we
all loved shared certain qualities—they took one idea
and covered it without hyperbole or superfluous language.
They possessed honest information—the police blotter or the
article which simply conveyed an overheard conversation.
Our goal with JACK SPADE PRESS was to capture some
of the appeal of those great newspapers and document them
in one place.

We have filled JACK SPADE PRESS with everything from
books to art to what one New Englander is willing to swop for
an Old Towne Canoe. All the things we like. Unfortunately,
this does not translate well into a pithy statement about what
you will find each time you open an issue. But, that's okay.
The world is crowded and time is scarce. In short, JACK SPADE
PRESS is an edited newspaper in a wonderfully congested
world. Which means you can read it front to back during the
previews at the Angelica, or at a stoplight on your way out of
town, or possibly even the ounce of time there is between
new Starbucks openings. In other words, it's all the news that
fit to print that you have time to read.

— ANDY SPADE

KATE AND ANDY SPADE

living the brand

"HER CONDUCT AT THE DINNER PARTY THAT NIGHT SEEMED STRANGE,"
READS THE NARRATOR. "'HOW FAR THAT LITTLE CANDLE THROWS ITS
BEAMS!'" WHEN PUT ON HOLD AT THE CORPORATE OFFICES OF ACCESSORIES
DESIGNERS KATE AND ANDY SPADE. THE PHONE TRANSFERS OVER TO AN
AUDIO RECORDING OF A JOHN CHEEVER STORY. SUSPENSION IN CHEEVER'S
FICTION IS NO COINCIDENCE, FOR THE SPADES ARE GUIDING THE CALLER TO
THE CENTER OF THEIR DREAMING BRAIN: A PLACE WHERE MIDDLE-CLASS
AMERICANS RISE TO LEVELS OF EMOTION AND BEAUTY THROUGH ACTS OF
GENTLENESS AND RESTLESSNESS.>

EVERY DETAIL OF THEIR ENVIRONMENT IS FASHIONED TO BUILD A PERSONAL NARRATIVE THAT BUYERS FIND IRRESISTIBLE. THE WRISTS THAT HOVER OVER KATE SPADE STATIONERY ARE FRAGILE; BRIGHT TEARS ARE HIDDEN BRAVELY BEHIND KATE SPADE SUNGLASSES; THE SCENT OF HONEYSUCKLE FLOATING IN ON AN EVENING BREEZE IS ALSO THE TOP NOTE IN KATE SPADE PERFUME; AND "HOW DIFFICULT IT WAS TO GET THE DAIMLER STARTED ON A RAINY DAY!" WHEN THE SPADES, ANDY FROM MICHIGAN AND KATE FROM MISSOURI, DEBUTED A LINE OF SIMPLY SHAPED, BRIGHTLY COLORED FABRIC HANDBAGS IN 1992, THEY WERE ALONE SAVE FOR PRADA'S EQUALLY UNORTHODOX BLACK NYLON OFFERINGS. KATE SPADE HAS SINCE BOOMED, AND NOW INCLUDES LUGGAGE, PAPER, SHOES, EYEWEAR, BEAUTY, KATE SPADE HOME, AND A SEPARATE MEN'S ACCESSORIES LINE, JACK SPADE. TENDING THIS $70 MILLION ENTERPRISE REQUIRES ALL THEIR FOCUS. EVERY POINT OF CONTACT MATTERS TO THE SPADES, WHO, FITTINGLY, MET WHEN BOTH CHOSE TO WORK IN A HABERDASHERY STORE. AND HEREIN LIES THEIR STRUGGLE: THEY DO NOT WANT TO BE LIKE ALICES IN WONDERLAND, CLUMSILY KNOCKING DOWN A FRAGILE HOUSE OF CARDS TO FEED THE MARKET'S EVER-WIDENING MAW. "NO BRAND GOT BIGGER AND GOT BETTER," OBSERVES ANDY.

"NO ONE EVER SAID: 'THEY GREW TO A HUNDRED MILLION AND YOU KNOW WHAT? THEIR DESIGN PRODUCT IS MUCH BETTER THAN IT WAS!'" SUCCESS HAS COME FROM SELLING WHAT THEY KNOW—AND WHAT THEY KNOW IS WHO THEY ARE. KATE IS REMINISCENT OF A MOMMY FROM ANOTHER TIME: PRETTY, TIDY, COMFORTABLE IN A TWIN-SET AND PEARLS. ANDY IS HANDSOME, WITH THE GOOD LOOKS OF SOMEONE WHO COULD FIX A BIPLANE IN AN EMERGENCY. TOGETHER THEY MANAGE EVERY DETAIL: AN EAMES INSTALLATION IN THE FOYER, LIVE CRICKETS FOR AMBIENT SOUND, A CLEANING-MAN'S BOW TIE. SUCCESS HAS ALSO COME FROM REFUSING TO SELL WHAT THEY NEITHER KNOW ABOUT NOR LIKE, SUCH AS THE LATE-90S, VELCRO-STRAP, OVER-THE-HEART BAG. "EVERY STORE IN THE WORLD SAID TO

No. 003

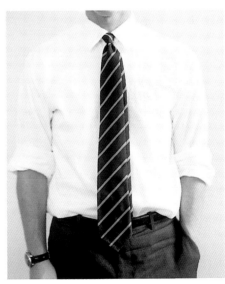

No. 0010

KATE, 'WELL, YOU HAVE TO DO A BODY-BAG, EVERYONE'S BUYING BODY-BAGS,'" SAYS ANDY. "AND KATE SAID, 'I THINK THEY'RE UGLY AND I'M NOT GOING TO MAKE ONE, AND IF EVERYONE ELSE IS MAKING ONE WHY DO YOU NEED ONE FROM ME?' AND EVERYONE SAID, 'YOU MISSED A MILLION DOLLARS IN BUSINESS BY NOT DOING THAT.' AND KATE REPLIED, 'BUT AT LEAST THEY KNOW I'M NOT TRYING TO BE EVERYTHING.'" PUTTING YOURSELF IN EVERY DETAIL HAS ITS DOWNSIDE. SAYS ANDY: "SHE GETS EXCITED WHEN PEOPLE BUY HER THINGS: SHE HATES IT WHEN THEY DON'T. SHE TAKES IT VERY PERSONALLY WHEN WHAT'S SHE'S DOING ISN'T RELEVANT." SAYS KATE: "IF EVER I'M IN A BAD MOOD. ANDY SAYS, 'C'MON, IT'S BEEN PRETTY GREAT. EVEN IF EVERYTHING WENT AWAY, IT'S BEEN A GOOD RIDE.'"

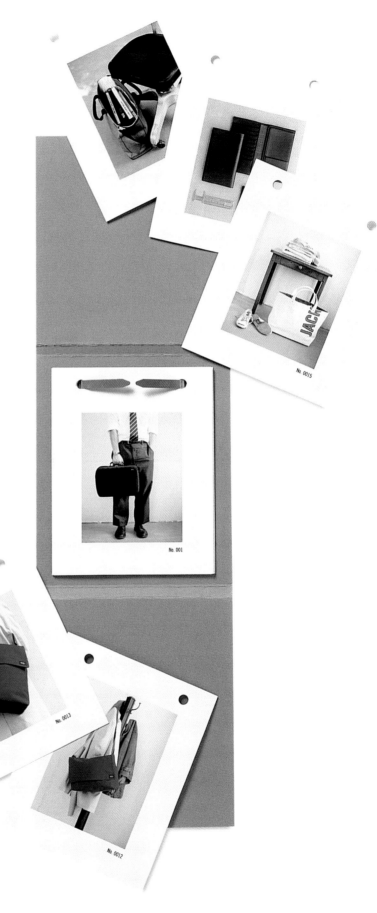

No. 0015

No. 001

No. 0013

No. 0012

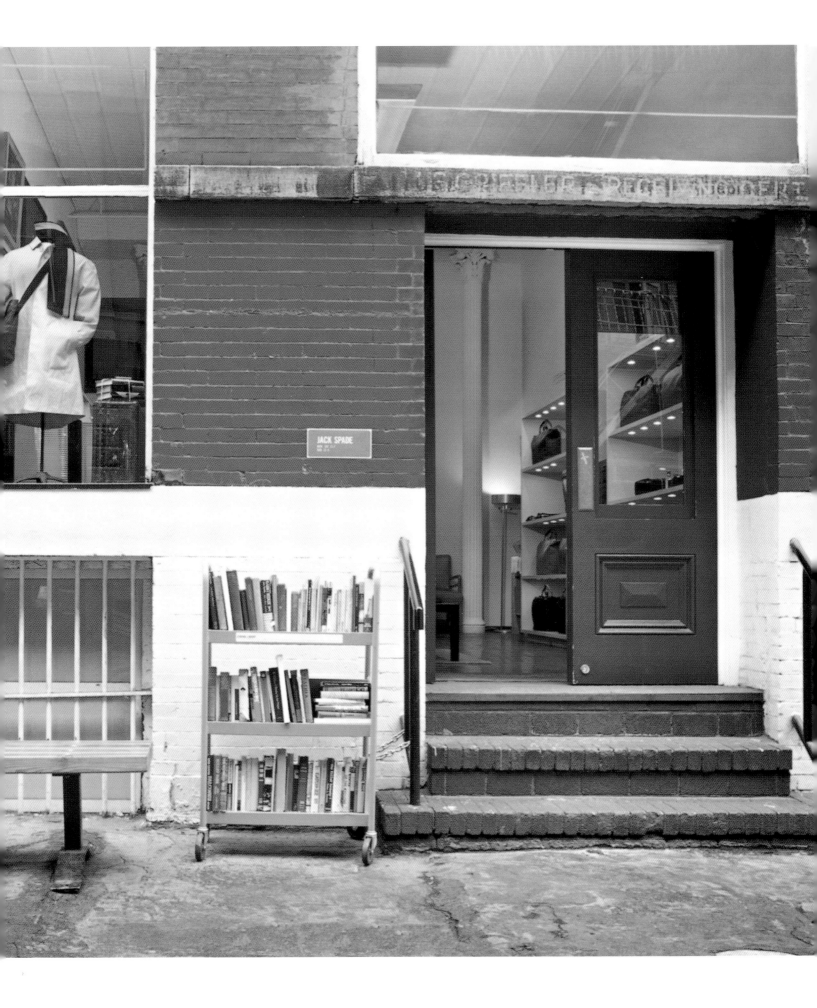

JACK SPADE

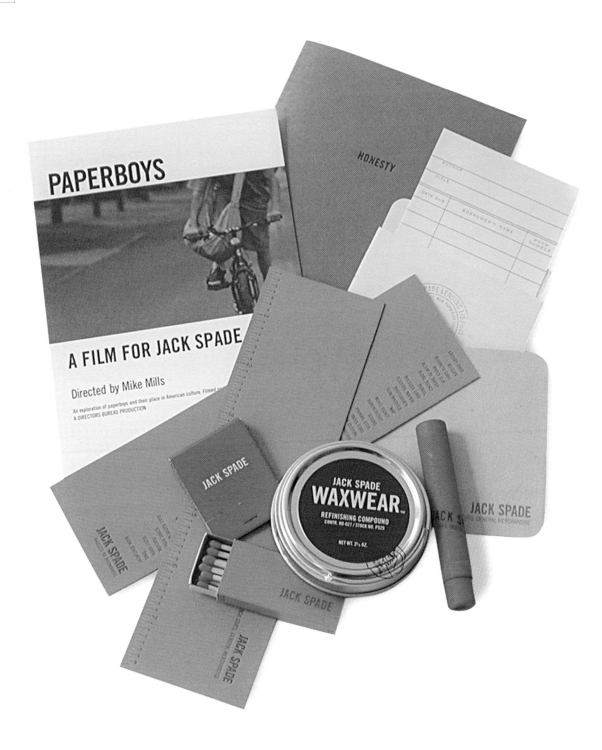

Ask a man if he once was a paperboy, and he will likely tell about the first true job he ever had, the one where he earned real money, rubbed shoulders with bundle-haulers, and learned how to fold and throw a paper. Entrepreneur, dreamer, alone every morning under every kind of sky, this quintessential American is the flint behind accessories company Jack Spade. "Jack Spade Warren Street New York," is stacked like a short paragraph, a narrative hinting of birthright and history. "I know who Gucci is," say the capital letters stitched in white against a black cloth rectangle, "but I choose not to live like that." Jack Spade: making art, fixing plumbing, smoking cigarettes and riding a bicycle without a helmet. Jack Spade: named for beat-poet Jack Kerouac, General Electric granddaddy Jack Welch, and creative father and CEO Andy Spade. Jack Spade: a blending of persona and commerce as SMOOTH AS A 14-YEAR-OLD SCOTCH, a man whose boarding-school years are not so far away; his address can still be found sewn in the lining of his clothes.

jack spade

COLLATERAL

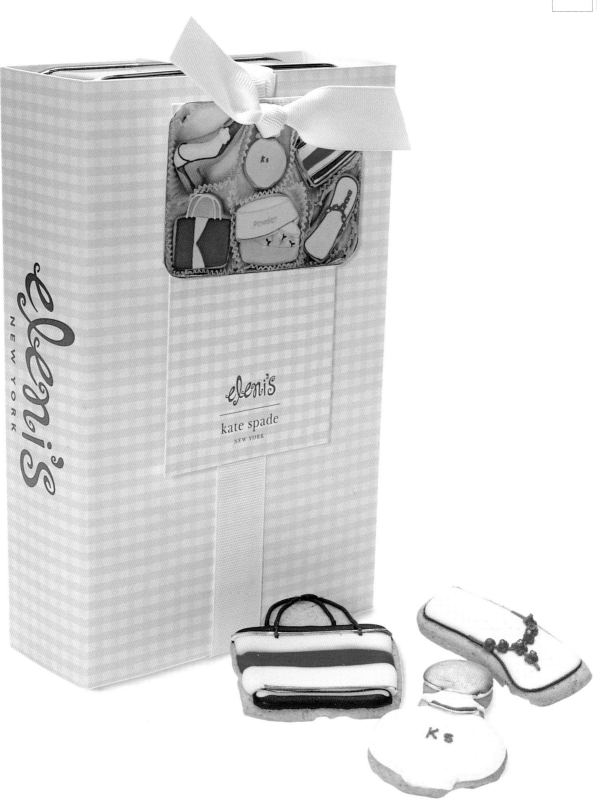

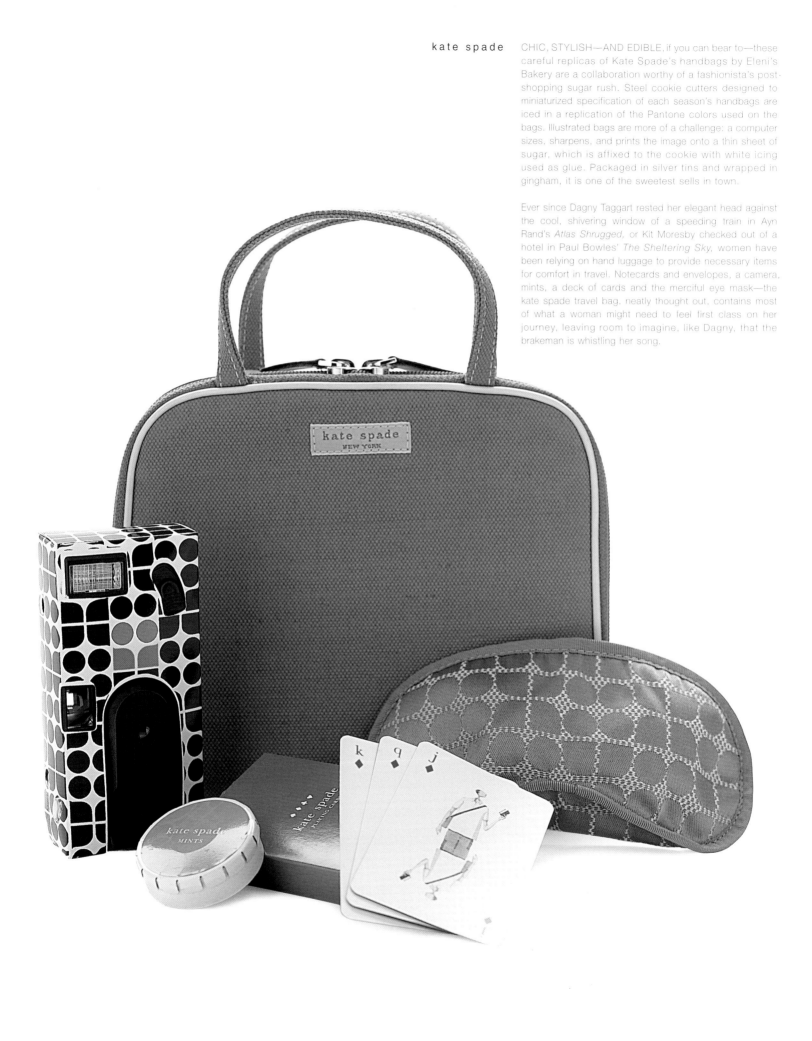

kate spade

CHIC, STYLISH—AND EDIBLE, if you can bear to—these careful replicas of Kate Spade's handbags by Eleni's Bakery are a collaboration worthy of a fashionista's post-shopping sugar rush. Steel cookie cutters designed to miniaturized specification of each season's handbags are iced in a replication of the Pantone colors used on the bags. Illustrated bags are more of a challenge: a computer sizes, sharpens, and prints the image onto a thin sheet of sugar, which is affixed to the cookie with white icing used as glue. Packaged in silver tins and wrapped in gingham, it is one of the sweetest sells in town.

Ever since Dagny Taggart rested her elegant head against the cool, shivering window of a speeding train in Ayn Rand's *Atlas Shrugged,* or Kit Moresby checked out of a hotel in Paul Bowles' *The Sheltering Sky,* women have been relying on hand luggage to provide necessary items for comfort in travel. Notecards and envelopes, a camera, mints, a deck of cards and the merciful eye mask—the kate spade travel bag, neatly thought out, contains most of what a woman might need to feel first class on her journey, leaving room to imagine, like Dagny, that the brakeman is whistling her song.

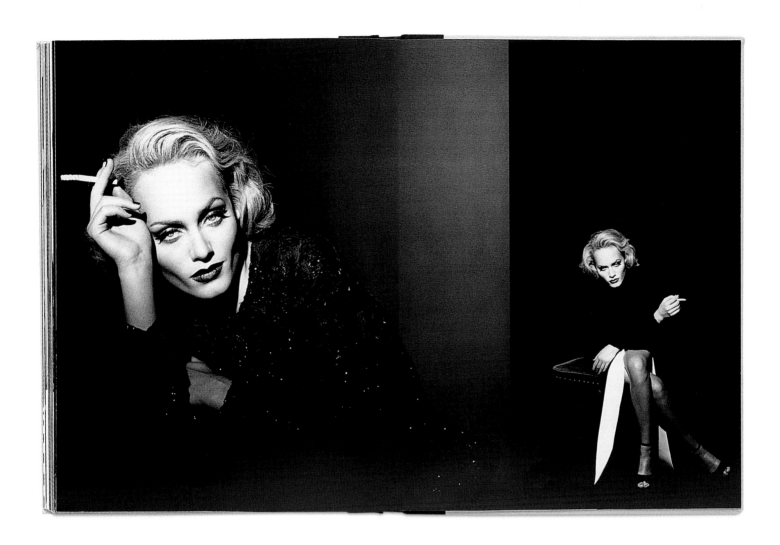

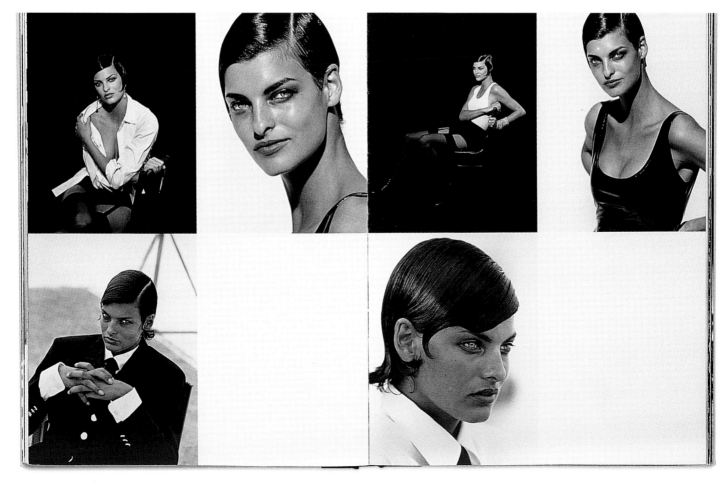

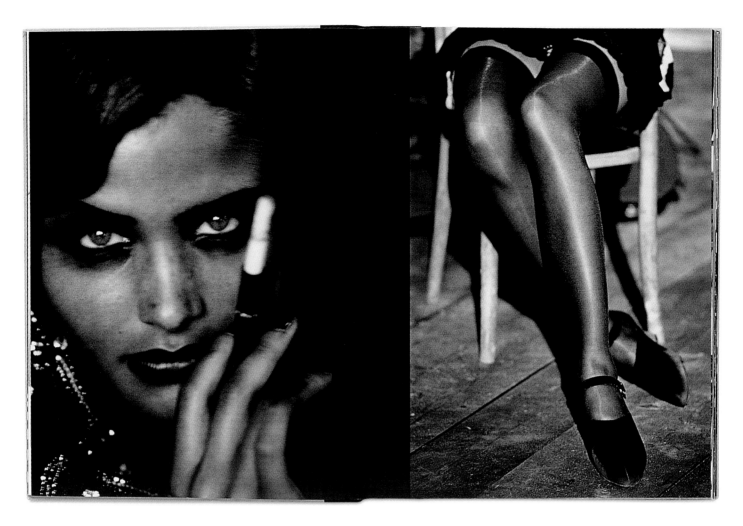

PETER LINDBERGH

the model as the metaphor

YOU CAN PUT A BRAND ON THE MAP IN ONE SEASON WITH THE RIGHT WOMAN. GERMAN-BORN, PARIS- AND NEW YORK–BASED PETER LINDBERGH IS A MASTER AT JUST THAT, A PHOTOGRAPHER WHO HAS FOUND FAME THROUGH HIS PORTRAITS OF WOMEN, AND HIS RARE KNACK OF COUPLING A MODEL TO A BRAND: MILLA JOVOVICH TO COMME DES GARÇONS; ERIN WASSON TO DONNA KARAN, AMONG MANY OTHERS. "YOU MEET SOMEONE AND YOU REALLY HAVE THE FEELING YOU UNDERSTAND HER, SO YOU MARRY HER. AND THAT HAPPENS ALSO PHOTOGRAPHING WOMEN." HE CONTINUES: "ERIN'S FACE CAN GIVE SO MUCH, AND THERE IS SUCH A GREAT CONNECTION. SHE CAN PLAY INCREDIBLY INTENSE, INCREDIBLY EMOTIONAL. WE CAPTURED ERIN'S AURA AND LINKED IT TO THE BRAND." SO IMPORTANT IS THIS CONCEPT THAT LINDBERGH TURNS DOWN JOBS WHEN HE

DOESN'T FEEL THAT BOND. "OTHERWISE THE PICTURES ARE COLD AND MORE PHILOSOPHICAL." AND HE TRUSTS ONLY HIMSELF. "NEVER ASSUME, BECAUSE A DESIGNER LIKES A MODEL, THAT THERE MUST BE SOMETHING THERE." VERY OFTEN, DESIGNERS ONLY SEE THE BODY AND HOW THE CLOTHES HANG, HE SAYS. FOR A BRAND TO COME ALIVE THROUGH A WOMAN, THERE HAS TO BE A TRIANGULAR RELATIONSHIP BETWEEN THE DESIGNER, MODEL AND PHOTOGRAPHER. IN 2000, JEWELER DAVID YURMAN AND LINDBERGH CHOSE AMBER VALLETTA AS A MODEL. "SUDDENLY, [YURMAN] EXISTS," SAYS LINDBERGH, "AND IT'S THROUGH AMBER'S FACE." TURNER'S FLASH OF LEGS DID IT FOR HANES IN THE EARLY NINETIES. "THEY PAID A FORTUNE FOR TINA." FOR FASHION, LINDBERGH PREFERS TO WORK WITH MODELS RATHER THAN ACTRESSES. "ACTRESSES CAN'T BE MODELS; THEY HAVE THEIR OWN PERSONA." BUT MODELS CAN BE MOLDED, MADE-UP, CHANGED. IRONICALLY, THE FEW MODELS WHO ALSO ACT, HE CONSIDERS MOST MEMORABLE— KRISTEN MCNEMANY AND MILLA JOVOVICH. "KRISTEN WAS TRULY THE MOST TALENTED MODEL I HAVE EVER WORKED WITH. SHE COULD GIVE YOU MORE THAN ANYBODY ELSE. SO MANY MODELS ARE SENT BY AGENCIES. AND THEY DON'T KNOW WHY THEY'RE THERE." WHEN A MODEL BECOMES A SUPERMODEL, SHE ACQUIRES HER OWN PERSONA, WHICH CAN COMPETE WITH THE BRAND FOR ATTENTION, SAYS LINDBERGH. BUT NOT LINDA EVANGELISTA: "LINDA IS A MODEL I LOVE TO SHOOT. SHE IS A CHAMELEON…THERE ARE SO MANY GREAT MODEL-PERSONALITIES, YOU CAN ALWAYS FIND THE RIGHT SPIRIT FOR THE BRAND."

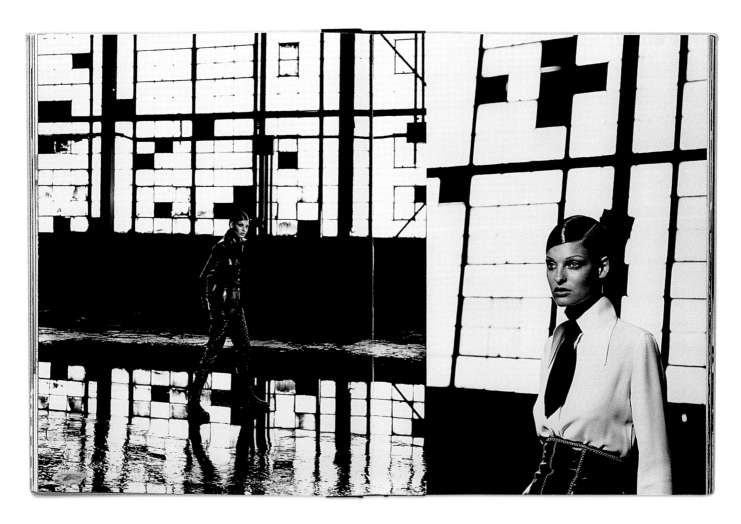

label

Ecce signum: nothing else endures. Long after brand hoopla, imagery, packaging, store music, and aromas fade away—and the single-stitch white shirt continues to hang in the cupboard. What remains is that exemplification of excellence and identity: the label.>

LABEL

AND HOW LABELS TRANSFORM CLOTH! THINK OF TOCCA'S CROWN AND DAISIES, OR THE INSTANTLY IDENTIFIABLE NIKE SWOOSH. SOMETIMES, DESIGNER AND CONSUMER COLLUDE: THREE SMALL DOTS AT THE NAPE OF A T-SHIRT; A WISH SEWN INTO A SHIRTTAIL; MICHAEL KORS' INKED AUTOGRAPH ON THE INSIDE POCKET OF LIMITED EDITION COUTURE JEANS. SOMETIMES, A THUMBPRINT LEFT BEHIND TAKES PLACE WITHOUT THE WEARER'S KNOWLEDGE: ALEXANDER MCQUEEN'S PROFANATIONS SCRIBBLED INSIDE SAVILE ROW LAPELS. THE RELATIONSHIP IS INTIMATE AND INTENSE: ONE MAN'S WORK ON ANOTHER MAN'S BACK. THE PERSONS CREATING THE GARMENT CARE PASSIONATELY; THEY ARE THE ORIGINAL DREAM WEAVERS. THEY LEAVE THEIR MARK, AND CLOTHES THAT ARE SHELF-BOUND GET SHIPPED TO OUTLET STORES, THEIR LABELS MARRED, BLACKENED, OR SLASHED, BECAUSE THESE TINY EMBLEMS LITERALLY BRAND THE BRAND. POTENT AS SALT, RICH-IN-TRADE AS SPICES: ONE RED STRIPE FLASHING DOWN THE BACK OF A MAN'S SHOE AS HE CYCLES THROUGH SOHO TELLS ALL—PRADA, RED LINE. DESIGNERS MIGHT ARGUE THAT EXTERIOR LABELS MATTER TO MEN WHO NEED ASSURANCE THAT THEY MADE THE RIGHT CHOICE. THE INWARD LABEL WORKS THEM HARDER; ARE YOU AN OLD BROOKS BROTHERS BOY? J PRESS? QUIRKY, LIKE PAUL SMITH? A GUGGENHEIM HIPSTER, IN YOUR HUGO BOSS? WOMEN PLAY A SUBTLE GAME: DO YOU RECOGNIZE THE FLASH OF PALE LIME INSIDE MY SIGERSON MORRISONS? THE ZIGZAG OF MY MISSONI? LONG AFTER THE GARMENT IS WORN THREADBARE OR SHRUNK OR DEEMED UNFASHIONABLE, THE LABEL REMAINS, MORE POWERFUL EVEN THAN THE THING TO WHICH IT IS SEWN. IT BEGAN LIFE AS A STRIP OF RIBBON AFFIXING A SEAL TO A DOCUMENT. COME FORWARD A THOUSAND YEARS, AND THE PRACTICE STILL RESONATES, A RITUAL WORTHY OF L'ANCIENNE NOBLESSE.

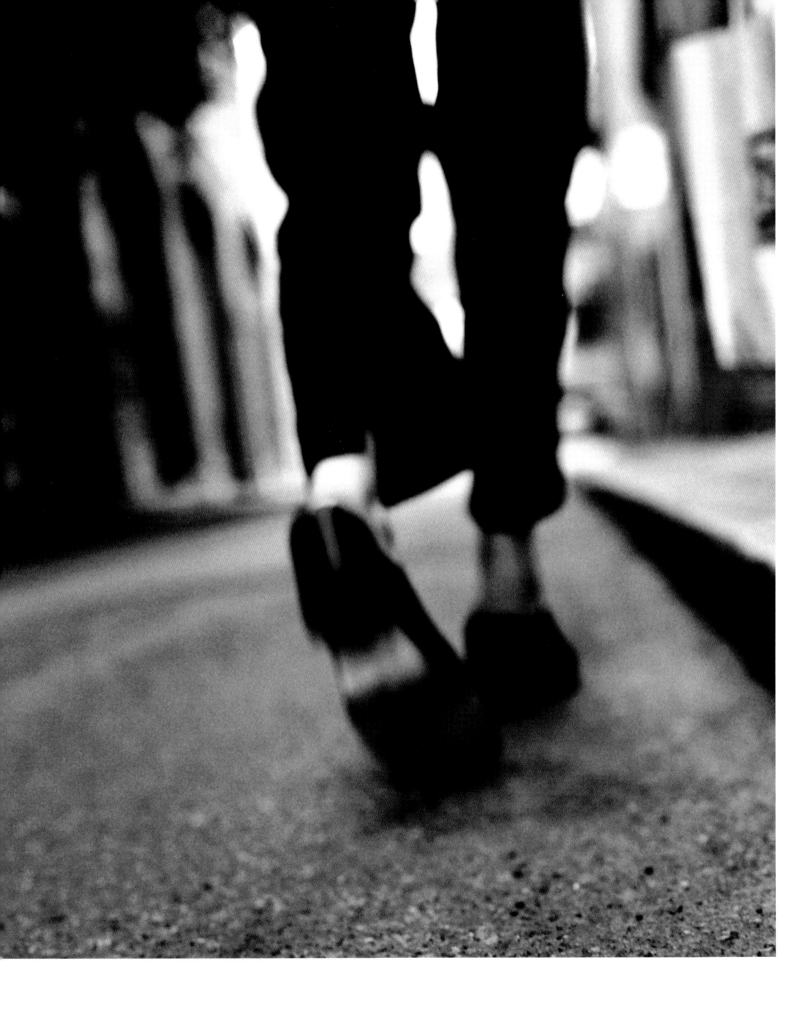

When designing the emblem for Prada's racing yacht bound for the America's Cup, CEO Patrizio Bertelli chose a background of gray to signify modernism and red lettering, because in Italy, red is the color of war. Red. The color of courage, of Communists and medics, of bull fights, of love. RUNNING LIKE AN ARTERY through their sportswear and shoes, Prada's red tag transforms the unremarkable into something to be reckoned with, and the wearer into someone to meet—urban and urbane, cool, chic, forever young. Stamped on a black rubber sole or curving the arc of a black ski cap, Prada wins hearts by design, enticing generations to jump the lines of subtlety, past this year's lilac or that year's buckle. And they do, eager as enlistees signing up: Give me the thin red line of Prada.

PRADA

LABEL

three dots Looking to bring their T-shirt's label up to speed
alongside such indelible symbols as the trisected
circle of Mercedes Benz, the once-bitten Macintosh
apple, and Nike's swoosh, John Ward, with Sharon
Lebon, thought globally and, in 1995, came up with
ellipses. PURE.ECONOMICAL.CONTAINED—much
like the product itself, with its unique, flat-lock stitch
manipulating the ring-spun cotton to lie smoothly
against the body. A T-shirt made in 3 styles, 3 sizes,
and 12 colors now had three dots heat-stamped
directly onto the inside neckline, eliminating the need
for a tag. A clean presentation for a clean product, says
Ward, who solved the next logical problem—where to
put size information—by darkening one of the three
dots, in the order of small, medium, large. Clever.
Casual. Sophisticated. In the language of Western
Union, three dots is an alert that "More Message Will
Follow." Seven years and $23 million later, women's
wear has expanded in both fabric and design; a men's
line, identified similarly with gray dots and differentiated
by underlining, has debuted with infant, toddlers', and
children's clothing, carrying purple, orange, and turquoise
dots, respectively. And more will follow.

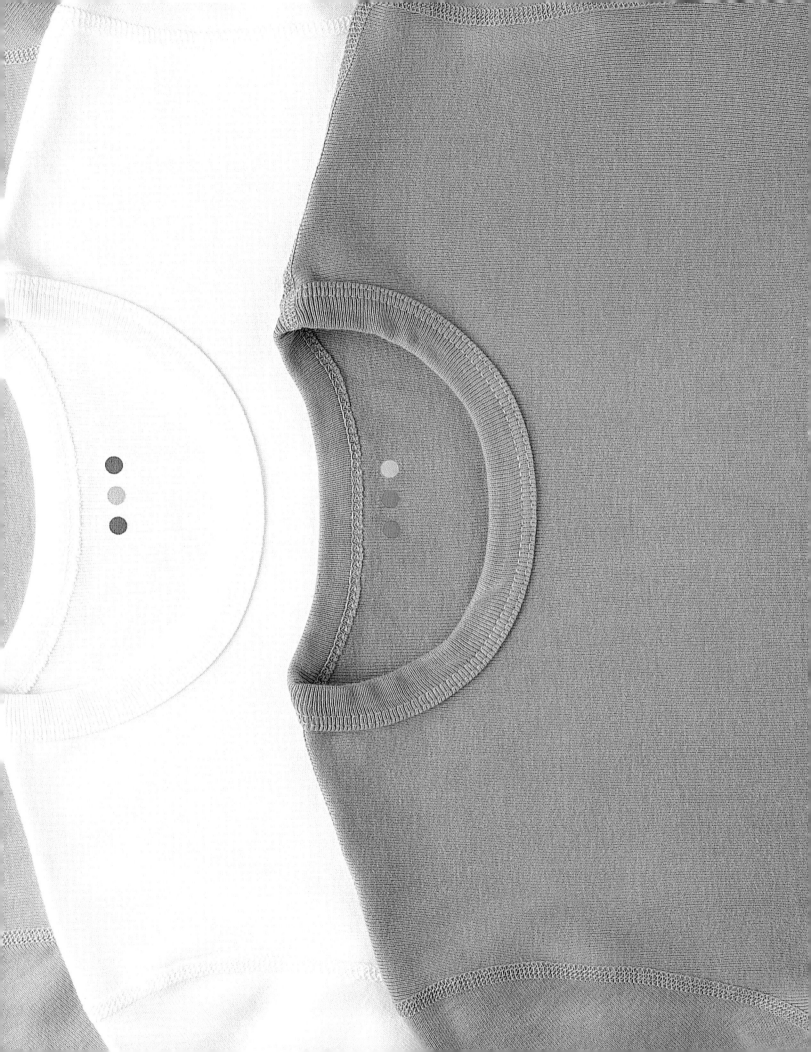

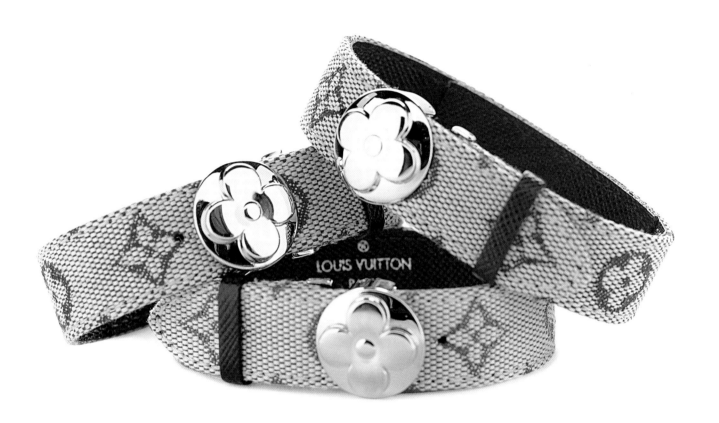

LABEL

LOUIS VUITTON

pattern recognition

PATTERNS IDENTIFY BOTH THE DESIGN AND THE DESIGNER BY ARRANGING COLOR AND SHAPE IN A PREDICTABLE, PRESCRIBED DISPOSITION OF PARTS, A CONSISTENT FLASH SWINGING PAST THE EYE. LIKE THE SWIRL OF A SIGNATURE, CAPABLE OF BEING FORGED, BUT NEVER DUPLICATED. THE BEST PATTERNS ADHERE AS RECOGNIZABLY AS A HONEYCOMB: DIOR'S DECO-LIKE CIRCLE OF DESCENDING AND ASCENDING LETTERS; GUCCI'S GG'S ECHOED BY COACH'S CC'S; KATE SPADE'S SMALL PLACARD PUT ASIDE IN FAVOR OF A CONTINUOUS STREAM OF RETRO KS'S. BURBERRY'S BLACK AND TAN PLAID—COLORS OF A BRITISH REGIMENT, LONGTIME PURVEYORS TO THE SHOULDERS OF ROYALTY—HAS BECOME, IN A FASHION-FANCY INVERSION OF TASTE, A BOLD EXTERIOR PATTERN FOR HATS AND MINI-KILTS, BIKINIS AND BABIES. PATTERNS ATTACH TO THE STRENGTH OF VISUAL MEMORY AS MAGAZINE PAGES FLIP BY: MISSONI'S WAVES, PUCCI'S STAINED GLASS GEOMETRY, A JUXTAPOSITION OF BRIGHT AND PASTEL COLORS INSPIRED BY THE FLAGS OF SIENA'S PALIO, STRETCHED ACROSS SILK JERSEY THAT CAN BE PACKED IN A CRUSH AND A HURRY. BUT ALL HAIL THE L AND THE V, STAMPED ON TRAVEL CANVAS IN TAUPE AND GOLD, CHECKERBOARDED WITH A FLOWER AND A CIRCLE, THE LONGEST RUNNING PATTERN AND THE GREATEST SUCCESS. SO SECURELY CULTISH, THAT THE HOUSE CHOSE DESIGNER STEPHEN SPROUSE TO DESIGN A LINE OF BAGS ABANDONING THE LV LOGO IN FAVOR OF GRAFFITI, AND, IN AN INSTANT, IMMORTALIZING THE LOWEST TO RISE UP.

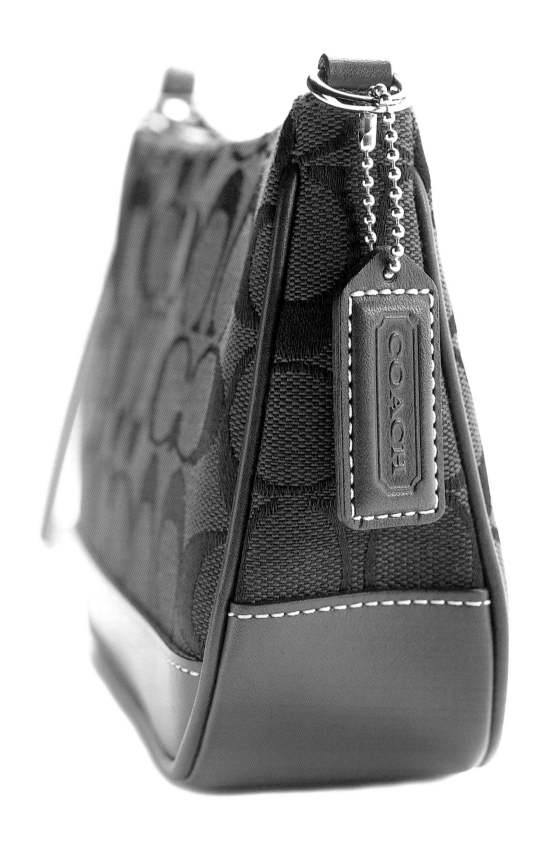

LABEL

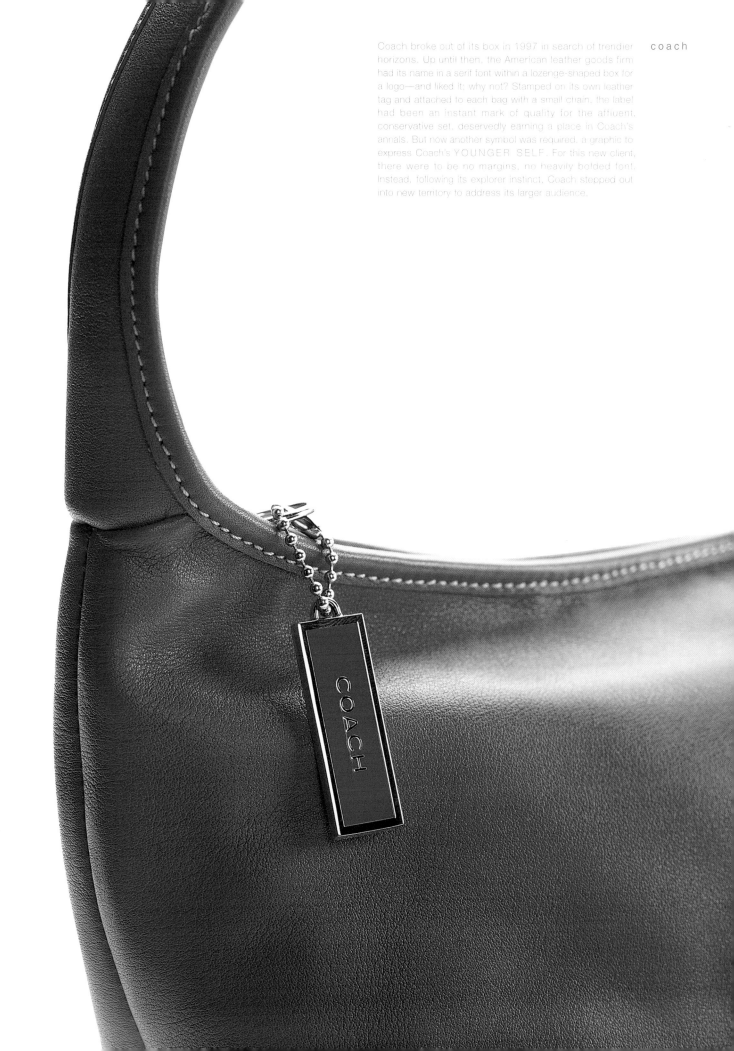

Coach broke out of its box in 1997 in search of trendier horizons. Up until then, the American leather goods firm had its name in a serif font within a lozenge-shaped box for a logo—and liked it; why not? Stamped on its own leather tag and attached to each bag with a small chain, the label had been an instant mark of quality for the affluent, conservative set, deservedly earning a place in Coach's annals. But now another symbol was required, a graphic to express Coach's YOUNGER SELF. For this new client, there were to be no margins, no heavily bolded font. Instead, following its explorer instinct, Coach stepped out into new territory to address its larger audience.

COACH

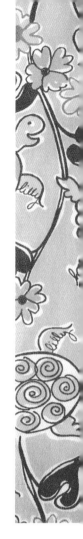

lilly pulitzer

Just as sand finds its way into soil, and herbaceous borders yield to hibiscus and heavy-headed lilies; just as swimming pools reflect that unique and curious shade of sun-lit aqua, so Lilly Pulitzer's bright and variegated fabrics continue to burst upon the tidy, color-matched scene of preppy clothing. What could go wrong in Lilly's world, as she dispenses to friends from an elegant garden stand drafts of freshly squeezed oranges, as top-tilting poufs of ROYAL PALMS sway to humid breezes against a blue and white sky? Nothing, for even inadvertent accidents play to her power of positive thinking—as when, having spilled juice on herself, she designed colorful shifts to mask the stains. Lilly creates fabrics as a paean to the subtropical beauty outside her Palm Beach door: tigers playing in pink hibiscus, turtles swimming through magenta water, blue crabs crawling in a purple sea—each with a signature "Lilly" swirled within, symbols of a discrete American world, imagined by an eye of steady assurance that none of this delightful life would ever disappear. That tranquility would become her charm, for each decade girls are born to embrace her clothes, as perennially sunny and unperturbed as the elements whose color and form provide the inspiration.

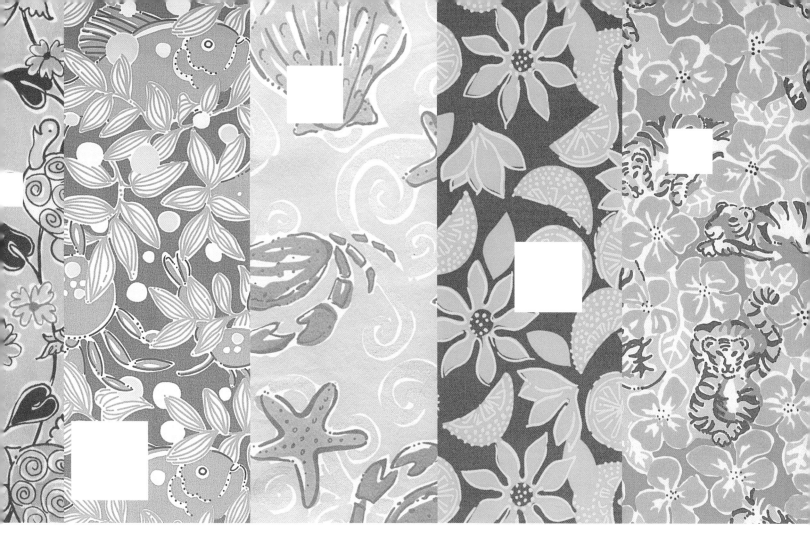

1 2 3 4 5 6 7 8

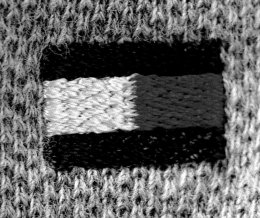

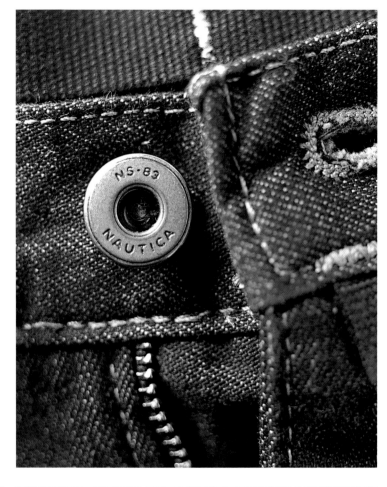

**nautica and
tommy hilfiger**

SHOW THE FLAG AND IDENTIFY YOURSELF. In this way apparel houses use emblems to vie against each other. Tommy Hilfiger takes on red, white, and blue in a bid to secure the homeland colors as his own. Nautica sketches out the minimalist lines of an ocean-cutting spinnaker, setting itself apart for those who understand the call of the sea. Hoist the pennants. Color, already vital to the designer, becomes a visual decoder: Hilfiger's deep green Ivy-bound buttonholes; Nautica's return each season to the cobalt blue of marina mariners. Letters punched onto a button; squares of fabric sewn over a pocket; the back-and-forth threading hammered out in silhouette—these make all the difference. Oh, what a lovely war.

packaging

The package: first impression for the receiver; last impression for the giver.
A complex relationship of shape, texture, and color, the packaging says it
first and last, a promise that the contents hold more.>

page 096-097

PACKAGING

THE JAPANESE PARE DESIGNS DOWN TO A MINIMALIST JUNCTURE OF UTILITY AND AESTHETIC. BAMBOO, PAPER, MAGNOLIA, AND OAK LEAVES ENCLOSE OBJECTS IN SPARE, SCULPTURAL SHAPES. THE FRENCH TAKE TIME TO ENCASE AN ÉCLAIR IN A FRAGILE PYRAMID OF TISSUE. A BOX OF RAISINS FROM A SHOP IN MILAN LIES BENEATH AN ONIONSKIN OF WHITE PAPER INKED WITH GOLD AND PURPLE, A CAREFUL, CORNER-FOLDED PACKET TO BE TUCKED INTO A POCKET FOR THE WALK HOME. IN CHINA, A CERAMIC BOWL GETS WRAPPED IN A SCARF FOR THE RIDE BACK. THE GRAPHIC DESIGNER, CHARGED WITH CONCEPTS OF WRAPPING ITEMS PROTECTIVELY IN A VISUAL SETTING, COAXES A PRODUCT INTO BECOMING SOMETHING GREATER THAN ITSELF. IT IS AN ART OF TROMPE L'OEIL, OF RE-CREATION, OF DELAYING THE MOMENT OF RE-SEEING THE OBJECT OF ORIGINAL DESIRE. AMERICA'S PERPETUAL RUSH AGAINST TIME SALUTES PRACTICALITY AND SPEED AS AESTHETICS IN THEMSELVES. HANGTAGS CARRY YARN AND BUTTONS. URBAN OUTFITTERS RED PLASTIC BANDS ARE PRINTED WITH A WORD PLAY: "YOU ARE GIFTED IN MANY WAYS." IN CONTRAST, WILLIAMS-SONOMA'S EXTRAVAGANT "SUN-DRIED PACIFIC SEA SALT" COMES PACKAGED IN A PRETTY METAL TIN, WIDE AND SHALLOW ENOUGH TO ACCOMMODATE THE DIPPED RIM OF A MARGARITA GLASS. IT IS THE STORE'S BEST-SELLING ITEM. BUYER BEMUSED: PAY EXTRA FOR AN IMAGINED LIFESTYLE OF PARTIES AND POPULARITY, AND FOR A CONTAINER CHARMING ENOUGH TO LIVE A SECOND LIFE.

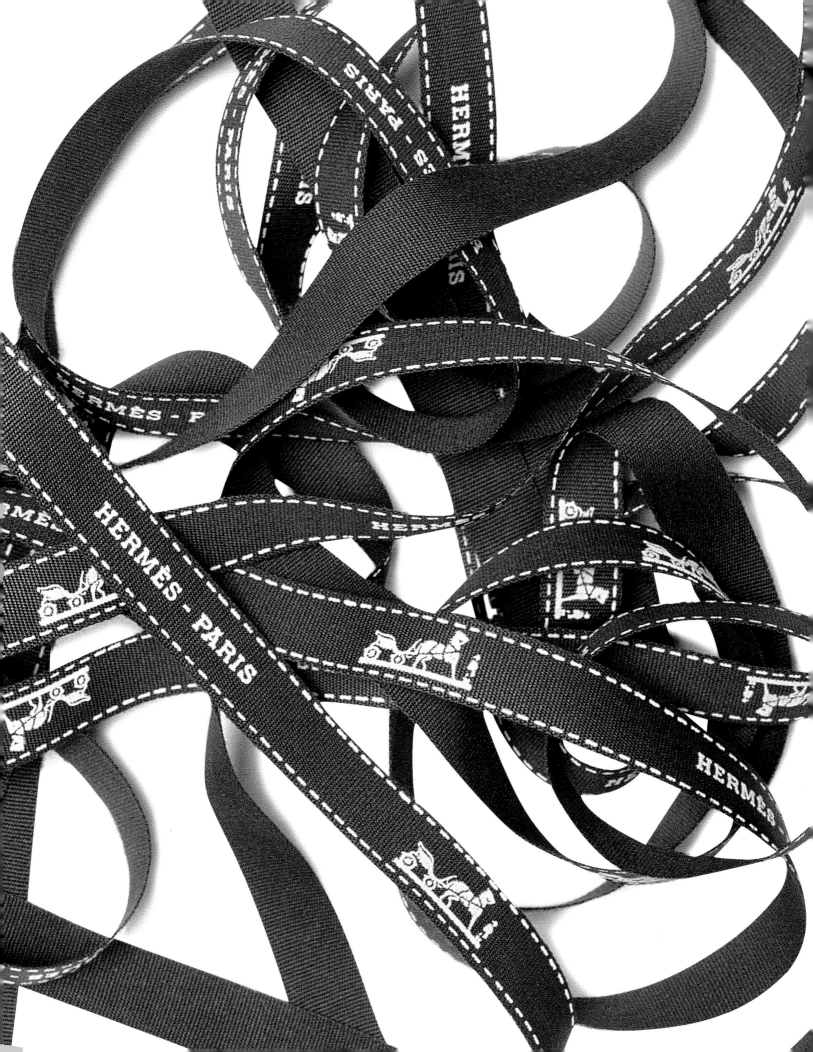

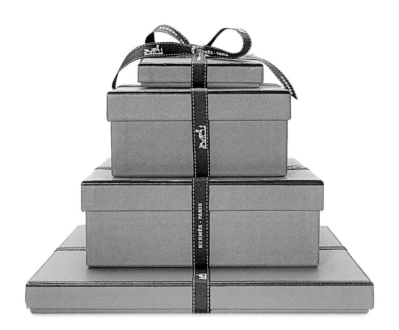

HERMÈS
maison classique

NO SYMBOL EXPLAINS BETTER THE HOUSE OF HERMÈS THAN JANUS, THE ROMAN PATRON OF BEGINNINGS AND ENDINGS, GLANCING BACK TO TRADITION, EVER STIRRING ONE'S SENSE OF DÉJÀ VU, AND LOOKING AHEAD TO NEW LIFE. HERMÈS IS A STORY OF GENERATIONAL CONSISTENCY EVOLVING THROUGH CENTURIES OF CHANGE, OF SHAKING OFF THE OBSOLESCENCE SNAPPING AT ONE'S HEELS WHILE ALWAYS REMAINING TRUE TO ITSELF. THIERRY HERMÈS COMMITTED TO HIS SUCCESSORS—SON AND GRANDSONS, GREAT GRANDSONS-IN-LAW, AND GREAT GREAT GRANDSONS—THE CULTISM OF QUALITY, MATERIALS SIMPLY CRAFTED INTO BEAUTIFUL OBJECTS MADE TO LAST, AND THE ÉLAN FOR KEEPING IT FRESH. HERMÈS' 1837 HARNESS AND SADDLE WORKSHOP IN PARIS' BUSTLING GRANDS BOULEVARDS QUARTER WAS RECOGNIZED WITH THE WORLD'S FAIR 1867 FIRST-CLASS MEDAL. CHARLES-ÉMILE HERMÈS SUCCEEDED HIS FOUNDING FATHER AND OPENED A STORE AT THE NOW FABLED 24 FAUBOURG SAINT-HONORÉ IN 1880. HIS SONS, ADOLPHE AND ÉMILE-MAURICE, HAD LEARNED ENOUGH BY 1914 TO ENCOMPASS OVER 70 SADDLERS, ATTRACTING LOYAL RIDERS IN EUROPE, NORTH AFRICA, RUSSIA, THE AMERICAS, AND ASIA. ON A NORTH AMERICAN TRIP TO SUPERVISE LEATHER PURCHASES FOR THE FRENCH CAVALRY DURING THE FIRST WORLD WAR, ÉMILE-MAURICE OBSERVED A CONTINENT HUMMING IN AN ERA OF MASS PRODUCTION, LEAPING TECHNOLOGY, AND AGGRESSIVE TRAVEL. SADDLERY WAS DEAD. WHILE HE DIDN'T JUMP ONTO THE FORD ASSEMBLY LINE, HE DID PURCHASE EXCLUSIVE EUROPEAN RIGHTS TO USE, FOR LEATHER AND CLOTHING, A UNIQUELY AMERICAN INVENTION, THE ZIPPER. DEVICE IN HAND, ÉMILE-MAURICE EXTENDED THE BRAND INTO THE POST-WAR FASHION FRENZY WITH ADDED ACCESSORIES LIKE HAND BAGS, LUGGAGE, BELTS, GLOVES, CLOTHING, AND SILK SCARVES, ALWAYS CAREFUL TO HONOR THE PAST BY SUCH MOTIFS AS

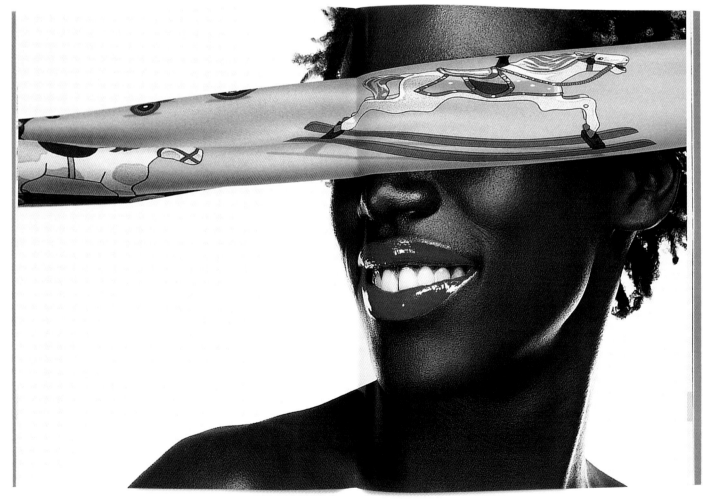

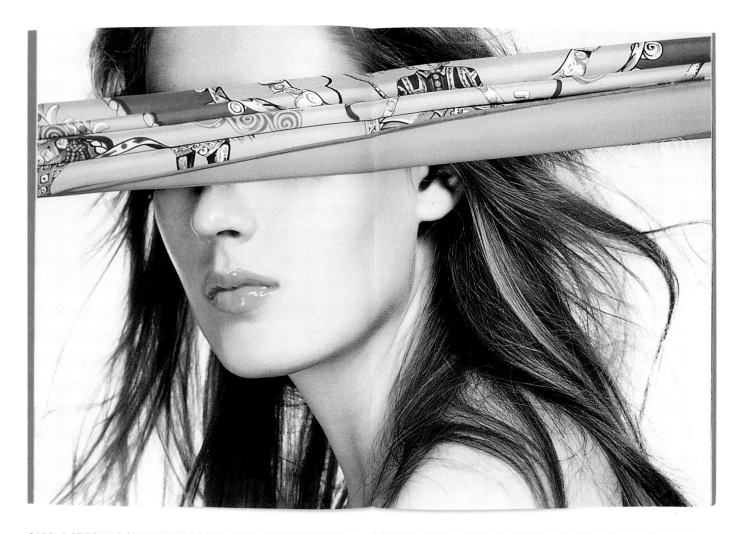

SADDLE-STITCHING ON LEATHER GOODS, DEMANDING PERFECTION FOR EACH ITEM BEFORE RELEASING THEM TO THE STORE. HERMÈS OPENED BRANCHES IN FRENCH RESORTS AND IN NEW YORK. IN 1951, THE REINS WERE HANDED OVER TO SON-IN-LAW ROBERT DUMAS. NOW HERMÈS HAD ITS LOGO, THE *DUC* CARRIAGE, AND ITS SIGNATURE ORANGE BOX AND BOLDUC RIBBON. IT HAD ITS TIE AND FRAGRANCE. ESPECIALLY NOTABLE WAS THE FLOURISHING PLETHORA OF EXQUISITELY ILLUSTRATED LARGE SILK SCARVES. GENERAL GEORGE PATTON, MARLENE DIETRICH, HUMPHREY BOGART, INGRID BERGMAN, THE DUKE AND DUCHESS OF WINDSOR, JOHN AND JACKIE KENNEDY ALL PASSED THROUGH THE DOORS OF 24 FAUBOURG SAINT-HONORÉ. GRACE KELLY, THEN PRINCESS OF MONACO, WAS PHOTOGRAPHED CARRYING A HERMÈS BAG. THE IMAGE STARTED A RUN ON THE SHOPS; EVERY WOMAN, STILL, WANTING TO OWN A HERMÈS KELLY. TRUE TO GRANDFATHER'S EDICT, DUMAS PRESENTED A KILT-SKIRT CUT FROM A HORSE BLANKET IN HERMÈS' FIRST READY-TO-WEAR FASHION SHOW, IN 1966. JEAN-LOUIS DUMAS-HERMÈS, REPRESENTING THE FIFTH GENERATION, AND TODAY'S CHAIRMAN AND CEO OF THE HERMÈS INTERNATIONAL GROUP, TOOK OVER IN 1978, BREATHING NEW LIFE INTO LEATHER, ACCESSORIES, AND READY TO WEAR: THE ARRIVAL OF THE HERMÈS WATCH, FOLLOWED BY THE BELOVED ANIMAL PRINT TIES. HERMÈS WAS HOT. NOT LOST ON DUMAS-HERMÈS, THE 1983 OPENING OF THE FIFTY-SEVENTH STREET STORE—THE THIRD IN NEW YORK—CELEBRATED ITSELF BY TRANSFORMING THE STORE INTO A HUGE ORANGE BOX TIED WITH A BOLDUC RIBBON. HIP ENOUGH TO SEEK OUT THE FRESHEST TALENT EACH SEASON TO PHOTOGRAPH ITS PRINT ADS. YET FIRM ENOUGH IN ITS ROOTS TO MAKE EVERY STORE A TRADITIONAL WALK DOWN HISTORY'S PATH, HERMÈS HAS ITS FLAG AT THE TOP OF FASHION MOUNTAIN. ITS MANTRA: "GROW, WITHOUT LOSING YOUR SOUL."

hermès First out of NECESSITY, then CHOICE, then the power of SUGGESTION. So Hermès moves forward. A shortage of materials during the 1940s occupation of France compelled the House to use a stock of faded orange paperboard. (Later, the color was punched up several notches and the paper indented with a *relief grainé* pattern.) With color the key, in 1949 Hermès introduced the chocolate brown Bolduc ribbon (from the town of Bois-Le Dec) to be tied around its boxes and printed each year with a theme, the first, in 1987, being fireworks. Finally, the Hermès logo itself is an interpretation of a nineteenth century lithograph by French artist Alfred de Dreux. Called *duc attelé*, the elegant, four-wheeled carriage was pulled by a pair of horses, and manned by its owner. Hermès' *duc* symbolizes the relationship between itself and its clientele: suppliers of an elegant car, freshly currycombed horses, a brilliant harness, but no driver represented. The seat awaits the customer; it is he who drives.

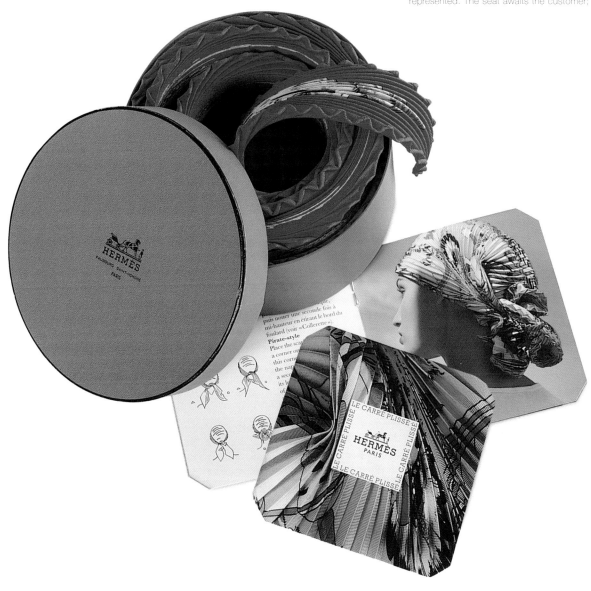

1	2

2
1

PACKAGING

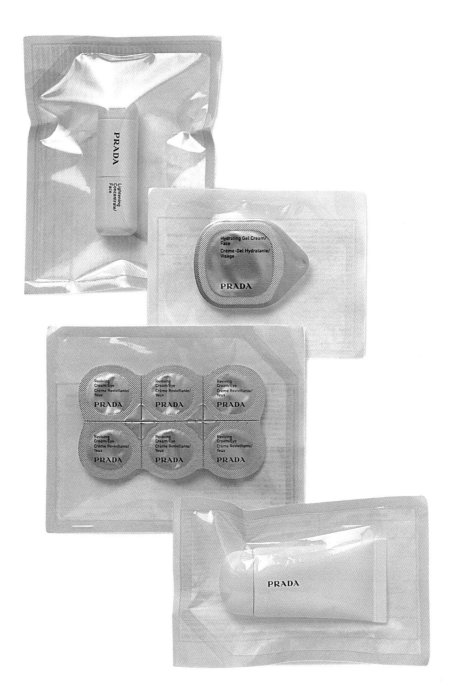

prada With their Haiku-type copy and somber wrappings, Prada's cleansing products have quieted the garrulous marketplace of cosmetic packaging. Respected designer Karim Rashid has dreamed up foil peel-backs and plastic-and-paper casings that echo a hospital supply room of sanitized catheters, needles, and horse-size drugs. All this from a label so unorthodox that it once inspired artist Tom Sachs to build a model-size concentration camp out of its packaging. Rashid's pharmaceutically styled, one-time-use containers, with their undertones of a sterile, postnuclear environment, are presented as the ultimate symbols of indulgent, HYGIENIC LUXURY. Even the language lulls: "mono dose packaging seals out light, air, and bacteria." Prada envisions beauty of the future, preserved in a time capsule; and when historians sort through the landmarks of advertising culture, these skin-care containers will surely be among them.

Pure. Potent. Personal.

Soothe

Advanced bio-plant concentrations
exfoliation smoothes multi-epidermal layers
and irritability.

Soothing Concentrate/Face Soothing Cream/Face
Soothing Gel/Eye Soothing Mask/Face

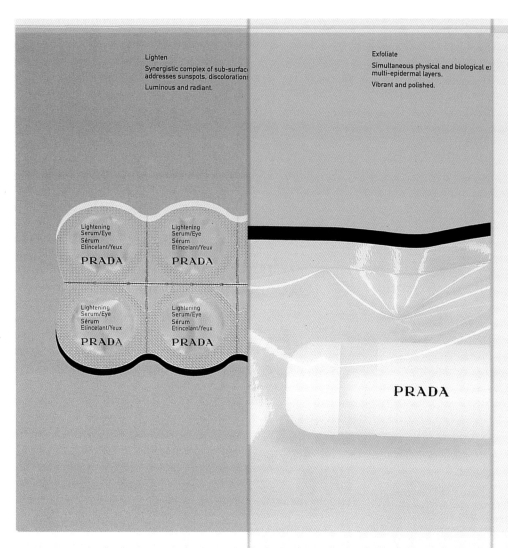

Lighten

Synergistic complex of sub-surface addresses sunspots, discolorations

Luminous and radiant.

Exfoliate

Simultaneous physical and biological ex multi-epidermal layers.

Vibrant and polished.

Hydrate

Rich bio-available moisture complex helps the skin reg its natural support system and improves elasticity.

Soft and replenished.

**Lightening Concentrate/
Face**

For: Skin with uneven tone and dark spots.

Function: Virtually diminishes dark spots and discoloration and increase skin's luminosity.

Fundamentals: Pure, 10% dose of Vitamin C helps brighten existing hyper pigmentation within skin. Beta Hydroxy Acid speeds up the visible brightening benefits by bringing fresher cells to the surface. Sugar Cane softens skin and helps prevent moisture loss.

Texture: A Vitamin C powder is mixed with a concentrated serum for a fresh application of pure Vitamin C every time.

**Lightening Serum/
Eye**

For: Appearance of dark circles and fine lines.

Function: Virtually reduces under eye circles, uneven pigmentation and fine lines. Adds moisture and firmness.

Fundamentals: Vitamin C helps to prevent the hyper pigmentation that can cause the appearance of dark under eye circles. Ginkgo Biloba stimulates circulation to help remove toxins that can contribute to darkness and puffiness. Lactic Acid helps accelerate the visible brightening benefits of the under eye area.

Texture: A sheer, fast absorbing cream.

**Lightening Gel/
Face**

For: Discoloration and uneven tone.

Function: Gently evens skin tone and improves radiance as it moisturizes.

Fundamentals: Vitamin C, helps to prevent the hyper pigmentation that can cause dark spots and evens out skin tone. Peony Root Extract counteracts oxidation in skin, which can activate melanin production. Beta Hydroxy Acid works within skin's layers to accelerate the visible lightening benefits.

Texture: A lightweight, translucent gel fluid.

**Exfoliating Concentrate/
Face**

For: Dull, devitalized skin.

Function: A potent resurfacing treatment to visibly re-texturize skin.

Fundamentals: A highly concentrated serum with 10% Glycolic and Lactic Acids biologically helps accelerate cell turnover and smooth out epidermal layers while moisture keeps skin soft and supple.

Texture: A crystal, clear serum.

**Exfoliating Scrub/
Body**

For: Dull, flaky skin.

Function: Visibly polishes body skin and improves texture.

Fundamentals: Polished polymer beads physically exfoliate skin's surface while Salicylic Acid works to biologically clarify and refine skin texture from within the epidermis. Algae is added to infuse the skin with vital nutrients that contribute to fresher and firmer skin tone.

Texture: Rich, creamy paste.

**Exfoliating Mask/
Face**

For: Dull, flaky skin with T-zone oiliness.

Function: Clears away dulling flakes and declogs pores.

Fundamentals: Rice Bran physically yet gently exfoliates the top layer while Salicylic Acid works biologically to reveal fresher looking, more radiant skin tone. Pores appear clear of impurities through the extracting action of the clay. Honey helps to leave the skin soft and smooth.

Texture: A rich, creamy clay.

**Hydrating Serum/
Face**

For: Skin with oily tendencies.

Function: Enhances biologically available hydration while controlling excess oil production.

Fundamentals: Soy helps recharge skin's natural ability to produce dermis fiber. Collagen and Hyaluronic Acid help skin strengthen its natural support system. Cell metabolism is invigorated with Yeast Extract, while Witch Hazel works to control excess oil production.

Texture: Lightweight, translucent serum. Oil free.

(Also available in multi dose package.)

**Hydrating Cream/
Face**

For: Skin with drier tendencies.

Function: Enhances biologically available hydration while providing intensive moisturization.

Fundamentals: Soy recharges skin's ability to produce dermis fiber. Hyaluronic Acid helps skin strengthen its natural support system. Cell metabolism is invigorated with Yeast Extract. Xylitol, a sugar derivative, acts as a moisture intensifying humectant and skin energizer.

Texture: A rich cream.

(Also available in multi dose package.)

**Hydrating Fluid/
Body**

For: Moderately dry skin.

Function: Enhances biologically available hydration while providing skin softening moisture.

Fundamentals: A pure Hyaluronic Acid compound and Collagen provide high levels of potent moisture to keep skin feeling pliant and smooth. Shea Butter, Vitamin C and Vitamin E help maintain elasticity and deliver antioxidant benefits for cumulative results. Avocado Oil and Bisabolol give skin an added nutrient boost and provide a silky feel and finish.

Texture: A medium weight lotion.

(Also available in multi dose package.)

**Hydrating Gel Cream/
Face**

For: Normal to combination skin.

Function: Enhances biologically available hydration while balancing moisture levels.

Fundamentals: Hyaluronic Acid helps skin strengthen its natural support system. Cell metabolism is invigorated with Yeast Extract and Serine to even skin's moisture levels.

Texture: A lightweight sheer cream.

(Also available in multi dose package.)

**Hydrating Serum/
Body**

For: Dehydrated skin that prefers no residue.

Function: Enhances biologically available hydration while providing silky moisture.

Fundamentals: Pure Hyaluronic Acid provides bio-available, potent moisture to keep skin feeling pliant and smooth. High levels of Collagen and Elastin help maintain firmness and buoyancy within the dermis and Caffeine helps stimulate the removal of toxins and energize the skin.

Texture: A lightweight translucent serum.

(Also available in multi dose package.)

**Hydrating Cream/
Body**

For: Dry to very dry skin.

Function: Enhances biologically available hydration while providing intensive moisture.

Fundamentals: Pure Hyaluronic Acid compound provides high levels of potent moisture to keep skin feeling pliant and smooth, while Collagen and Elastin help maintain firmness and buoyancy in the dermis. Skin is protected and assisted in repair with a Vitamin E complex and Allantoin.

Texture: A rich, full-bodied cream.

(Also available in multi dose package.)

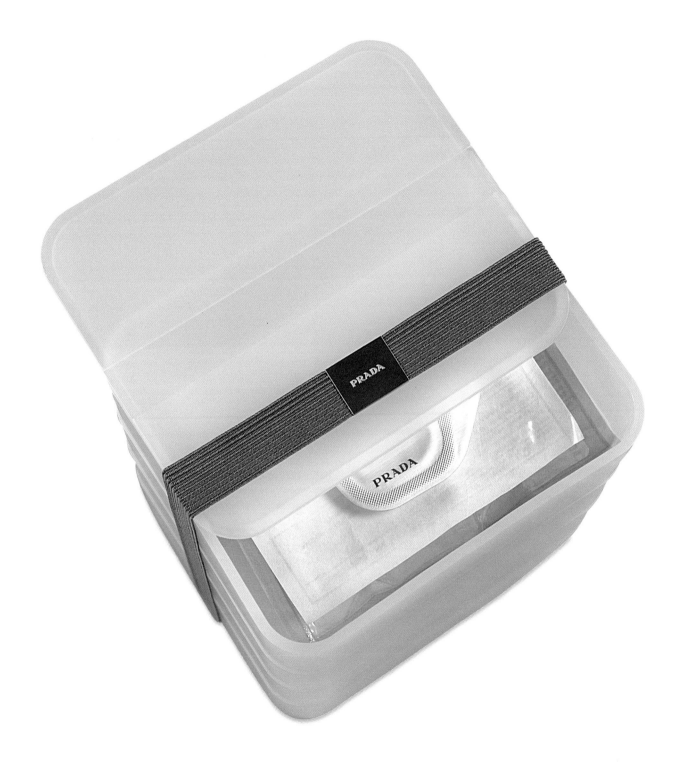

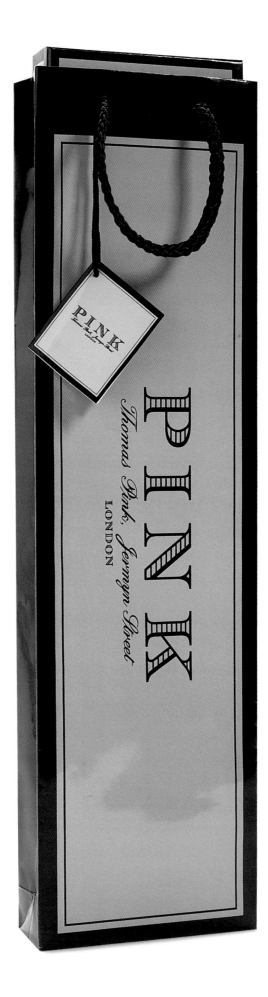

pink The impact of Thomas Pink packaging is simply the color: rock-candy pink, Graham Greene *Brighton Rock's* Pinkie's pink, a blend of red and white that mirrors the shirt maker's name, establishing the very British-ness of it: a conjuration of fox hunting, red wool jackets, and black velvet riding hats, of being "IN THE PINK," that is, ready to ride in a Thomas Pink jacket. Shiny—almost sticky—dark pink cardboard is folded into a rectangular box, tied with black ribbon, and fit snugly inside a shiny dark pink oblong bag that is edged in black—the somber font also framed in black. On Valentine's Day, the store celebrates by packaging gifts in heart-shaped pink boxes. "The Thomas Pink man can walk down the street carrying a pink bag and not be concerned," says marketing director Andrew Wiles.

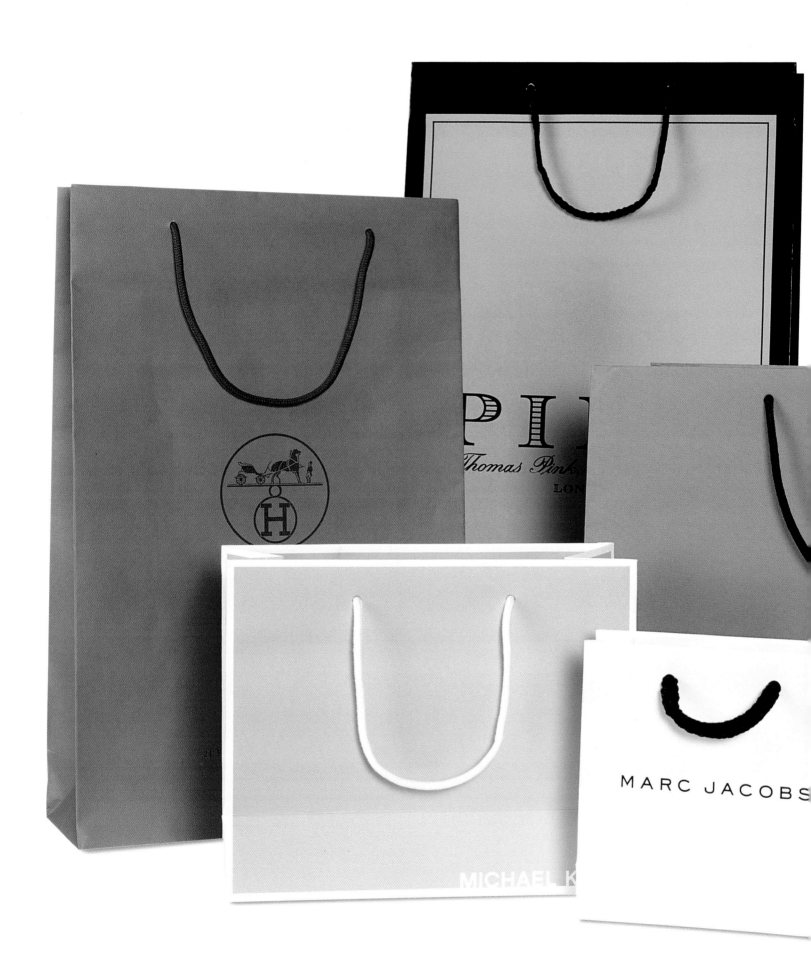

PI[L]

Thomas Pink

LON

MICHAEL K

MARC JACOBS

SHOPPING BAGS

sidewalk status

SHOPPING AT A DEPARTMENT STORE TO PURCHASE A GIFT FOR A FRIEND, A YOUNG WOMAN DECIDES UPON A $38 SWIVEL-HEAD BLUSH BRUSH BY CHANEL. IT'S PERFECT, SHE THINKS, A LUXURY ITEM THAT MOST WOMEN WOULD LOVE TO OWN. MIGHT SHE HAVE IT IN A CHANEL BAG, RATHER THAN THEIR STANDARD BROWN BAG? ALL OUT OF CHANEL BAGS? CRESTFALLEN, SHE LEAVES FOR ANOTHER STORE. WHAT'S SO SPECIAL ABOUT A BAG? FOR DESIGNERS, GETTING A PRODUCT-FILLED BAG INTO THE HANDS OF A BUYER IS THE MEASURE OF A SUCCESSFUL AD CAMPAIGN. THE TRANSACTION MEANS THAT THE WELL-PLACED VISUAL TARGETS—GRAINY MOMENTS ON MAGAZINE PAGES; OUTSTRETCHED LIMBS ON BILLBOARDS; MOODY STORE WINDOWS; WARM SALESPERSONS PICKED FOR THEIR GOOD LOOKS AND DEFT WEARING OF THE BRAND'S CLOTHES—WORK. THE NEXT VITAL MOMENT COMES WHEN THE CUSTOMER ARRIVES HOME, DECIDING WHETHER TO DISCARD THE BAG OR SAVE IT. IF THE BAG STAYS—AS IT MOST OFTEN DOES—LIKE A BUR HOOKED TO A SWEATER, THE BRAND LIVES ON. A BAG CAN WORK MAGIC: WHAT DO WE THINK OF THE MAN CARRYING A HELMUT LANG TOTE, OR THE GIRL WITH ONE FROM TULEH, WITH THEIR HINTS OF PLACES TRAVELED, OR ACCESS TO PRIVILEGE? IN CELEBRATING ITSELF, THE BAG CELEBRATES THE BUYER; IT TELLS ALL WHO SEE ITS LOGO AND RECOGNIZE ITS UNIQUE DESIGN THAT HERE IS A PERSON OF DISTINCTION. A BAG HAS THE ABILITY AND POWER BOTH TO THANK YOU AND COMPLIMENT YOUR GOOD TASTE AS YOU SAY TO A WORLD OF ONLOOKERS: THIS IS WHO I AM. AND THE BEST BAGS MOVE THROUGH SECOND, THIRD, AND FOURTH INCARNATIONS, INSTANTLY IDENTIFIABLE: HERMÈS' HEAVY, BURNT-ORANGE RECTANGLES, PINK'S PINK, SEPHORA'S TALL ENVELOPE WITH ITS LUXE BLACK RIBBON, BLOOMINGDALE'S CELEBRATED THREE-SIZE DESIGN. A YOUNG WOMAN RIDES THE SUBWAY HOME. TWENTY-SOMETHING AND PRETTY, SHE HAS STYLE AND A MODEST BUDGET. CRAFTING OUTFITS TOGETHER WITH TASTE, THOUGHT AND HOURS OF HUNTING THROUGH SALES RACKS, SHE CARES. ONE DAY, SHE KNOWS SHE WILL BE THE KIND OF PERSON WHO BUYS MORE THAN JUST THE CAROLINA HERRERA WALLET OR PERFUME. FOR THIS MOMENT, HOWEVER, SHE HAS THE BAG, AN ICON FOR ALL TO SEE.

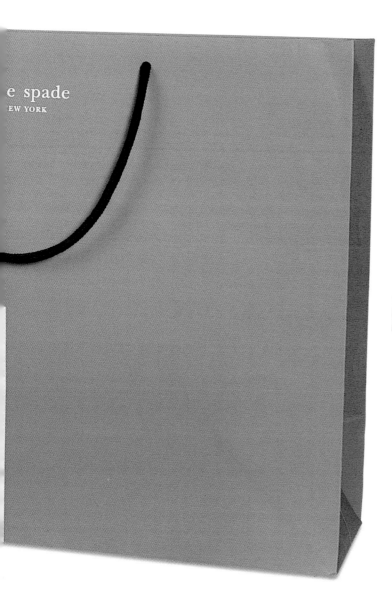

e spade
EW YORK

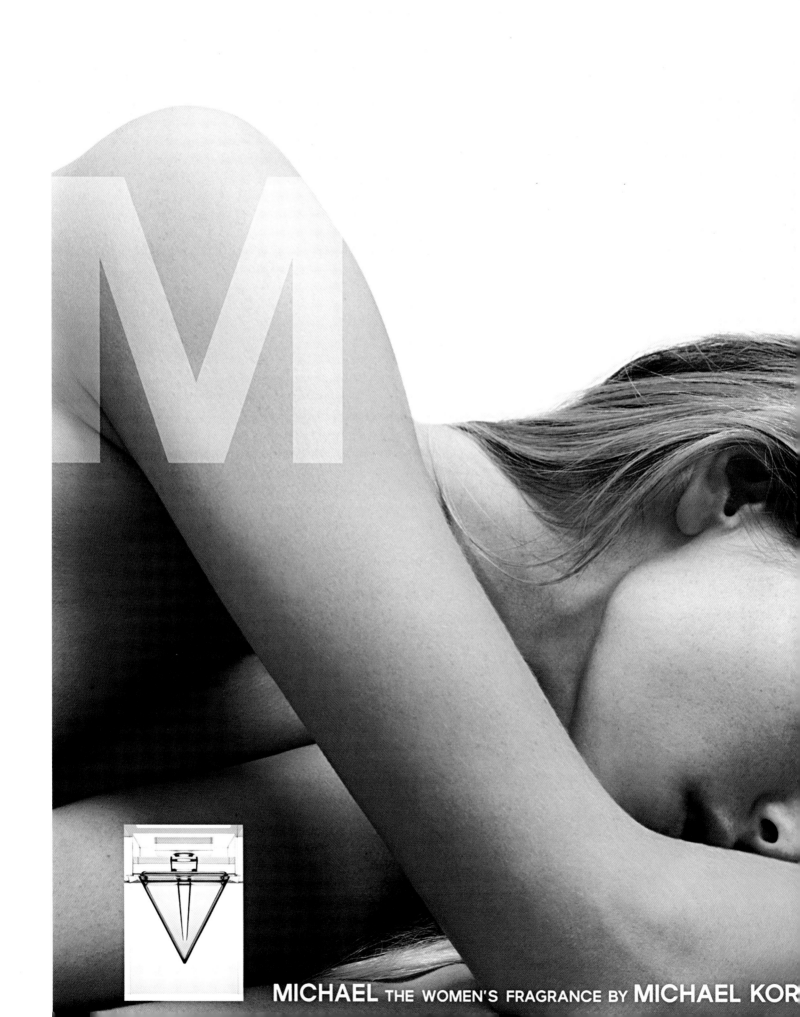

MICHAEL THE WOMEN'S FRAGRANCE BY MICHAEL KOR

Spinning the bottle—a game designers play. What thoughts cross a woman's mind when she reaches for her perfume? Clothing and fragrance designer Michael Kors and creative designer Chad Lavigne ruminated on just that when they crafted a perfume bottle of just the right heft—1.25 pounds—and size—to be cradled in the palm of a hand—and look—loose, ambient amber liquid moving within the flash of refracted light in a clear crystal bottle, raising the question to the pulse point of a woman's heart. Lavigne designed an angular M within the architectural formation of crystal facets, a sharp-angled sublimation of an initial, A REMINDER OF A MAN. But design is one thing and production another. Lavigne was told the bottle couldn't be made. Camille McDonald, president and CEO of American Designer Fragrances, Parfums Givenchy, LVMH, searched until she found a French crystal vendor, Cristallerie de Haute Bretagne, in Fougéres, who was willing to execute the design by an old crystal-fusing technique, one never before tried in perfume bottle production. Instead of blowing a cavity, workers press a V into the base, heat-seal it to the shoulder of the bottle, then hand cut, trim, and polish the pieces. But success is won at a cost: Each bottle requires 24 man-hours and 11 glass workers. Here, packaging breathes the same rarefied air as perfume. "The Lauders and L'Oréals of the world would never do anything like this," says Lavigne. "It shows the LVMH commitment to over-the-top luxury and creativity. Nobody's ever done what we've accomplished."

michael kors

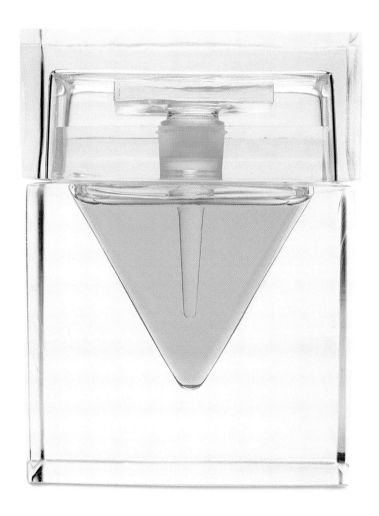

PACKAGING

| 1 | 2 |

111

R by 45rpm

The door opens to the scent of sandalwood and Japanese cedar, the sound of water settling down on stone. Yellow and gray mud walls meet a platform of Bubinga hardwood, its great weight balanced by the *wabi-sabi* aesthetic of imperfection, with necklace beads imbedded in its cracks. Pottery gleams. These are the sights and smells and sounds of Japan, imported by the denim and casual-wear boutique, 45rpm. Mesmeric: an American clothing icon, interpreted by Japanese designers, sold SINO-STYLE in the heart of New York's Soho. Long-time chief designer Yasumi Inoue imparts her vision on the three indigo-influenced lines: &, R, and Badou-R, as does interior designer Shiro Miura, re-creating his homeland in the American store. And no expense is spared: mud masters with their masons; ceramics from the Oogoya kilns of the Shiga prefecture; Jendai cypress floors; and Henri Béguelin leather doors. Everyone—the manager, the buyer, the PR person—cleans, every morning, from 9:30 to 11:00, until everything is ready to usher in the new day. A ladle of water is measured out against the stone floor; the door opens.

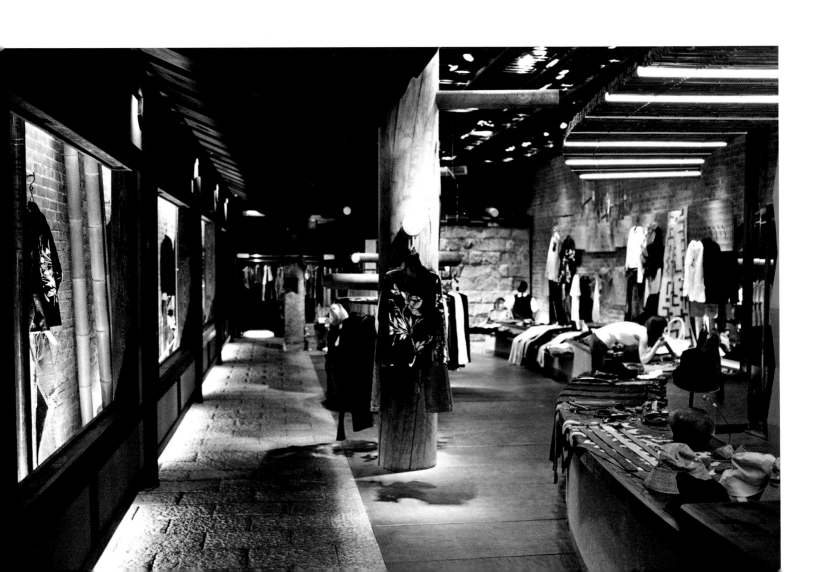

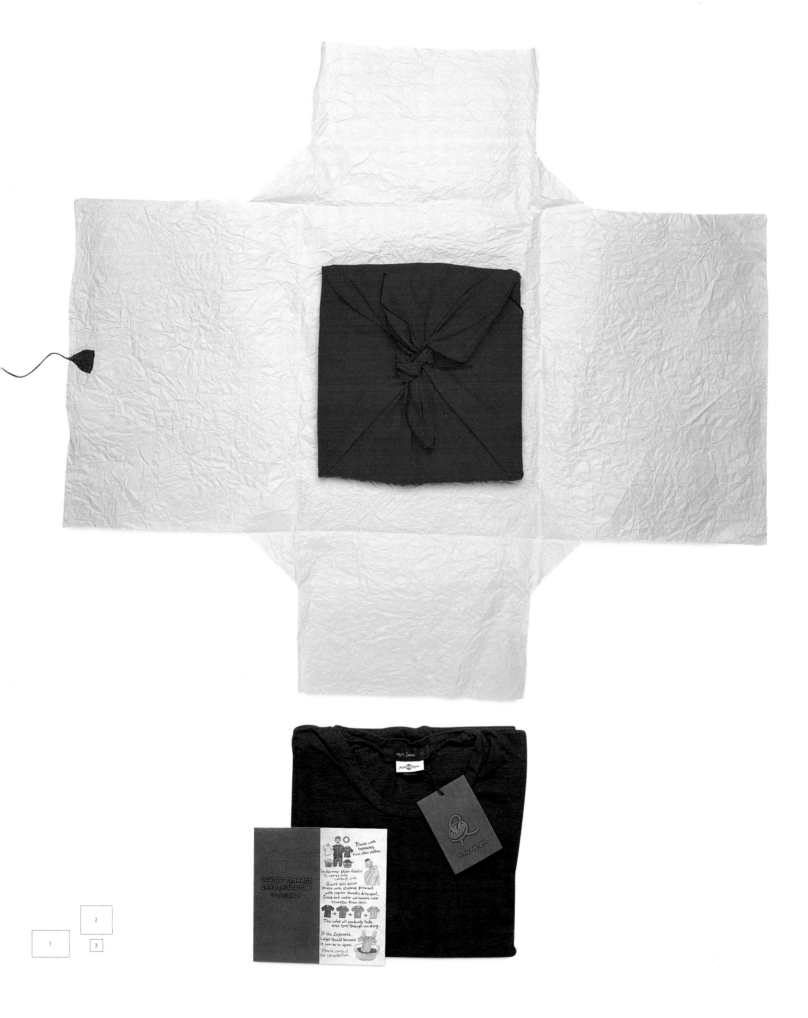

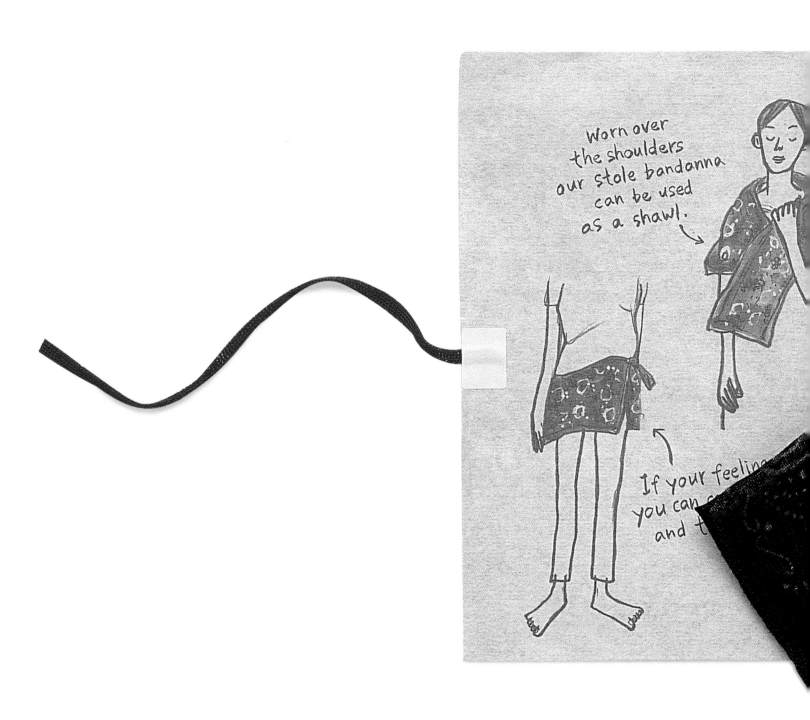

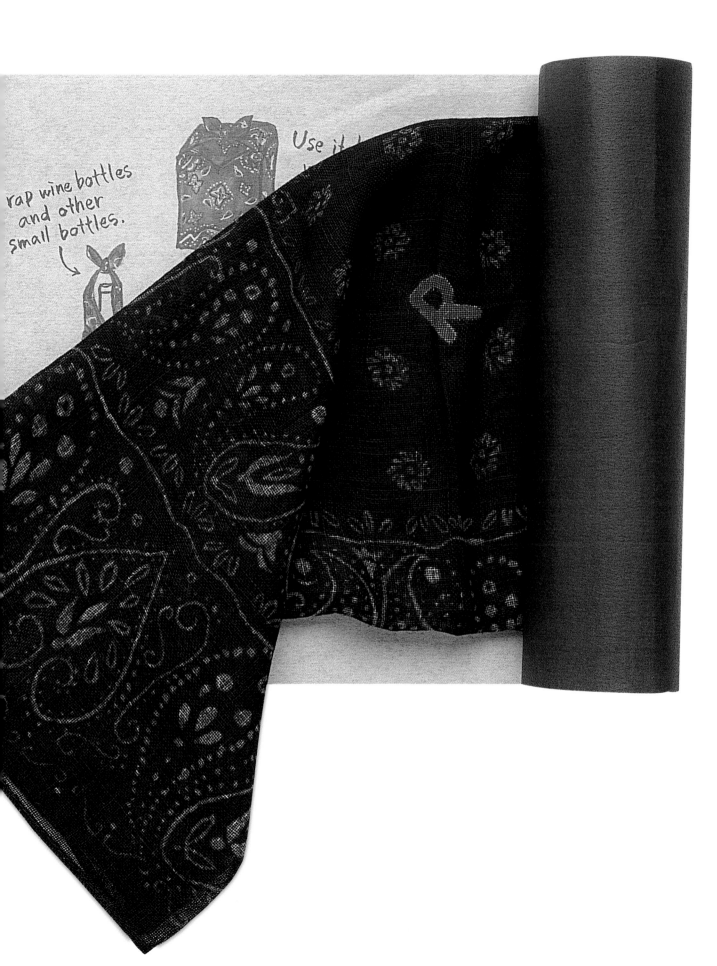

rap wine bottles
and other
small bottles.

Use it

PACKAGING

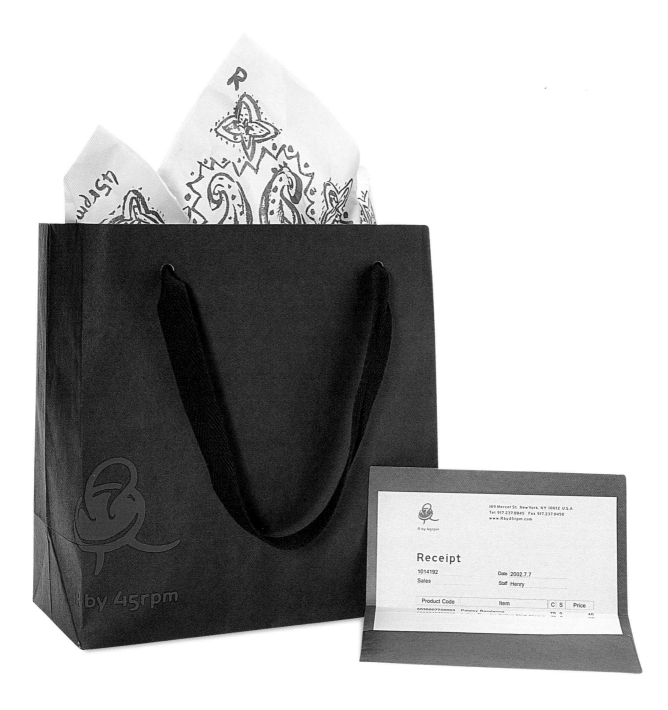

Receiving a gift from New York clothing store 45rpm is as traditional as old-world Tokyo, AN HOMAGE PAID IN COLOR AND DESIGN. Two logos—a sleeping R (rotated to lie on its side), and an R as a filigree of thread, dancing through a buttonhole—adorn their bags, envelopes, and cards. Three colors—indigo, beige, and brick red—resurface on totes, scrolls, corded Washi, and tissue papers, repeated even on hangtags, in the color of care instructions and offers to re-dye faded garments, next to watercolor sketches of smiling indigo-dyers. The interiors of scrolls are covered in diagrams, ways to utilize a scarf: as a shawl, a belt, a sling to carry wine. Light items are laid flat and rolled within the deep-blue tube, secured by a red ribbon, whose tails invite easy carrying, reminiscent of ways to wrap five eggs: traditional but not formal, useful but not daunting. Midsize pieces are folded in Japanese tissue. Heavier wear gets wrapped in Furoshiki—blue-edged, red scarves that are tied, squarely, with a bow in the middle—a handle for carrying. Special gifts layer together all these concepts: an exterior of traditional white Washi, shaped into the modern flaps of an envelope; beneath, a Furoshiki; within that, tissue paper held together by an R, pulled as thread through a button, beneath which, at last, lies the product.

To be young is to be green as grass, living a life outdoors, voting for the Green Party. Diesel's choice for its perfume name and color woos all that with a MORDANT TWIST, the company's signature voice describing the scent as "an invasion of nature." To package tenderness and an unblemished sensibility without seeming too serious or juvenile, Diesel designers conceived of a spritz bottle made of glass and plastic, for buyers to spray themselves as if they were ferns on a window sill. Setting itself apart from the pack, Diesel invents not only a new perfume but a new way of scenting yourself, a type of home gardening, aiming the nozzle at the inner self as much as the skin. Cleverly designed to further the expectation of youth and growth, the scent adds a layer to Diesel's already powerful aura. "It's what they expect from us," explains vice president of marketing Maurizio Marchiori. "People don't buy a product, they buy what is generated by the product…wanting to be in the Diesel lifestyle."

diesel

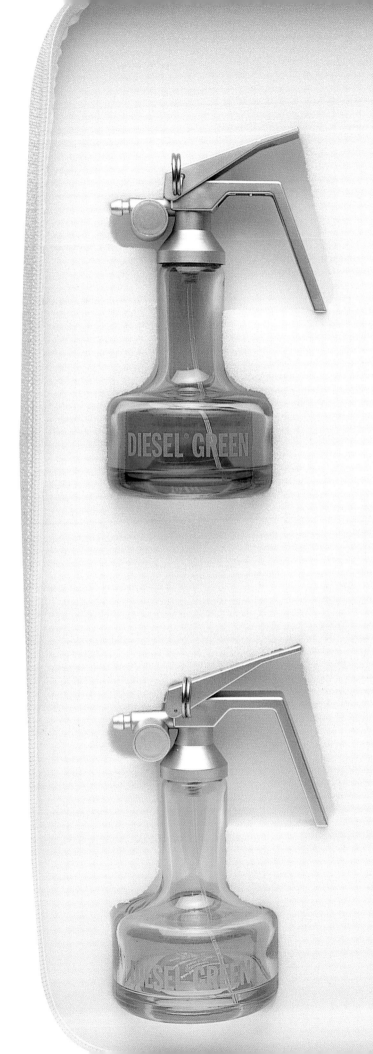
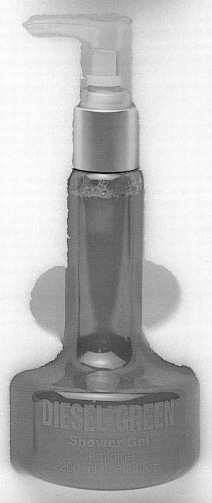
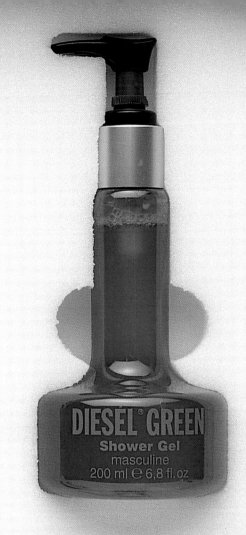

retail space

One hundred people stroll along Madison Avenue. Forty of them are shopping for what they need. Sixty of them will buy something they like.

The shops, like she-gods, beckon.>

121

RETAIL SPACE

A PERFECT SHOP COURTS A CUSTOMER'S EVERY STEP, WITH ENTICING SOUNDS, SMELLS, TACTILE SENSATIONS, AND EVEN TASTE, SUSTAINING A MOOD DESIGNED TO ELICIT A RESPONSE. EVERY LIGHT FIXTURE, DOORKNOB, CHAIR, EVEN THE STYLE OF A SALESPERSON'S HAIR, HAS BEEN SEDUCTIVELY COORDINATED TO BUILD A PRIVATE DWELLING PLACE. DRESSING ROOMS BEAR SILENT WITNESS TO THE QUIET UNVEILING OF A DREAM. THE CUSTOMER FINALLY COMES BEFORE A MIRROR, FACE TO FACE WITH THE PERSONA OF THE BRAND. ALONE, THE CUSTOMER PROCEEDS TO DO THAT MOST PERSONAL AND TRUSTING THING: UNDRESS. DEEP INSIDE THE BRAIN OF THE BRAND, A HALF-DREAM DEVELOPS, AND TIME MOVES ALONG IN A FREE-FALLING FANTASY AS THE CUSTOMER REVISITS AN INNOCENCE ALLOWING THEM TO BE ANYONE THEY WISH TO BE. A PERFECT SHOP ESTIMATES HOW MUCH SOLITUDE TO PROTECT AND HOW MUCH COMPANY TO GIVE. DEPARTMENT STORES CAN ONLY OFFER CORNERS, WHILE MALLS PROVIDE LITTLE WHITE CUBES, SO A BRAND MUST HERALD ITSELF THROUGH ITS FLAGSHIP STORE. DIESEL, NIKETOWN, PRADA/GUGGENHEIM, AND STORES THAT ARE THEMSELVES THE BRAND—BERGDORF'S IN NEW YORK, HARRODS IN LONDON, COLETTE IN PARIS—ARE DESTINATIONS IN THEIR OWN RIGHT, PURE THEATRE. *BREAKFAST AT TIFFANY'S* INDELIBLY BRANDED THE FLAGSHIP STORE WHEN THE CLERK CONSIDERED THE COUPLE'S CRACKER JACK RING WITH THE SAME COURTESY EXTENDED TO FLAWLESS D DIAMONDS. THE STORE MAINTAINS THAT ALL-AMERICAN GENTILITY, FILLING THE VISITOR WITH AN EVOCATIVE RUSH, MUCH AS THE WHOOSH OF AIR TRANSPORTED THROUGH THE ROTATING DOORS. EACH VISIT BRINGS BACK A HOST OF CHILDHOOD POSSIBILITIES: ANYONE CAN TRY ON A $30,000 NECKLACE; EVERYONE CAN PLAY AT BEING ENGAGED. THE LAST THREE FEET OF THE SALE, THE FINAL YARD TO THE CASH REGISTER, IS THE LONGEST WALK. MAKING SURE THE CUSTOMER DOESN'T LOOK BACK, MANAGERS CUT THROUGH LINES, SALESPERSONS MURMUR APPROVAL AND AFFIRMATION AT THEIR CHOICES; CLUB MEMBERSHIPS AND MAILING LISTS ARE OFFERED. A PERFECT SHOP ANSWERS CUSTOMERS' QUESTIONS BEFORE THEY EVEN RISE TO THE SURFACE: IS THIS THE PLACE I'VE WAITED FOR? YES. IS THIS WHERE I CAN BE FREE? YES. AM I HOME? YES.

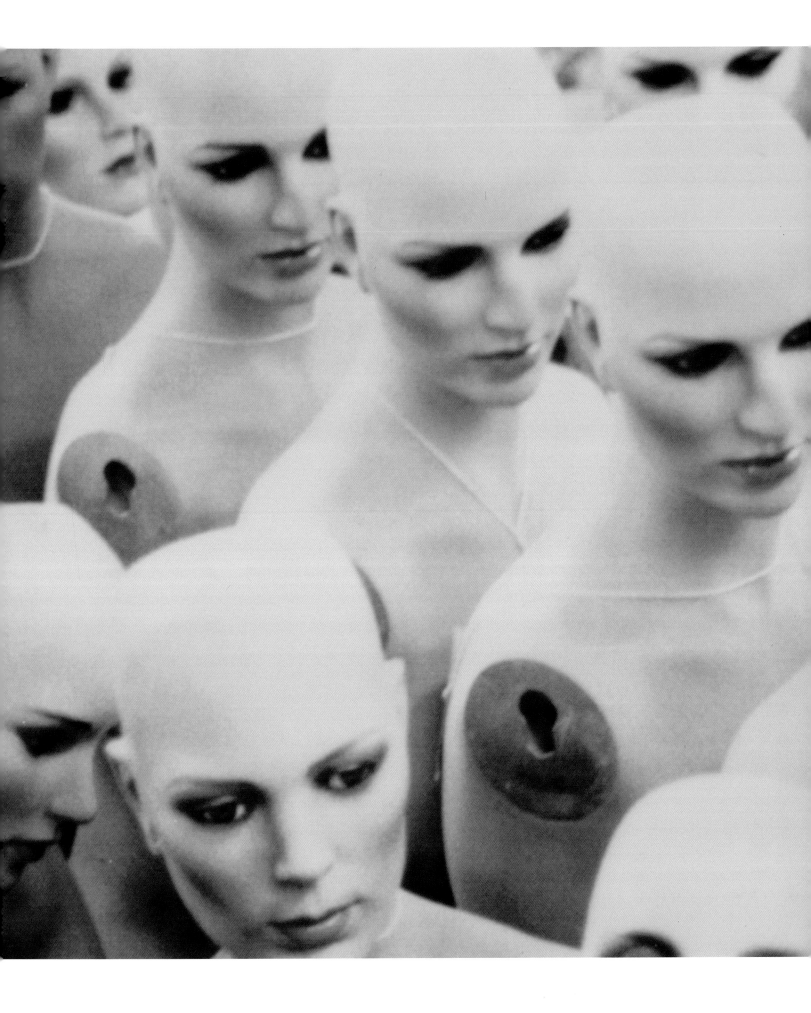

PRADA
modern medici

SLIGHT, SMALL, SHY, 14-YEAR-OLD CATHERINE D'MEDICI LEFT FLORENCE IN 1542 TO BE PRESENTED AS THE WIFE OF FRANCE'S FUTURE KING, HENRI II. CHIC, SOPHISTICATED, AND NATIONALISTIC, THE FRENCH COURT AWAITED HER ARRIVAL WITH CONTEMPT. HOW TO ENTER A COURT DOMINATED BY *FASHIONISTAS* AND MAKE ANY KIND OF AN IMPRESSION? D'MEDICI ENLISTED THE HELP OF A FLORENTINE COBBLER, WHO CRAFTED FOR HER ONE OF EUROPE'S FIRST PAIR OF HIGH HEELS. WHEN SHE MADE HER ENTRANCE, HIPS UNDULATING IN THE SIGNATURE WAY OF THE CUSTOM SHOE, IT CAUSED A SENSATION. D'MEDICI *ÉTAIT*

ARRIVÉE, AND FRENCH FASHION MADE ROOM FOR HER. **THERE'S A LOT OF MEDICI IN MIUCCIA PRADA.** QUIET, WELL-EDUCATED, ELEGANT IN SAINT LAURENT AND DIOR, THIS GIRL OF PRIVILEGE TOOK OVER HER FAMILY'S MILANESE LEATHER GOODS BUSINESS AND CHOSE INNOVATION AS THE TOOL TO HACK A PATH THROUGH THE FASHION FOREST, SEWING A HIKER'S BACKPACK OUT OF THE SAME NYLON HER GRANDFATHER USED FOR THE INTERIOR OF HIS BAGS, AND AFFIXING TO IT A TINY SILVER TRIANGLE, SHE CHANGED THE COURSE OF FASHION FOR AT LEAST TWO DECADES. DECONSTRUCTED MINIMALIST PRADA PROVIDED A ROAD

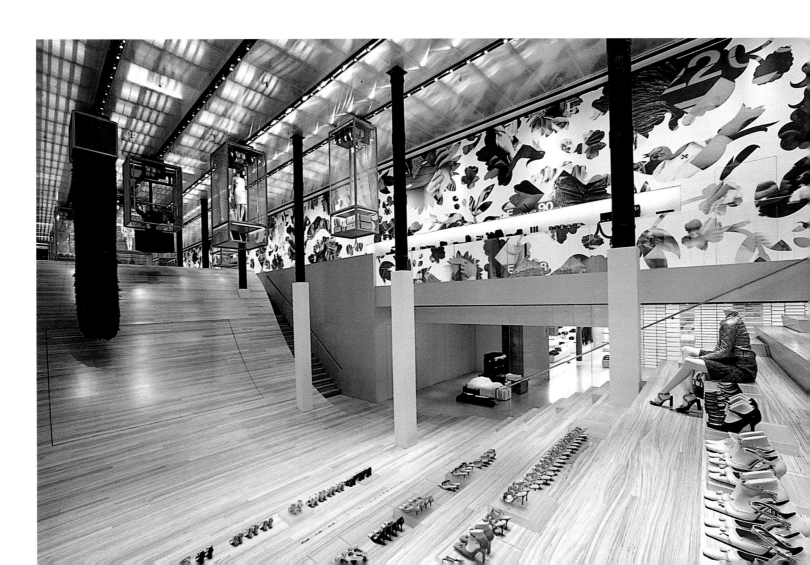

NOT CRISSCROSSED BY THE GILT CHAINS OF THE EIGHTIES—AND STREAMS OF PEOPLE WALKED IT. "THE MOST IMPORTANT THING IS IF A BRAND HAS HISTORY, IF IT HAS LEFT A MARK ON THE MARKET," PATRIZIO BERTELLI, CEO OF PRADA AND THE DESIGNER'S HUSBAND, HAS SAID. "THEN EVERYTHING CAN BE REDEFINED AND REEVALUATED. HISTORY IS ALWAYS STRONGER THAN PEOPLE." THE PRADA/BERTELLI DYNASTY, LIKE A RENAISSANCE STATE, EXERTS INFLUENCE AND POWER, PRESENTING IDEAS ON THE WORLD'S STAGE BY CONTRACTING WITH THE BEST IN THEIR FIELDS TO ACTUALIZE THEIR DREAMS, AND NOT LETTING MONEY STAND IN THE WAY. WHETHER SECURING REAL ESTATE IN NEW YORK OR BACKING A SAILBOAT IN THE AMERICA'S CUP, OR FUNDING ART PROJECTS. PATRIZIO, A ONE-TIME LEATHER MANUFACTURER, MARRIED MIUCCIA IN 1988, AND SEVEN YEARS LATER THEY MERGED HIS TUSCANY-BASED FACTORY AND GRANELLO LINE WITH HER COMPANY. BERTELLI BUILT A FORTRESS FOR PRADA'S DESIGNS, ESCHEWING THE TRADITIONAL MOVE OF LICENSING AND FRANCHISING. INSTEAD, HE CHOSE CONTROL: OF QUALITY, COST, IMAGE, AND ACCESS THROUGH THEIR SELF-OWNED FACTORIES AND SHOPS. THEY COLLABORATED WITH TECHNOLOGISTS AND FINE-TUNED AN ASSEMBLY-LINE STYLE OF MANUFACTURING THAT FLEW IN THE FACE OF TRADITION. RATHER THAN SEEMING BOURGEOIS OR DOWNSCALED, THE MOVE POLISHED PRADA'S PROFILE: CLEAN, EFFICIENT, FUTURISTIC. BUSINESSES ACCUMULATED UNDER THE HOUSE OF PRADA: FENDI, JIL SANDER, HELMUT LANG. CHURCH'S SHOES, AZZEDINE ALAÏA, AND THE GENNY GROUP RECEIVE THE SAME MANAGERIAL TREATMENT. BERTELLI'S STRATEGY: BUILD THE BRANDS INTO BILLIONS BY 2010, THEREBY CHALLENGING THE STANDING CONGLOMERATES, LVMH (LOUIS VUITTON MOET-HENNESSY) AND PINAULT-PRINTEMPS-REDOUTE (WHICH OWNS GUCCI). PRADA'S STYLE JUXTAPOSES MINIMALIST DESIGN AND LIGHTWEIGHT, OFTEN SURPRISING, MANMADE FABRICS, ALLOWING WOMEN TO DRESS IN A NOSTALGIC WAY THAT IS ALSO REVOLUTIONARY AND LIBERATING IN FIT AND ACCESS. HERS IS A PRIVATE-KEY GARDEN OF COOL COMFORT, ONE WITH DISTINGUISHABLE FEATURES THAT ONLY INSIDERS RECOGNIZE, CLOTHES OF THE HEARTH AND THE POSTMODERN CITY. BERTELLI'S STYLE IS A COMMITMENT THAT EACH ACTION MEETS ITS EXPECTATION; IF NOT, HE THROWS PRODUCTS OUT OF WINDOWS, SMASHES MIRRORS, BERATES STAFF. TOGETHER, THEY ACT AS TRANSFORMERS, DOMINATING WITH PRADA DONNA, PRADA UOMO, MIU-MIU, AND PRADA SPORT. LIKE CATHERINE, BIDING HER TIME IN A FOREIGN LAND, MIUCCIA HAS SAID, "I KNOW THE MOMENT OF DANGER. IT COMES WHEN THEY LOOK TO YOU FOR ONE THING ONLY." ERGO, HER SIGNATURE SHOES: CHUNKY, ODD, DETAILED, TRANSFORMING THE LEG INTO A THING OF BEAUTY WITHOUT DISCOMFORT, HIGH ENOUGH TO ENSURE THE MESMERIC WALK. AND THEY ARE MARY JANES, THE SHOES OF CHILDHOOD, WHEN GIRLS BELIEVED THEY RULED.

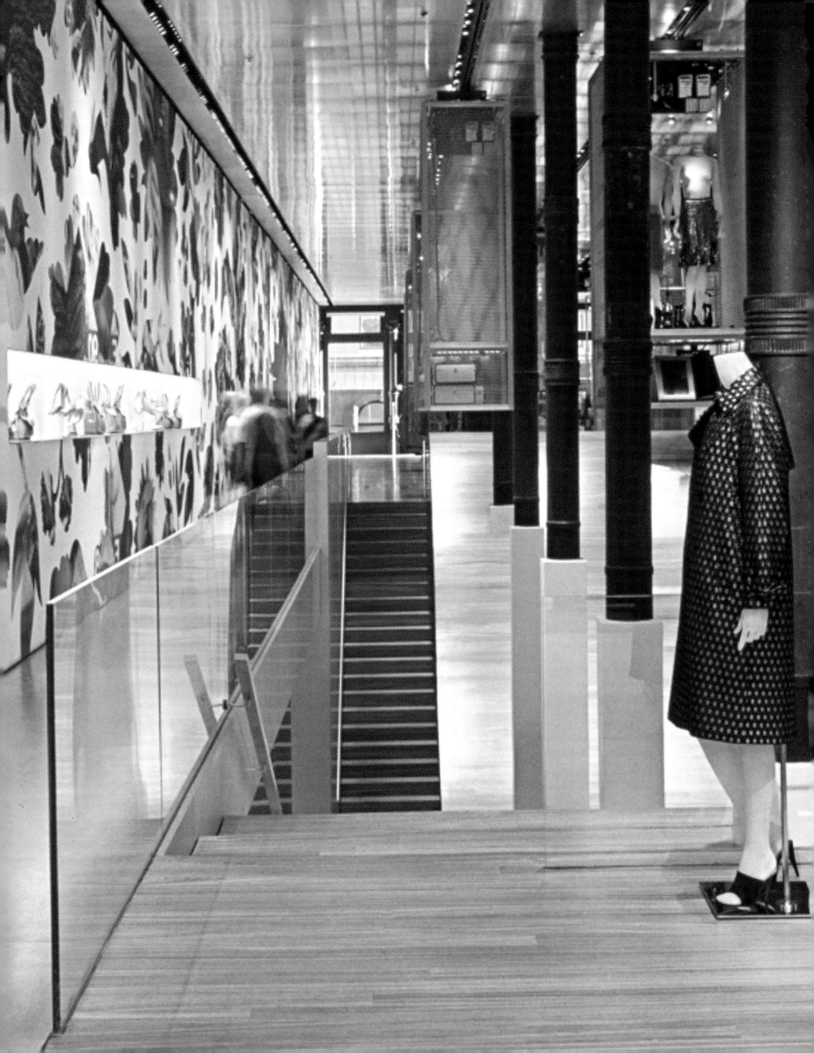

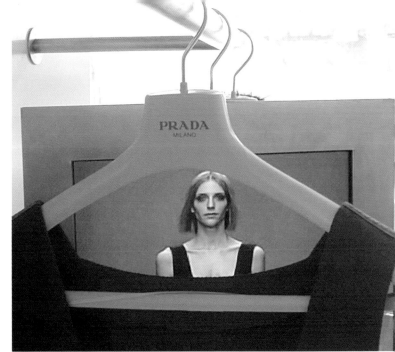

CLEMENS WEISSHAAR & REED KRAM

function.form.fashion.

PRADA WHEELED REM KOOLHAAS AND HIS OFFICE FOR METROPOLITAN ARCHITECTURE (OMA) ONTO ITS STAGE LIKE A DEUS EX MACHINA, AND HE HAS WORKED HIS TECHNOLOGICAL MAGIC, TURNING THE FIRM'S SELF-DESCRIBED EPICENTER STORE IN SOHO INTO AN EPIC-CENTER, A DESIGN TREAT FULL OF THE BEST TRICKS, IMPLEMENTED BY THE WORLD'S TOP TALENT. KOOLHAAS FEEDS NEW YORK'S TWO APPETITES, FOR LEARNING AND CREDIT-CARD SLIDING, AND FINESSES THE FASHION LEADER'S IMAGE FROM "LITTLE PRADA," A SMALL SHOP IN MILAN, TO "GLOBAL SUPERPOWER PRADA," MIGHTY, CORPORATION INCLUDING SEVERAL OTHER FASHION HOUSES.>

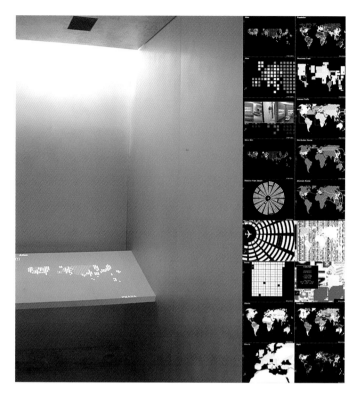

KOOLHAAS IS A DUTCHMAN OF WELL-PLACED WORDS AND VISIONS, METICULOUS AND PATIENT, HOLDING OUT FOR PERFECTION, AND CHARISMATIC ENOUGH TO GET OTHERS TO JOIN HIS 30 MONTH RUN. IT'S A COLLABORATION WORTHY OF AYN RAND. THERE IS MARKUS SCÄFER, PROJECT COORDINATOR AND DIRECTOR OF KOOLHAAS' PRODUCTION AND RESEARCH COMPANY AMO; JENS HOMMERT, OVERSEEING VIDEO AND BOOK CONTENT; MEDIA DESIGNER REED KRAM, FORMERLY WITH MIT'S MEDIA LAB, FOR INTERFACES; INDUSTRIAL DESIGNER CLEMENS WEISSHAAR, ENVISIONING THE DISPLAYS; GRAPHIC ARTIST MICHAEL ROCK AND HIS FIRM 2 X 4, FOR WALLPAPER DESIGN; AND LONDON'S IDEO, FOR THE DRESSING ROOMS' FROST-TO-CLEAR GLASS DOORS. AS TO THE 30,000-SQUARE-FOOT (2,787-SQUARE-METER) SPATIAL CREATION, KOOLHAAS AND HIS OMA DREAMED IT UP TO INCLUDE A TWO-STORY WAVE HIDING A MECHANICAL STAGE, AN AMPHITHEATER OF STEPS, AND A HANGING CITY OF CLOTHES AND LED SCREENS SUSPENDED FROM THE CEILING ON RAILS, WHICH ARE COMPRESSED AT NIGHT. AT THE HEART OF THE DESIGN IS MEDIA, FROM DRESSING ROOM CAMERAS PLAYING BACK IMAGES OF CUSTOMERS WEARING OUTFITS TO AN INTERACTIVE ATLAS THAT INVITES SHOPPERS TO SPEND TIME WITH THE BRAND—AND

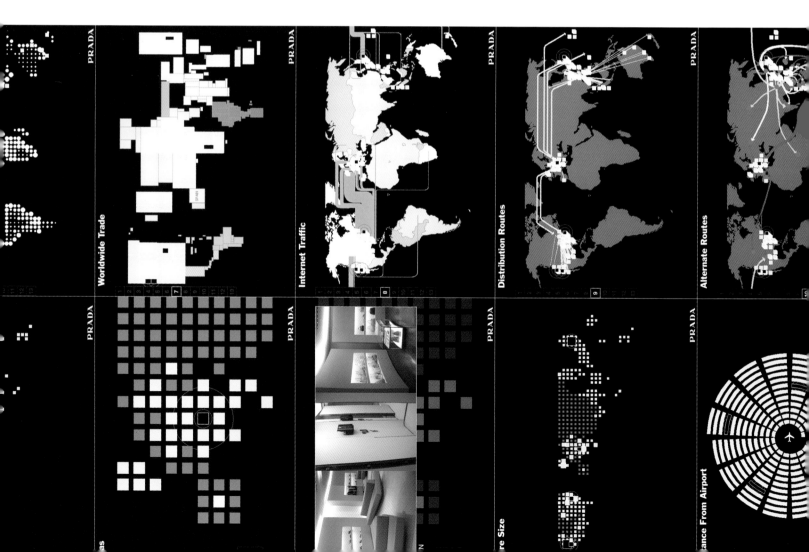

WITH EACH OTHER, IN THE TINY, DARK VESTIBULE. TOUCH IT AND FIND STORE LOCATIONS, INTERNET ROUTES, TRADE ROUTES, DISTRIBUTION OF WEALTH, RELIGIONS, CLIMATES. PLACE YOUR HAND OVER SOUTH AMERICA AND COMMAND-VIEW RELIGION: A PALE RED CROSS COVERS YOUR PALM, LIKE STIGMATA. "THE INTERACTIVE ATLAS [FUNCTIONS] AS A STORE LOCATOR, BUT ALSO AS A WINDOW TO THE LARGER IDEA OF PRADA," SAYS KRAM, WHO DESIGNED THE INTERACTIVE ATLAS, THE PROTOTYPES FOR THE MEDIA WITHIN THE DISPLAYS, THE DRESSING ROOMS, AND THE HAND-HELD DEVICES. "IT'S DISINGENUOUS TO PRETEND [PRADA] IS A SMALL COMPANY. [BUT] IT ALSO DIFFUSES THE IDEA OF THE MULTINATIONAL CORPORATION AS [BEING] SOMETHING OF A THREAT." WHAT WORKS IN NEW YORK AND FITS CULTURALLY IN SAN FRANCISCO AND LOS ANGELES WILL BE INCORPORATED TO THOSE CITIES' PROJECTS AND FILTERED DOWN TO THE BRAND'S 300 OTHER STORES. WEISSHAAR'S 62 PORTRAIT FORMAT SCREENS PROVIDE "SERVICE" DATABASES OF FASHION INVENTORY FOR SHOPPERS AS WELL AS WHAT KOOLHAAS REFERS TO AS "AURA"—PRADA TEAMS TRAINING IN THE MORNING; PRADA FACTORIES AND THE TUSCANY ROADS LEADING TO THEM; PRADA'S RUNWAYS. THE 20 LARGEST SCREENS ARE SUSPENDED BETWEEN THE GARMENTS FROM HANG BARS; 20 MORE ROTATE; 6 OTHERS LIE WITHOUT MECHANICAL SUPPORT. "IT WAS A MASSIVE PUSH TO DEVELOP SOFTWARE," SAYS WEISSHAAR, "AN INTERNAL STRUCTURE CAPABLE OF BEING SUSPENDED FROM ONE TINY LITTLE HOOK." THE CREW WORKED IMPECCABLY AND ALONE AGAINST DEADLINE. WEISSHAAR HIRED EMECO, MAKERS OF PHILIP STARCK'S LIGHTWEIGHT CHAIRS, FOR THE DISPLAY ENCLOSURES; SCHARFF-WEISSBERG TO BUILD A CUSTOM GRAPHICS CARD AND RF LAN NETWORK; AND WAGNER RAPID TOOLING FOR THE MANUFACTURING OF THE INTERNAL STRUCTURES. THIS VERSAILLES-LIKE ATTENTION TO THE VERY BEST MATERIALS AND JOURNEYMEN SUSTAINED A PROJECT WHOSE GOAL WAS "TO SHOW WHAT PRADA REALLY IS ABOUT, BY REVEALING THINGS NORMALLY NOT SHOWN IN THE FASHION WORLD, TO RESTORE THE EXCLUSIVENESS AND SHOW THE ITALIAN-NESS OF PRADA," SAYS WEISSHAAR. ITALIAN-NESS: A FUSION OF QUALITY-ORIENTED VALUES AND INDUSTRIAL ONES; OF MULTIPLICATION OCCURRING IN A SOPHISTICATED WAY. IT'S ABOUT PASSION. THE FINAL ACT IN THIS POST-MODERN PLAY: THE INTERACTIVE ATLAS SHOWING WHERE TO BUY FAKE PRADA. "IT'S A CLEAR STATEMENT MADE BY PRADA," SAYS WEISSHAAR. "AS REM SAYS: 'THE ULTIMATE LUXURY IS NOT TO BUY ANYTHING.'"

diesel Diesel, an empire that sprang from a singular worship of denim. "We treat denim like a piece of art," Renzo Rosso, owner and founder, has said. "We invest in it." So much so that Rosso designed three empty, white spaces to display his indigo riches in Soho, Osaka, and Tokyo. The public quickly named them the "DENIM GALLERIES" and they feature limited edition, five-pocket denim jeans that hang, in all their detailed glory, from a steel apparatus. Only items that "enhance the concept of denim" are included in the display: certain watches, sunglasses, bags, and design items by Karl Lagerfeld make the cut. Every four weeks a new installation features about 300 one-off jean prototypes and "product capsules" of a jacket, skirt, and jeans. The buyer is pampered: customized alterations by a staff tailor, hand-stamped with personal identity information on the inside pocket lining, and washed three times a week by a complimentary jean-laundering service. Out-of-towners are offered a unique detergent labeled, with Diesel's unmistakable twist of the comic-macabre, "the complete denim solution."

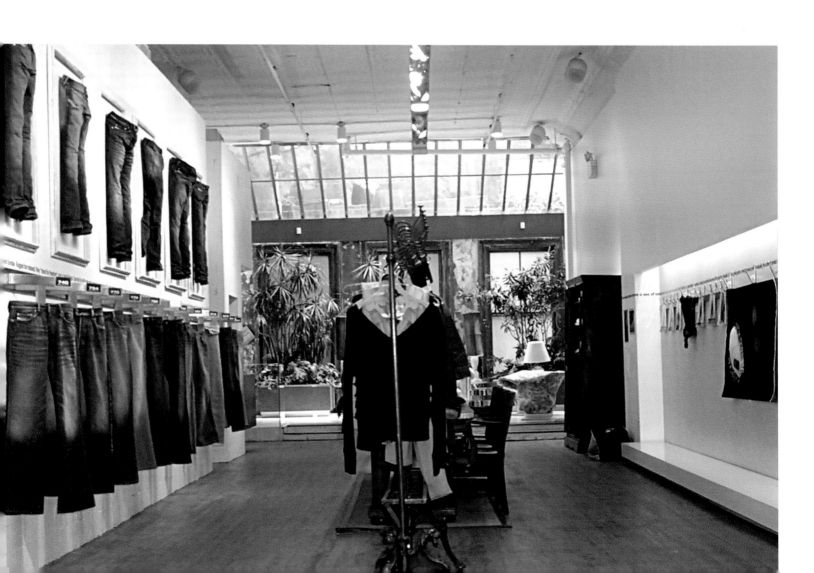

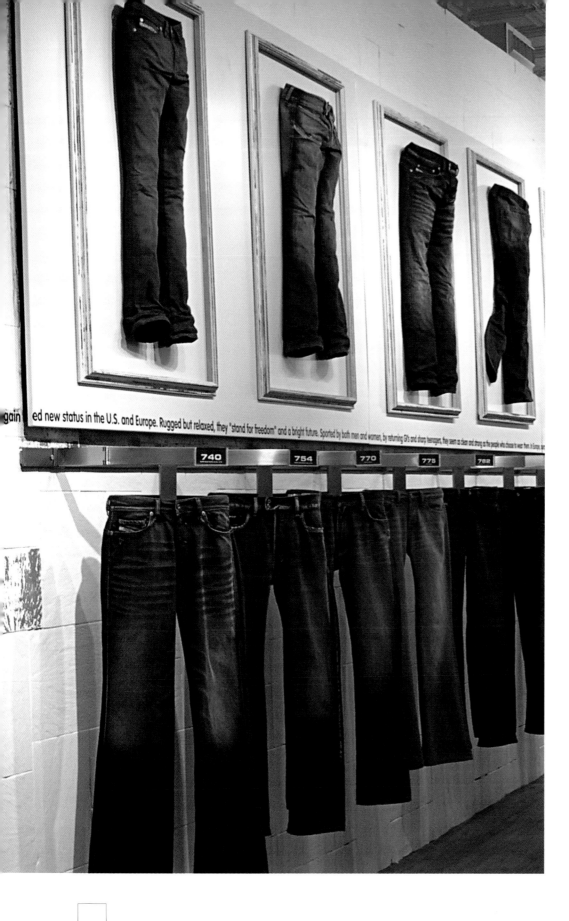

gain ed new status in the U.S. and Europe. Rugged but relaxed, they "stand for freedom" and a bright future. Sported by both men and women, by returning GIs and sharp teenagers, they seem as clean and sharp as the people who choose to wear them. In Europe, an

740 754 770 775 782

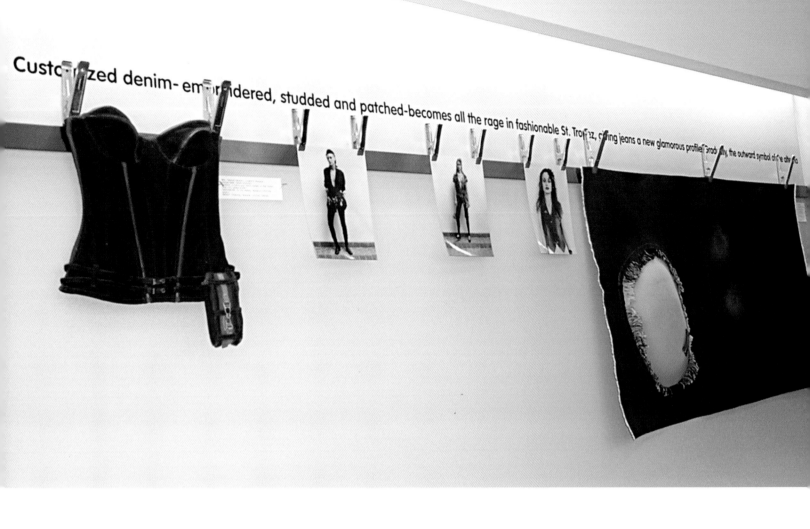

Customized denim- embroidered, studded and patched-becomes all the rage in fashionable St. Tropez, giving jeans a new glamorous profile. Grab it, the outward symbol of the above

1

2

3

HELMUT LANG PARFUMS

WWW.HELMUTLANG.COM

JENNY HOLZER

provoking the senses

SCENT AND MEMORY ARE SO DEEPLY CONNECTED
THAT WHEN ARTIST JENNY HOLZER PUT HER ELECTRONIC
SIGNS IN CLOTHING AND FRAGRANCE DESIGNER
HELMUT LANG'S GREENE STREET STORES, SHE
EVOKED A PROUSTIAN REMEMBRANCE OF THINGS
PAST. EMOTIONALLY CHARGED WORDS FLY BY THE
EYE, TICKER TAPE–STYLE, JOLTING THE UNGUARDED
VIEWER INTO A LICIT AND FORBIDDEN RANGE OF
MEMORIES. THE LANG TEXT—AND HOLZER'S THOUGHTS
ABOUT THE COMMINGLING OF HER ART AND HIS
DESIGN—ARE PRINTED BELOW

I WALK IN
I SEE YOU
I WATCH YOU
I SCAN YOU
I WAIT FOR YOU
I TICKLE YOU
I TEASE YOU
I SEARCH YOU
I BREATHE YOU
I TALK
I SMILE
I TOUCH YOUR HAIR
YOU ARE THE ONE
YOU ARE THE ONE WHO DID THIS TO ME
YOU ARE MY OWN

"I WOULDN'T HAVE DONE ANYTHING LIKE THIS IF IT
HADN'T BEEN FOR HELMUT. HE'S A FRIEND. THOSE
PIECES AREN'T ADVERTISING; THEY ARE ARTWORKS
IN PUBLIC SPACES."

I SHOW YOU
I FEEL YOU
I ASK YOU
I DON'T ASK
I DON'T WAIT
I WON'T ASK YOU
I CAN'T TELL YOU
I LIE

"I CALL THIS THE 'ARNO TEXT' AFTER THE RIVER IN
FLORENCE, WHERE I PLACED AN INSTALLATION FOR
THE 1996 ART & FASHION BIENNALE. I PROJECTED THIS
TEXT ON THE RIVER, AND THAT WAS THE FIRST TIME I
WORKED WITH HELMUT. INGRID SISCHY PAIRED US UP.
WE COLLABORATED ON AN INSTALLATION IN A PAVILION
DESIGNED BY ISOZAKI, WITH ELECTRONIC SIGNS OF
MINE, AND HELMUT MADE UP A SCENT. SO THE
ATMOSPHERE OF THE PAVILION WAS AFFECTED BY
THE TEXT AND BY THE SCENT. THE SCENT AND THE
TEXT WERE TOGETHER AT THE INCEPTION."

I AM CRYING HARD
THERE WAS BLOOD
NO ONE TOLD ME
NO ONE KNEW
MY MOTHER KNOWS

"PEOPLE WHO GO INTO SHOPS ARE CONSCIOUS OF
THE BODY—AS HELMUT'S CLOTHES TEND TO MAKE
ONE FEEL. THIS WRITING ALSO HAS MUCH TO DO WITH
FLESH. IT'S A VERY NAKED TEXT; IT NEEDS CLOTHES.
ONE TEXT IS LYING DOWN. ONE TEXT IS VERTICAL;
IT RISES."

I FORGET YOUR NAME
I DON'T THINK
I BURY MY HEAD
I BURY YOUR HEAD
I BURY YOU
MY FEVER
MY SKIN
I CANNOT BREATHE
I CANNOT EAT
I CANNOT WALK
I AM LOSING TIME
I AM LOSING GROUND
I CANNOT STAND IT
I CRY
I CRY OUT

"I WAS THINKING ABOUT LOVE AND TRAGEDY. LOSS.
AND THEN LOVE AGAIN. TRAGIC ROMANTIC LOSS.
RELATIVE TO DEATH. THERE'S A DOSE OF BETRAYAL
THROWN IN THERE. PERHAPS THEN, THERE'S THE
RETURN OF LOVE."

I BITE
I BITE YOUR LIP
I BREATHE YOUR BREATH
I PULSE
I PRAY
I PRAY ALOUD
I SMELL YOU ON MY SKIN

"IT ALWAYS IS PERSONAL, BUT IT IS NOT A RECOUNTING. I
LIKE THINGS TO BE POTENTIALLY RELEVANT TO AS MANY
PEOPLE AS POSSIBLE."

I SAY THE WORD
I SAY YOUR NAME
I COVER YOU
I SHELTER YOU
I RUN FROM YOU
I SLEEP BESIDE YOU
I SMELL YOU ON MY CLOTHES
I KEEP YOUR CLOTHES

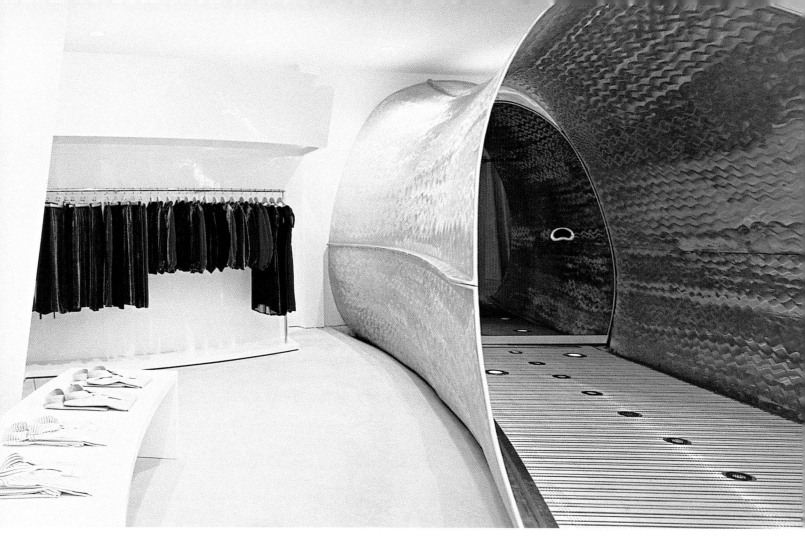

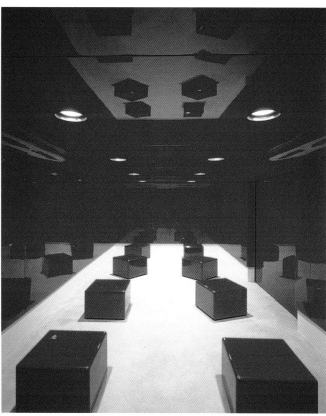

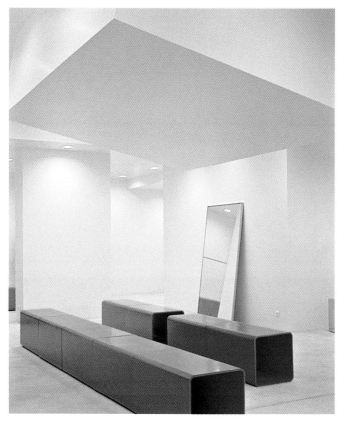

When constructing retail spaces for Rei Kawakubo's clothing line, Comme des Garçons, Kawakubo, with architect Takao Kawasaki, presents a docile façade by leaving the urban landscape untouched: A Paris courtyard reveals nothing but three flashes of red; Tokyo coordinates with a curved wall of glass; and in New York's Chelsea, the profile of a lazy street remains intact, down to the subtly referential auto-body shop sign, "Heavenly Body Works." But once THROUGH THE CURVED PORTAL ALL ARCHITECTURAL DEFERENCE STOPS and Kawakubo's vision of a futuristic, androgynous world takes flight. Six white enamel arcs twist up to 20 foot (6.1 meter) ceilings and bright fluorescent light. Exposed seams, wrap-around sleeves, flat-topped hats—Comme des Garçon's deconstructed clothes are stacked and hung in military rows and lines, laid within shelves and closets cut into the curving structures that are hollow, hiding excess clothing. Two large, black-lacquered dressing rooms stand, door-less. Black-clad salespersons hover in the empty doors, like the unspoken challenge, hanging in the air: Are you, in the end, like the boys?

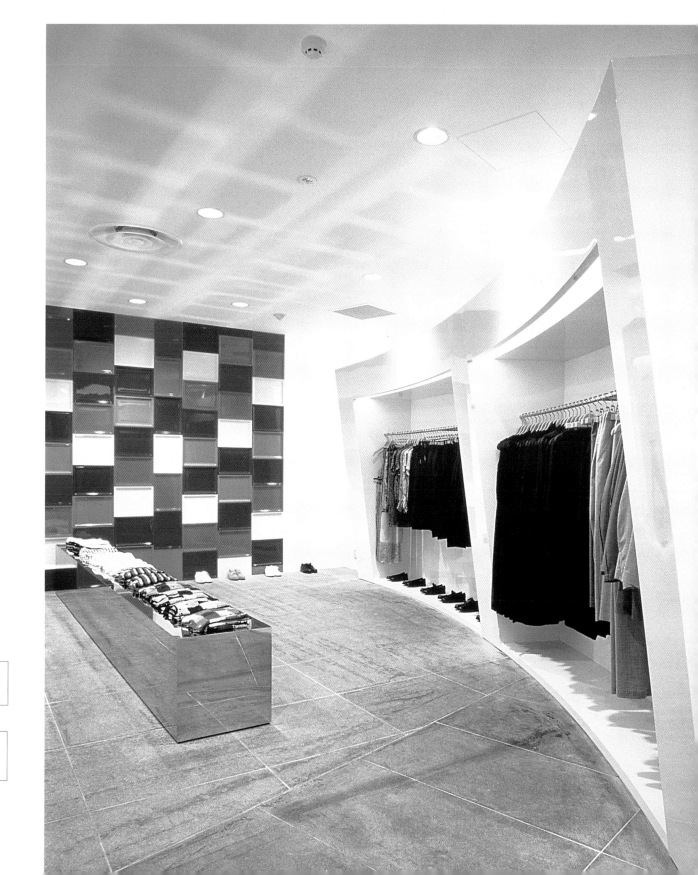

page 142-143

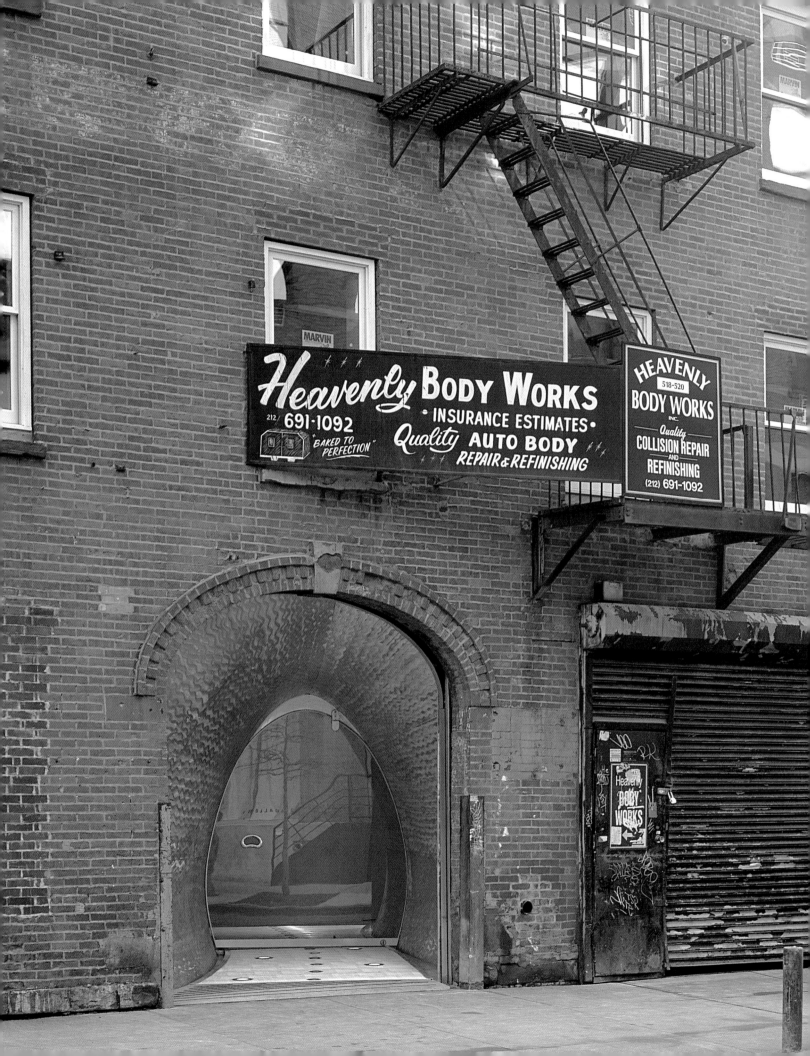

Just where rue Saint-Honoré matures into rue Faubourg Saint-Honoré stands Colette, like an adolescent on the verge of adulthood, the hippest shop in Paris. In one window, 16 videos play scenes from the Netherlands, while mannequins wear clothes by Dries van Noten. The other, a window knee-high in dead leaves; not a reflection of the season—outside is sweet June—rather, a tale of the clothes amidst the swirl: those of the once-vanished dauphin of design, Raf Simons. Every item, from kitsch to high-end has a story, each sought out in the world, brought back by the woman who owns the store, Colette, her daughter Sarah, and her staff. Like the CDs compiled in her name, Colette's success is in the mix; INDIVIDUALISM IS JUXTAPOSED WITH ANONYMITY. Enigmatic and intense, she hires staff on instinct and passion, trusting her taste; once approved, they are free to dress, talk, buy, and sell. And they do: Scruffy, sweet, scratching their bed-heads, they sell shoes by Marc Jacobs, Yves Saint Laurent, and Converse All-Star; books on Bellocq and Alba Nero; beauty by Nars and Kiehls. A clerk holds up leaf-woven 1,000-euro Henry Duarte jeans. Yes, they cost a lot. But they look great on Rosanna Arquette. They would look great on you. The one point of abundance is the water bar, with 73 choices, from Vittel to Llanllyr. Post-modern mistress of the twenty-first century, Colette recognizes the future of world currency and describes it as such: *Wattwiler, des Monts des Vosges, rare, très pure, 50 cl., 3.05 euro.*

colette

shiseido A picture box within a picture box contains an airy, white wood grid whose first-column squares are filled with vivid ruby-red acrylic. At the column's base stands a line of four glass bottles of the same deep crimson. Placed on either side of the grid, the bottles accent the three-dimensional depth of the composition, a reference to the LONGEVITY AND TIMELESSNESS of Eudermine, Shiseido's oldest and most symbolically important skin-care product, here in its eighth packaging reincarnation. "Shiseido has always emphasized the window space as equally commercial and artistic," says creative director Taisuke Kikuchi, who designed this window for New York's Clyde's Chemist. "[In it] I am always trying to communicate Shiseido's innovative technology and cultural heritage." No text, no background shots, no repeat ensembles of product, no Western multiple-media blitz; just the pure elemental details of straight lines, primary color, and shadow. Cost-effective? No. Influential? Yes. Affirms Kikuchi: "Old Japanese companies like Shiseido have a different point of view. It might not connect directly to sales profit, but should be beneficial in an indirect way."

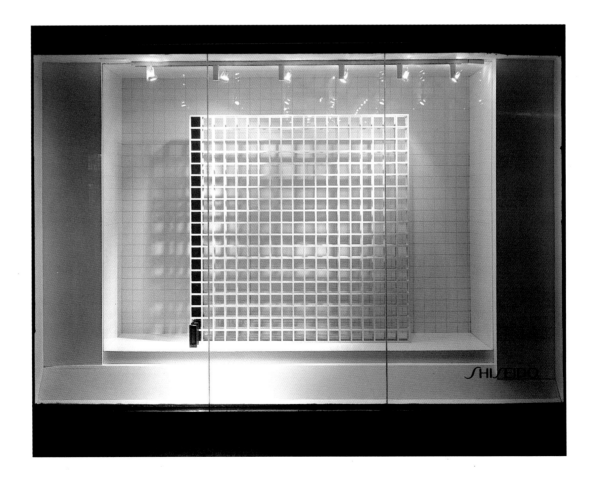

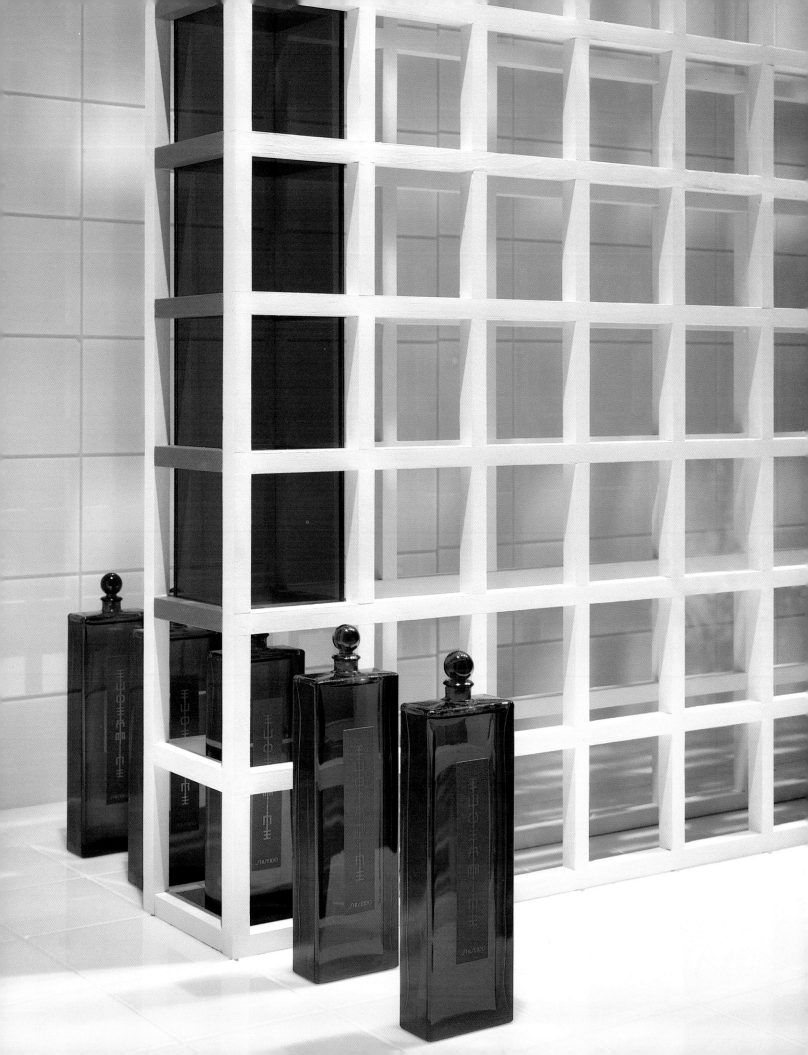

public relations

When an editor walks down the hall of a magazine office the morning after a fashion party, there had better be a residual sprinkling of last night's magic, enough to keep imagination ignited beyond next month's pages. Editors are the critics of the brand, and all the advertising dazzlement in the world will not stop consumers from turning to them for opinion. The discretion of editors churns the fashion machine with enormous power, determining the taste of millions.>

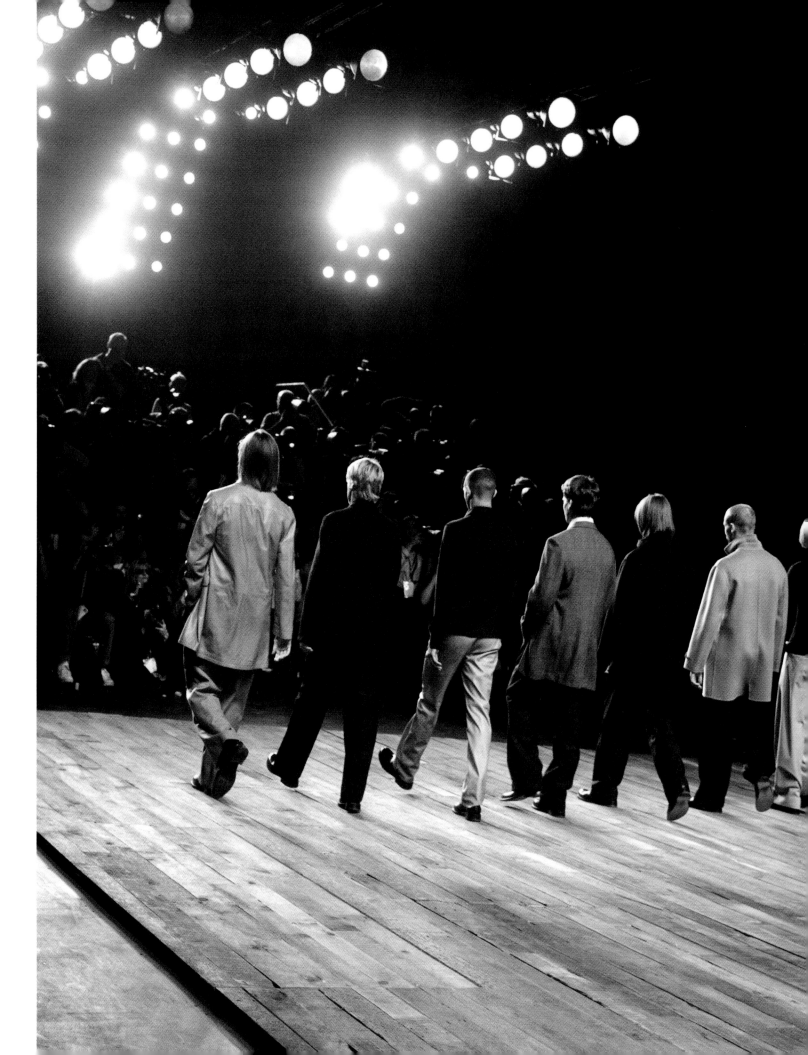

WITH EQUAL AUTHORITY STANDS THE CELEBRITY STYLIST—WHAT HALLE BERRY WEARS THE NIGHT BEFORE IS SHOWN ALL OVER THE FASHION HUNGRY WORLD TOMORROW; AND WHOEVER SITS IN A RUNWAY'S FRONT ROW—GWYNETH, SARAH JESSICA, MADONNA—WEARING THE CLOTHES OF THE DESIGNER, BECOMES AS IMPORTANT AS THE SHOW ITSELF. **UP-AND-COMERS HOPING TO BE NOTICED, ESTABLISHED AMERICAN DESIGNERS, HALLOWED FRENCH LABELS, AND CONGLOMERATE BUY-OUTS ALL TWIRL WITH INDIVIDUAL COLOR AND NUANCE, VYING FOR ATTENTION.**

ENTER PUBLIC RELATIONS: BACK ROOM DEALMAKER FOR THE DESIGNER, BEHIND-THE-SCENES BROKER PUSHING NEXT SEASON'S LOOK TO MULTIPLE MAGAZINES IN MULTIPLE VARIATIONS; KNOWING WHEN TO SCHEDULE SHOWS; TACTFULLY PRESENTING CLOTHES AND FRONT ROW SEATS, KEEPSAKES, CHARITY EVENTS AND THE MOST FABULOUS PARTIES-OF-THE-YEAR—CONSTANTLY KEEPING THE BRAND UNIQUE IN A WORLD THAT MUST ALWAYS BE FRESH, MEETING A CHALLENGE AS UNENDINGLY NEW AS FASHION ITSELF.

PSST...PSST...I HAVE SOMETHING YOU'D LIKE diesel
TO POSSESS. DO YOU KNOW WHAT IT IS?
ITS DARK AND MYSTERIOUS, SLEEK YET
SEXY. CURIOUS? IS YOUR HEART BEATING
WITH ANTICIPATION? Bullying the buyer, Diesel's
copy took advantage of the six-week window in August and
early September 2002 to launch its five shades of black
denim as a back-to-school alternative to the chino. Sent
to select customers, style-setters, and magazine editors,
the "Blackmail Style List" was a promotional concept of torn
newspaper strips, black cats, satin curtains, and low-rise
jeans. Creating buzz with a few weeks, a few people, and a
few images shimmering with the firm's signature anti-society
spin, Diesel goes after the trendsetting high-school market
and nails it: Hush, Stripp, Zink, Puller, and Fuse for her;
Stark-o, Rabox, Ravix, and Roody for him.

Close your eyes and imagine yourself in a film noir. Something happened. Someone knows a secret that cannot be revealed. Who is trying to blackmail whom? And why? We want to share a secret... We give you somet

BLackmail

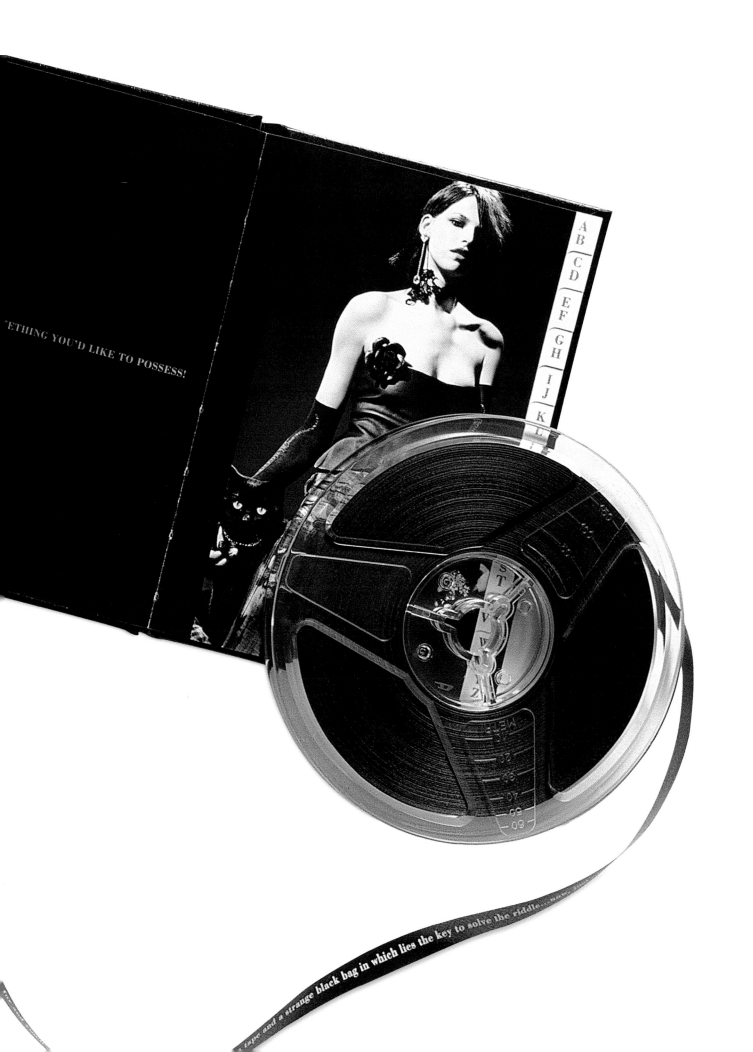

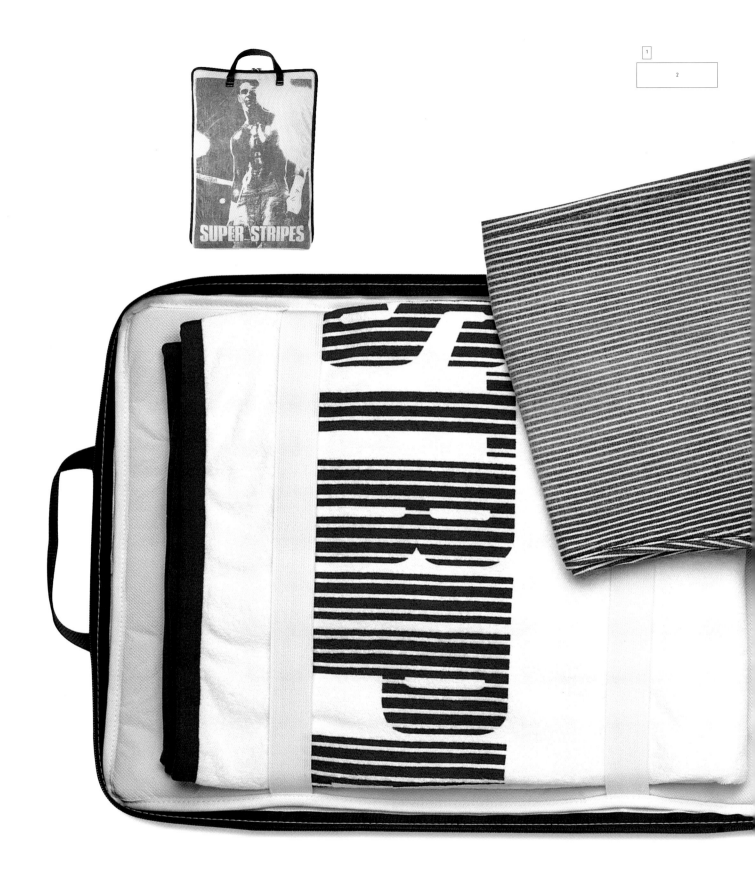

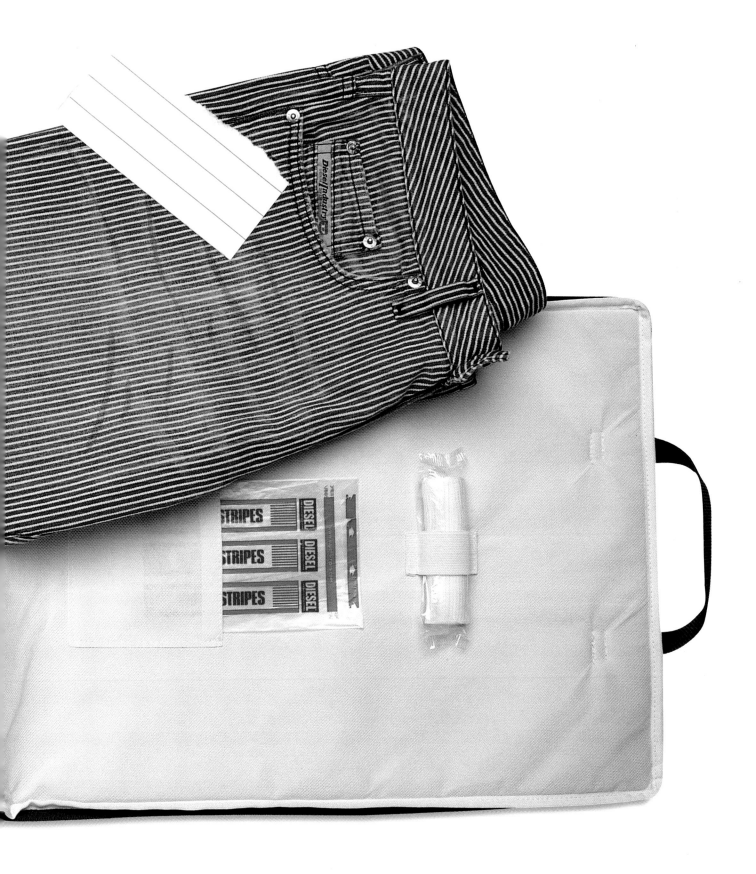

"Wear it, feel comfortable, and...be beautiful!" Shop windows in February and March of 2002 in New York, San Francisco, and Philadelphia **d i e s e l**
featured the two-fisted boxing beauties of Diesel's imaginative mind to sell its super stripes denim, a fabric as old as the 1920 HICKORY
STRIPED BRAKEMAN. Staging mannequin-boxing matches, Diesel returns to its exploration of America's vagaries, this time, the
reward of its Dream for a winning pair of gloves. A fore-running promotion was the arrival of a soft canvas bag, hand-delivered to editors,
style setters, and top-tier clients, containing a roll of gauze, bandages, a white towel, and a pair of super stripes jeans.

john varvatos The invitation, the color of dunes and hand-knotted with jute, slides off the pile of mail that arrives at an editorial office, making its silent presence known. "John Varvatos, The Artisan Collection, Spring 2001." The facts are as carefully chosen as the blind-embossed style printed on tea-dyed paper. Inside, a black-and-white image of faraway trees studding a horizon floats above handwritten text. It is in moments of such CRAFTED QUIETUDE that clothes assert themselves before they are even seen, and fashion lines advance.

Spring 2001 Collection
Thursday 14 September 11 am
The Studio Sixth Avenue at 40th Street Bryant Park
RSVP Paul Wilmot Communications 212 604 9249

2

1

EDITORS
image as the world

EDITORS AND CREATIVE DIRECTORS, WITH THEIR INTUITIVE SENSE OF STYLE, HEAD UP MAGAZINES THAT TAKE ON PERSONALITIES AS DISTINCT AS THE FASHION HOUSES THEMSELVES: *W, VOGUE, VISIONAIRE, V*—EACH WITH A PROFILED READERSHIP LOYAL TO THE DECISIONS LAID OUT ON ITS PAGES. "YOUR POWER—IF YOU WANT TO CALL IT THAT—IS SOMETHING THAT HAS TO DO WITH WHAT THE MAGAZINE ENDS UP STANDING FOR," SAYS STEPHEN GAN, EDITOR IN CHIEF OF *VISIONAIRE* AND *V*, AND CREATIVE DIRECTOR AT *HARPER'S BAZAAR*. "IT'S NOT [ABOUT] ME, IT'S MY CONTRIBUTION TO THE WHOLE; AND IT'S A WHOLE THAT PEOPLE EITHER TAKE SERIOUSLY, OR NOT. THE MORE SERIOUSLY PEOPLE TAKE THE WHOLE, THE MORE INFLUENCE YOU HAVE." EACH SEASON—AND WAY BEFORE THE SEASON (NEXT SPRING IS SHOWN THIS FALL; THIS FALL WAS SHOWN LAST SPRING, WITH RESORT WEAR AND HAUTE COUTURE SHOWN IN BETWEEN), DESIGNERS PUT ON FASHION SHOWS TO DECLARE TO THE PRESS WHAT'S NEW IN THEIR HOUSE. DOWN RUNWAY AFTER RUNWAY, THE MODELS LOPE PAST THE CROWD; EDITORIAL LEADERS SIT, THEIR HEADS GLANCING LEFT TO RIGHT AS THEY FOLLOW THE CLOTHES, PENS POISED TO PICK AND CHOOSE, DECIDING IN AN INSTANT THROUGH A RARE INSTINCT WHAT THEY WANT TO REVIEW AND WHAT THEY DON'T— CHOICES MADE WITH READERS IN MIND. THE FINALISTS ARE GIVEN OVER TO THE MAGAZINE'S ART DIRECTORS AND FASHION STYLISTS, WHO TRANSLATE THE

RUNWAY THEMES INTO STORYLINES FOR THE BOOK'S PAGES AND COVER. "MY CHALLENGE, MY MAGAZINE'S CHALLENGE, IS TO DEPICT WHAT'S GOING ON IN FASHION AND MAKE IT SEEM AS EXCITING AS POSSIBLE TO THE READER, TO THE MARKETPLACE," SAYS GAN. "IT'S LIKE REVIEWING A PLAY OR SOME FORM OF THEATER. [THEIRS] IS A FORM OF ARTISTIC EXPRESSION THAT HAS TO BE CAPTIVATING; THAT IS THEIR LIFE'S GOAL. AND WE NEED TO COMMUNICATE THAT EXCITEMENT." GAN WAITS OUTSIDE DESIGNER RICK OWENS' VENUE DURING FASHION WEEK. INSIDE, THE DESIGNER, HAIR AND MAKEUP ARTISTS, STYLISTS, AND MUSIC AND LIGHTING TEAMS WORK TOGETHER TO DRAW A MOOD OUT OF THE FASHION'S DESIGN. A VARIATION IS BEING SHOWN THIS SEASON OF WHAT HAS COME BEFORE, DIFFERENT BUT NOT TOO FAR FROM THE BASIC TENET OF THE LOOK. WHATEVER OWENS HAS DREAMED UP FOR HIS RUNWAY WILL HAVE TO IMPRESS WITH PERFECTION, SHAKE UP IMAGINATION, AND AWAKEN DESIRE. "THE IMAGE IS AN ENTIRE WORLD," SAYS GAN.

EDITORIAL PAGES REMAIN FAITHFUL TO THOSE WORLDS, WORKING IN SYNERGY WITH THE DESIGNER'S VISION, LAYERING ON THE THEME FIRST FORMED ON THE CATWALK. "IT'S HOW YOU TELL THE STORY," SAYS GAN. "THE BEST STORYTELLERS ARE THE BEST PHOTOGRAPHERS, IN MY OPINION. IT'S OUR JOB TO DO THE BEST LAYOUT WE CAN AND GET THE BEST IMAGE WE CAN. IT ALL GOES INTO MAKING THAT HAPPEN. IT'S LIKE FILMMAKING."

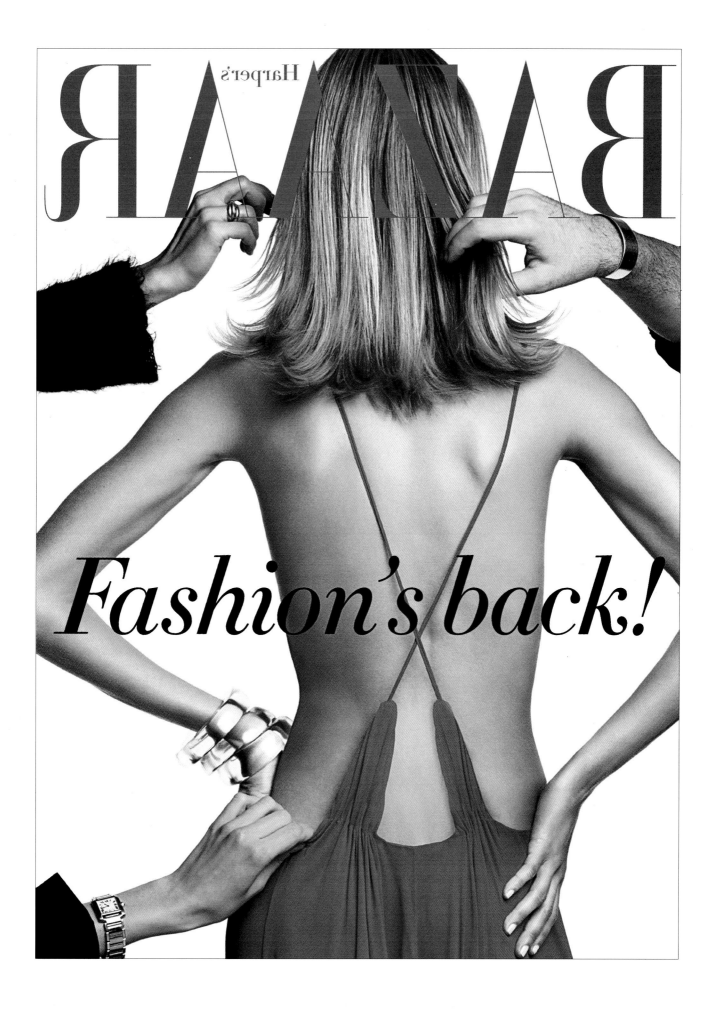

Fashion's back!

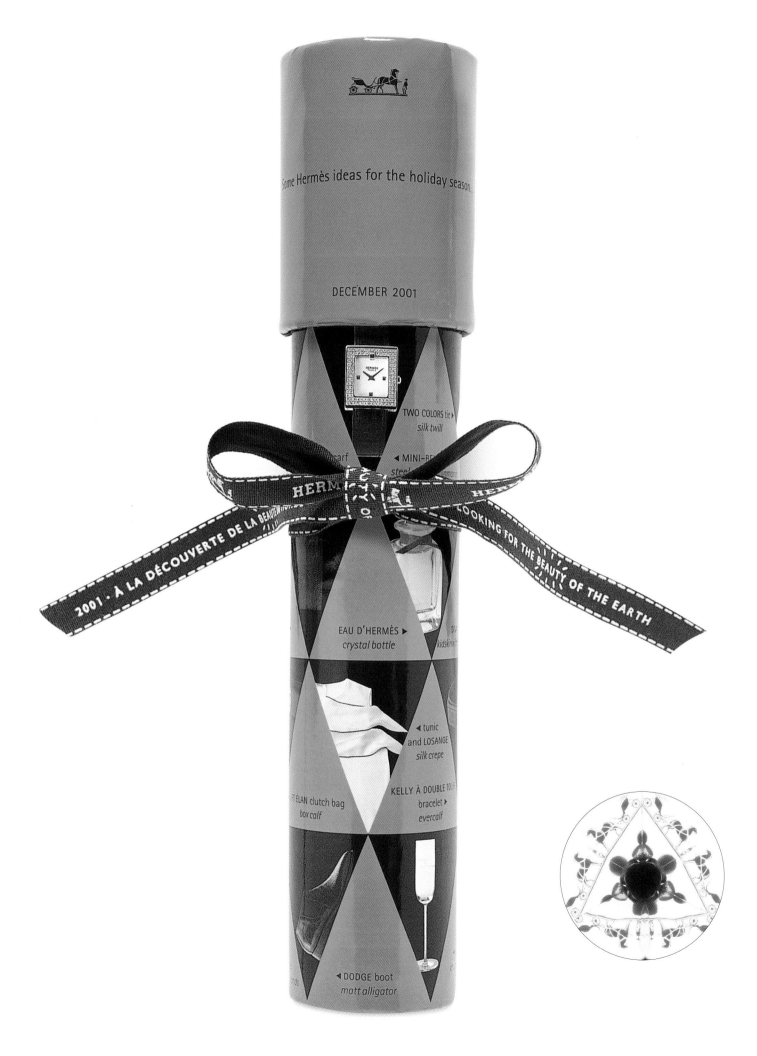

Some Hermès ideas for the holiday season...

DECEMBER 2001

2001 · À LA DÉCOUVERTE DE LA BEAUTÉ

HERMÈS

LOOKING FOR THE BEAUTY OF THE EARTH

TWO COLORS tie ▶
silk twill

scarf

◀ MINI-BE
steel

EAU D'HERMÈS ▶
crystal bottle

kidskin

◀ tunic
and LOSANGE
silk crepe

FT ÉLAN clutch bag
box calf

KELLY À DOUBLE TOU
bracelet ▶
evercalf

◀ DODGE boot
matt alligator

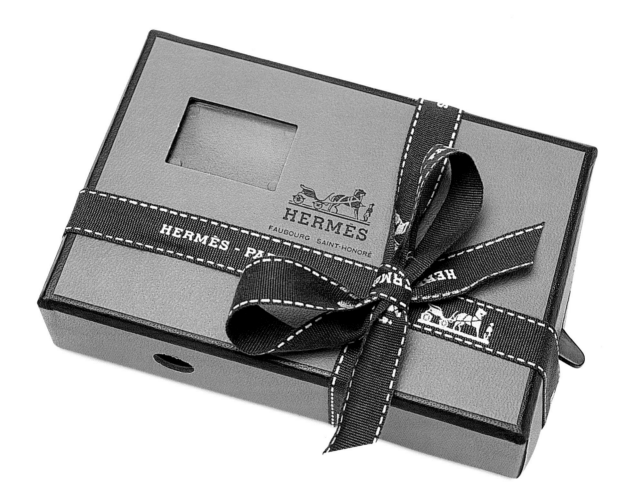

Magazine editors are visual people for whom a tilt back in a chair and a long gaze through the jewel-toned eye of a kaleidoscope is cool refreshment. Hermès sent out such a gift for the 2001 holidays: a limited-edition kaleidoscope modeled in a heavy gloss cardboard and designed in a harlequin's pattern of orange and brown. Dotted among the diamond shapes are small photographic images of Hermès accessories—reminders for the magazines' pages. What better nostalgia than looking once again through a View Finder and marvelling that the richer-than-real colors and depth perception remain the same as one remembers. Hermès, in 2000, celebrated the millennium and the PERMANENCE of its own quality with the construction of 500 limited-edition Hermès-boxed View Finders. Looking through a small window, top-lit images of gift ideas rotate, with a click of a button, past editors' eyes, providing a moment of privacy and the aura of remembrance.

hermès

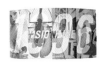

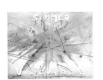

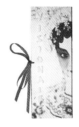

VISIONAIRE
widening horizons

VISIONAIRE, A MULTIFORMAT REPRESENTATION OF FASHION AND ART, PRODUCED QUARTERLY IN LIMITED EDITIONS, IS ALL ABOUT WIDENING HORIZONS, ABOUT CONCEPTS TAKING FLIGHT FROM THE PILLOWS OF OUR DEEPEST DREAMERS. EACH ISSUE PRESENTS IDEAS IN A NEW FORMAT, WITH ARTISTS, DESIGNERS, AND IMAGE-MAKERS OFFERING PRISM-CUT GLIMPSES OF THAT FANTASY-FORMED HYBRID, ART-AND-FASHION. MORPHED INTO DIFFERENT SHAPES—A DECK OF CARDS, PAPER DOLLS, A LIGHT BOX—THESE "ALBUMS OF INSPIRATION," AS CO-FOUNDER STEPHEN GAN CALLS THEM, OFFER NO PARTICULAR COMMERCIAL PURPOSE. PROPELLED BY A LOVE AFFAIR WITH IMAGERY, *VISIONAIRE*'S GALLERY-IN-PRINT PROVIDES RESPITE FOR ARTISTS WITH A VISION BUT NO HOME. "FINDING ARTISTS TO TAKE ON ASSIGNMENTS WITHOUT PAY WAS THE EASIEST PART," SAYS GAN, "BECAUSE EVERY ARTIST WAS OPEN TO THE IDEA OF A PLACE WHERE THEIR WORK COULD BE EXPRESSED IN PRINT." FINDING SPONSORS WAS ALSO EASY,

VISIONAIRE
NO.19
BEAUTY

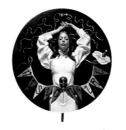

VISIONAIRE
#20

COMME
des
GARCONS

DESPITE THE SMALL CIRCULATION (4,000) AND THE INEVITABLE SHUT-DOOR REACTION OF MARKETING AND ADVERTISING CHIEFS. "*VISIONAIRE* IS SEEN AS AN ARTISTIC GESTURE THAT'S VERY SINCERE IN A WAY," SAYS GAN. "THAT SINCERITY ALWAYS TOUCHES SOMEONE WHO IS CONNECTED WITH A BIG COMPANY, AND THAT'S HOW WE STRIKE UP A CONVERSATION. EVERY TIME WE WORK WITH A BIG COMPANY, IT'S A LEAP OF FAITH FOR THEM." AND SO IN 1999, *VISIONAIRE 1* WAS RELEASED, A COLLABORATION BY FOUNDERS GAN, CECILIA DEAN, AND JAMES KALIARDOS, OFFERING A COLLECTION OF LOOSE-LEAF SHEETS OF PHOTOGRAPHS, DRAWINGS, AND PAINTINGS INSPIRED BY SPRING. FROM THAT FIRST SUCCESS, OTHER CONCEPTS FOLLOWED, INCLUDING *LIGHT* (#24, MAY 1998)—A BLACK PLEXIGLAS CASE WITH IMAGES PRINTED ON TRANSPARENT PAPER AND ILLUMINATED BY A FILAMENT, EDITED BY GUCCI'S TOM FORD—AND *LOVE* (#38, AUGUST 2002)—A TIFFANY-BLUE-BOXED COLLABORATION—AND ON AND ON, UNTIL THE LIGHTS ARE TURNED OUT.

1	7	13	16	19	22	26	32
2	8			20	23	27	33
3	9					28	34
4	10					29	35
5	11	14	17	21	24	30	36
6	12	15	18		25	31	37

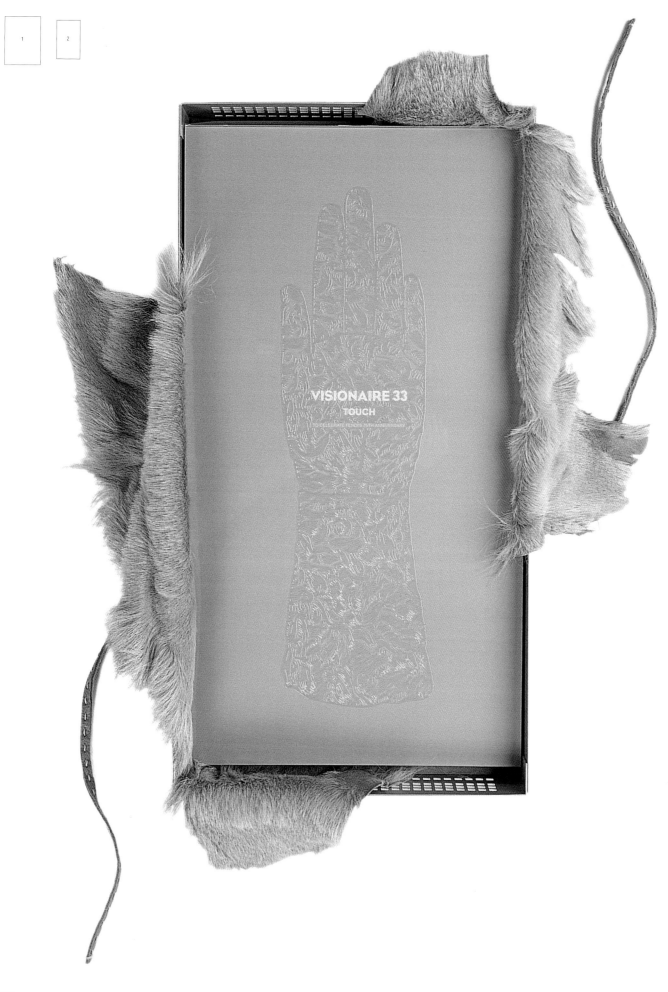

VISIONAIRE 33
TOUCH
TO CELEBRATE FENDI'S 75TH ANNIVERSARY

Sitting at a Fendi fashion show watching the downright sumptuousness of a white mink coat stenciled in black being modeled down the walkway, its filaments swaying in the air, Stephen Gan's imagination takes flight, shooting back down from the hot Klieg lights in the form of a question: What would fur look like reproduced in paper? "I was crazy about the idea of really, really laborious paper techniques, like embossing, dye cuts, silk screening, and all these crafts that aren't done that much anymore," he says. Illustrator François Berthoud was approached to take on *Visionaire 33*: a book of tactile FENDI PAPER DOLLS that reinterpret texture and tone through different media. In a neat symmetry, the white mink coat resurfaces as thick white flock, sculpt-embossed, foil-stamped, and silk-screened, with color appliqué.

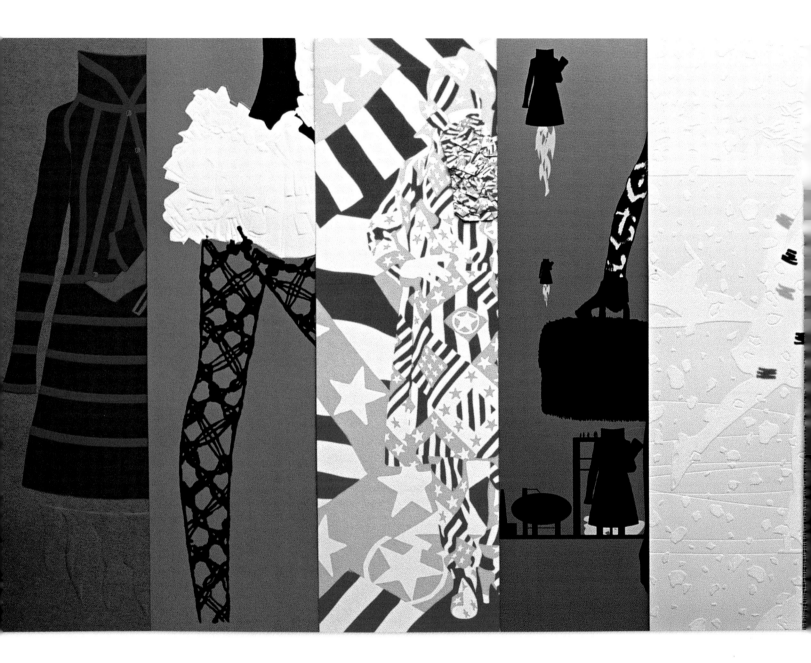

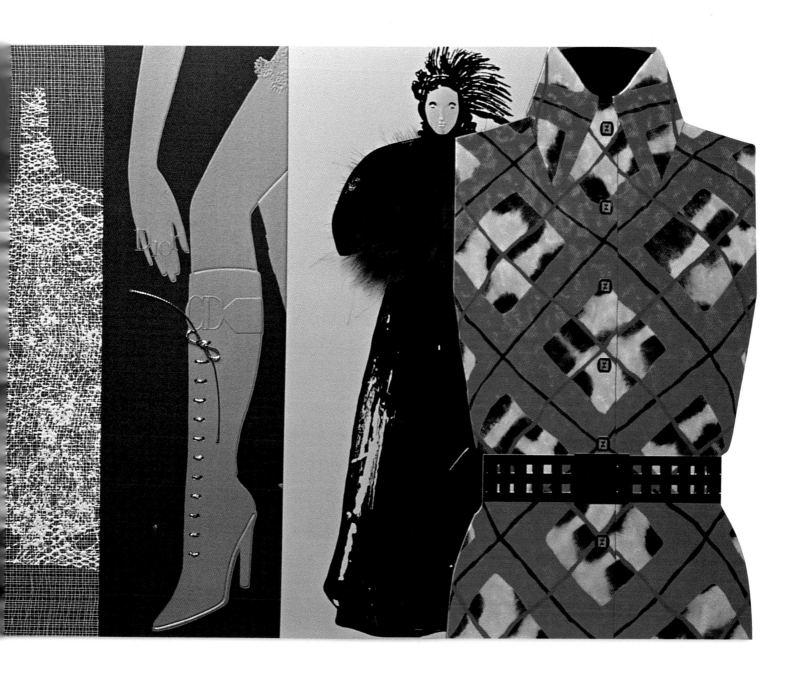

visionaire 21: The 21st issue. Our anniversary. Four suits, 13 cards apiece. We dealt Clubs to Lee Swillingham and Stuart Spalding of *The Face*, Spades
deck of cards to design boutique m/m in Paris, Hearts to whom else but Fabien Baron; the House of Diamonds we kept ourselves. Mario Testino photographed John Galliano as the King, and Iman as his Queen. Karl Lagerfeld shot the Ace. And there were others. David la Chapelle made Amanda Lepore snort a diamond up her nose. It was fun playing with real DIAMONDS FROM H. STERN! And it works, too. You can do it. You can play 21. Many Happy Returns *Visionaire*.

A postcard is saved, a reminder of someone who passed through your life. "What if I sent postcards from imaginary places to people; what would they think?" mused editor Stephen Gan, thereby inspiring *Visionaire 32*, a collaboration with the WELL-TRAVELED HERMÈS. Fifty artists photographed 50 landscapes: Wolfgang Tillmans' ethereal clouds, Nan Goldin's empty tundra, and Pedro Almodóvar's embrace on a rocky beach, to name a few. "We wanted to do something with Hermès for many years, and this was the right idea," says Gan, who approached the house to design a portfolio for the cards. "A family-run business with a heart...wonderful people who do things because they feel for it."

visionaire 32:
where?

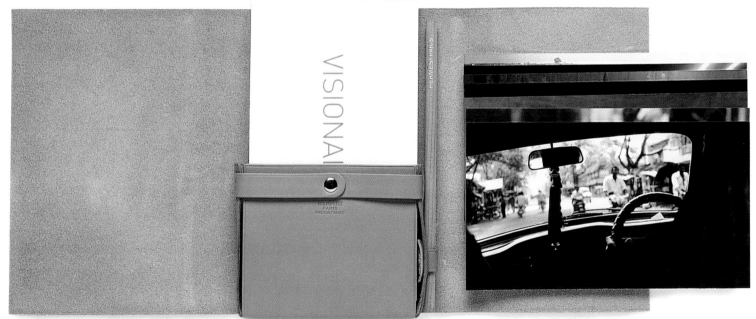

1 2

ADVERTISING

COLLATERAL

PACKAGING

ABOUT THE AUTHORS Whether playing line-backer at the College of Holy Cross in Massachusetts or struggling as an artist in Paris' Latin Quarter, Mike Toth never met a challenge he didn't learn something from. On the long flight home from France, a chance conversation with a fellow passenger led to a job offer in the New Orleans–based apparel firm, Wembley Industries, now Wemco. There, Toth found his calling. Traveling the country with a sales team, he orchestrated the company's presentations to store buyers, soaking in experiences he would later describe as "a Master's degree in branding and the elements that create commerce."

Toth was a natural with ideas about marketing, and soon began amassing awards. In five years he was ready to strike out alone, opening his own design studio in 1982. One of his first clients was a little known mail-order company, which Toth named J.Crew, and for it envisioned the first "lifestyle" catalogue—a marketing technique that revolutionized the business and earned him natioanl acclaim. Vogue has regarded him as one of the most creative, image-oriented "brand gurus" in the United States.

Toth Brand Imaging has offices in New York City and is headquartered in Concord, Massachusetts. Toth lives with his wife Susan and their four children in nearby Carlisle. Grateful for what has come to him, Toth seeks to give back in pro-bono work, supporting the future of inner-city youth through the Fresh Air Fund, advocating on behalf of the Special Olympics, and doing his part for the environment: biking to work!

Jennie D'Amato is a freelance writer living in New York City.